P9-DTC-350

THE ARTIST'S COMPLETE GUIDE TO
FIGURE DRAWING

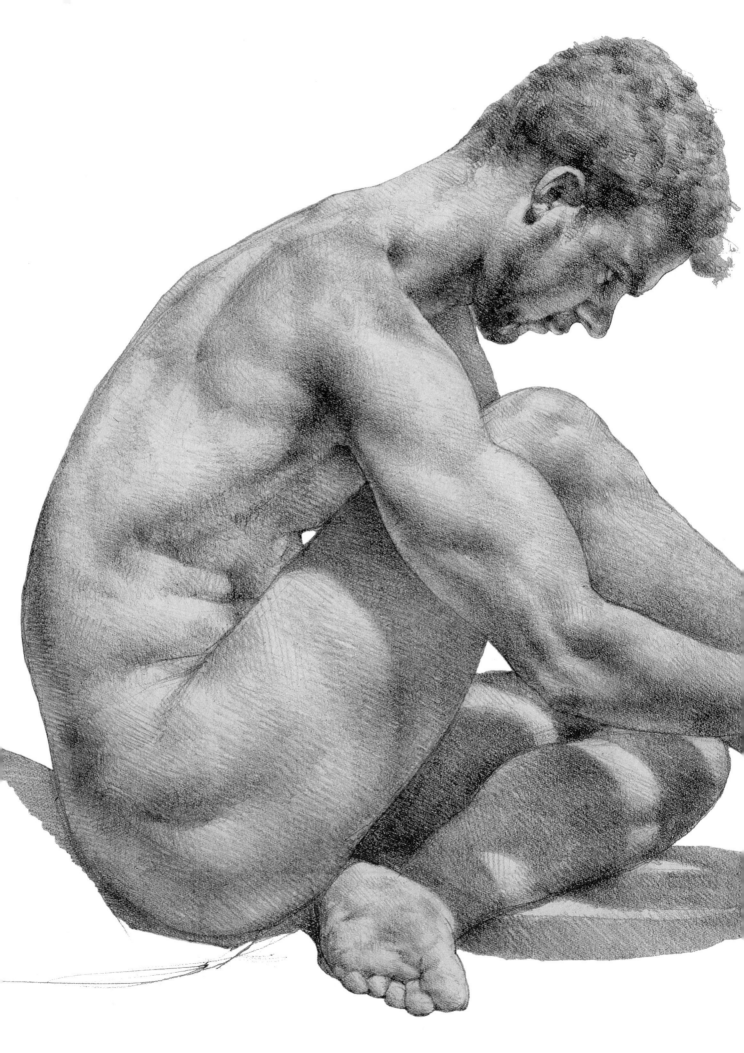

THE ARTIST'S COMPLETE GUIDE TO
FIGURE DRAWING

A CONTEMPORARY PERSPECTIVE ON THE CLASSICAL TRADITION

Anthony Ryder

WATSON-GUPTILL PUBLICATIONS/NEW YORK

Notes on the art

On the cover: *Twilight,* 1998
Pencil and pastel on gold paper, 25 x 19" (64 x 48 cm)

On pages 2–3: *Potential,* 1996 (image shown in reverse)
Pencil on paper, 18 x 24" (46 x 61 cm)

On pages 4–5: *Paintbrushes,* 1998
Pencil on paper, 18 x 24" (46 x 61 cm)

A note from the author: All the drawings in this book
were done from life.

Please note that all images have been cropped and enlarged for
maximum visibility. The dimensions given for each piece are
those of the original paper, not of the image as shown.

Senior Editor: Candace Raney
Editor: Julie Mazur
Designer: Jay Anning
Production Manager: Ellen Greene

Copyright © 2000 by Anthony Ryder
First published in 2000 by Watson-Guptill Publications,
a division of VNU Business Media, Inc.,
770 Broadway, New York, NY 10003
www.watsonguptill.com

Library of Congress Cataloging-in-Publication Data

Ryder, Anthony.
 The artist's complete guide to figure drawing / Anthony Ryder.
 p. cm.
 Includes index.
 ISBN 0-8230-0303-5
 1. Figure drawing—Technique. I. Title.
 NC765.R94 1999
 743.4—dc21 99-22843
 CIP

All rights reserved. No part of this publication may be reproduced or used in
any form or by any means—graphic, electronic, or mechanical, including
photocopying, recording, taping, or information storage and retrieval
systems—without written permission from the publisher.

Printed in the United States of America

4 5 6 7 8 9 / 08 07 06 05 04 03 02

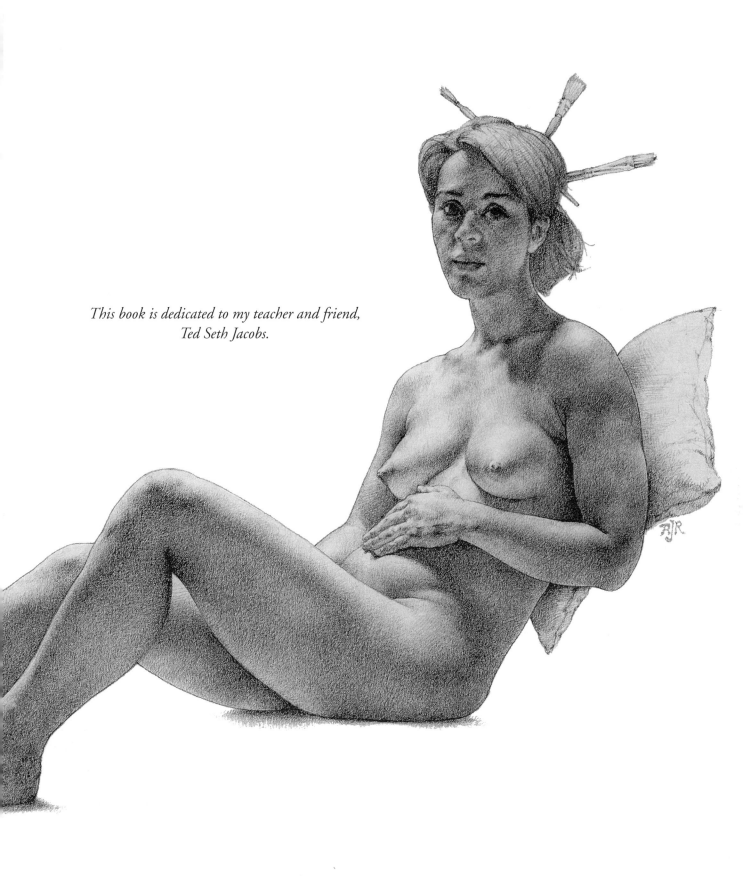

This book is dedicated to my teacher and friend,
Ted Seth Jacobs.

ACKNOWLEDGMENTS

Drawing is an experience. It can be talked about and interpreted, but I don't think that it can, in the final analysis, be defined or really comprehended. Because of this incomprehensibility, teaching the art of drawing involves not only conveying information, but creating certain conditions through which students can enter into the *experience* of drawing. Then it's a little like lighting one candle from another. Once the conditions of the learning experience have been organized, the teacher ignites the art of drawing in his or her students and then guides them into more and more profound states of realization.

I would therefore like to thank my teacher, Ted Jacobs. His devotion to the true essence and practice of drawing and his unbending adherence to principle have been the guiding lights of my career as an artist and teacher. This is a very confusing world for an artist, like a dark and stormy sea. Ted has been for me a lighthouse, the one point of reference in all the shifting currents and trends. In gratitude to him I offer this book, even though I recognize that it does not really reflect the true depth of his teaching.

I would also like to offer this book to my peers: Ted's other students. Many of you either are, or will someday be, teachers in your own right. If you haven't already begun, I encourage you to enter upon the teaching path. It is very rewarding. I hope that this book will come in handy as a source of reference material. Since you yourselves have studied with Ted, you'll have insight into its shortcomings. These, too, can be of use to you.

And I would like to offer this book to all drawing students. If you can bring yourselves to read and seriously study this method, it will be of great benefit to you.

Finally, I would like to thank the following people:

Celeste Ryder

Pam Belyea and Gary Faigin

Cynthia West and family

Lynne Hough and Charles Ervin

Catherine and Walter McTeigue

Candace Raney, Julie Mazur, Ellen Greene, and Jay Anning

Jane Myers

Robert Blake, Herb Lotz, and Richard Nicol

Patricia Arquette, Ed Bettancourt, Jim Blanchard, Anna Bogaard, Lancelot Bourne, Veronica Bowles, Angie Chamberlain, Scott Cherry, Diane Constantine, Chris Dixon, Jennifer Dove, Cullen Dwyer, Goyko, Keri Greeves, Jane Gregory, Anne Hitchcock, Robert Hoggard, Pete Jackson, Emily Kuenstler, Jessica La Cass, Michael Leonard, Claire Mack, Ramona McNabb, Aline Mendonça, Justine Mendonça, Dane Nogar, Nicole Paterson, Prem, Rima Ralff, Kelly Sandberg, Sandy, Christina Santucci, Lorraine Sauerland, Josh Schrei, Jonathan Silbert, Free Walker, and Shale Wills

CONTENTS

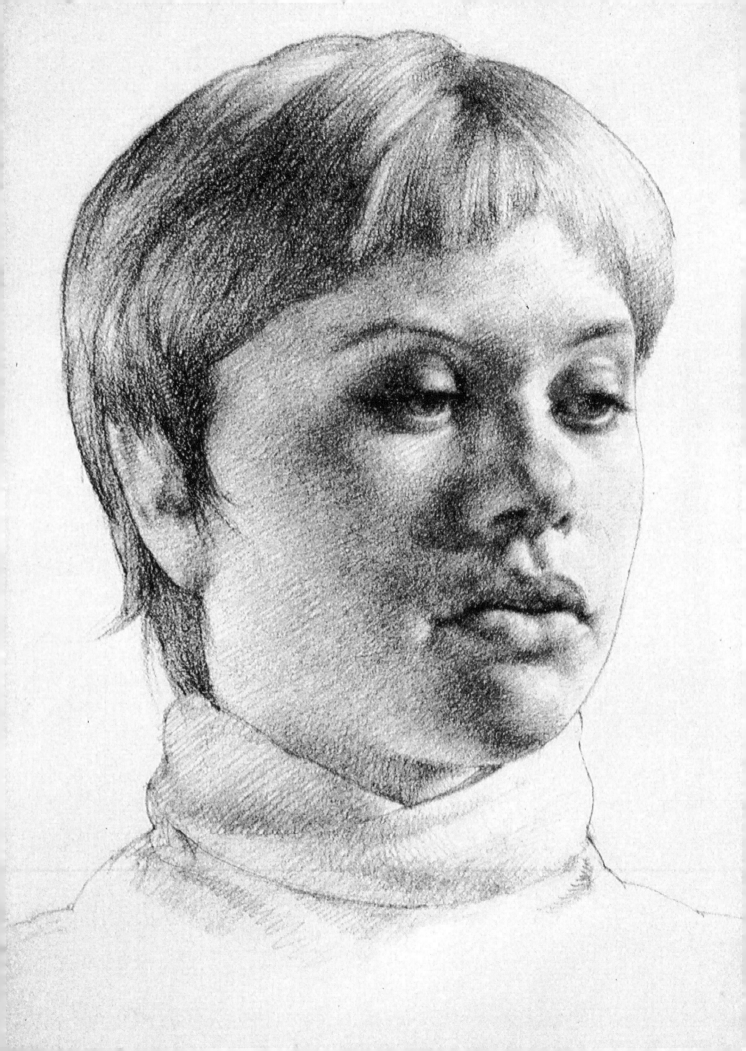

PREFACE

FROM 1983 TO 1989 I studied painting and drawing with Ted Seth Jacobs at the Art Students League of New York, in New York City. In those days, the whole place reeked of turpentine and linseed oil. Students wore smudges of cadmium red and lead white on their hands and clothing like medals of distinction. There was paint everywhere. It probably was, at least from a chemical point of view, a very toxic place. But I loved it. Everybody loved it. We loved it because there was something else mixed in with the solvents and heavy metals, another kind of spirit in the air: the League was saturated with the history of art. A few blocks north, just a nice little walk through Central Park, stands the Metropolitan Museum of Art. The Met is bursting at the seams with incredible paintings, but it was in the studios of the League that I found the living tradition of the great masters. This book has been an outgrowth of that experience.

On my first day of art school, I attended a portrait painting demonstration that Ted was giving. I was a few minutes late. I sat in back on a tall, ancient wooden stool. Ted was demonstrating a two-step glazing method of working in oils. He was working on the first stage that night—a grisaille underpainting. The model was a young man named Carlos who wore blue jeans, a leather vest, and a red headband.

While he worked, Ted talked about the subject of painting—not about painting Carlos, the leather vest, and the red headband, but about the perceptual process, the process of *vision*. He defined vision as a continuum, consisting of the model, the light, and the viewer. He said that the model himself, the light by which we saw him, and the image we saw in our minds were all part of the same perceptual reality. Moreover, he said that the key to painting this perceptual reality was to understand "the effect of the light." He referred to a tradition in the history of painting called the optical tradition, in which masters like Vermeer, Velázquez, and Rembrandt had worked, conducting profound research into the nature of light. Meanwhile he painted Carlos and everyone sat quietly, watching and listening. I was totally blown away.

What I learned from Ted over the course of the next six years became the fundamental core of my existence as an artist. And as I absorbed his teaching, I also absorbed his desire to teach. I've now been teaching for fourteen years. Throughout this period I've been guided by one principle: stick to what you were taught. I've never had any desire to teach anything new, to invent anything, change anything, or innovate in any way. I've always just wanted to learn how to draw and paint in the way I was taught. And I've felt a duty to at least try to teach in the same way. Of course, I have to say that my way of teaching differs from Ted's. How could it not? I'm a different person, with a different perspective. It would be wrong to say that this book reflects his teaching. It's my interpretation. It's my effort to express what I learned from him, and to pass it on.

In painting, everything depends on the drawing. The drawing is the inner structure that upholds and organizes the composition, and anyone who wants to learn to paint must therefore learn to draw. But drawing is more than just an adjunct to the art of painting: it is an art in itself. Whether one pursues it alone or in conjunction with painting, one soon realizes that it occupies a unique aesthetic territory. There is a quality to drawing that is all its own.

I sincerely hope you find this book on drawing to be useful and informative. I wish you many felicitous pencil strokes!

LEFT: *Homage to Vermeer,* 1995
Pencil on paper, 17 x 14" (43 x 36 cm)

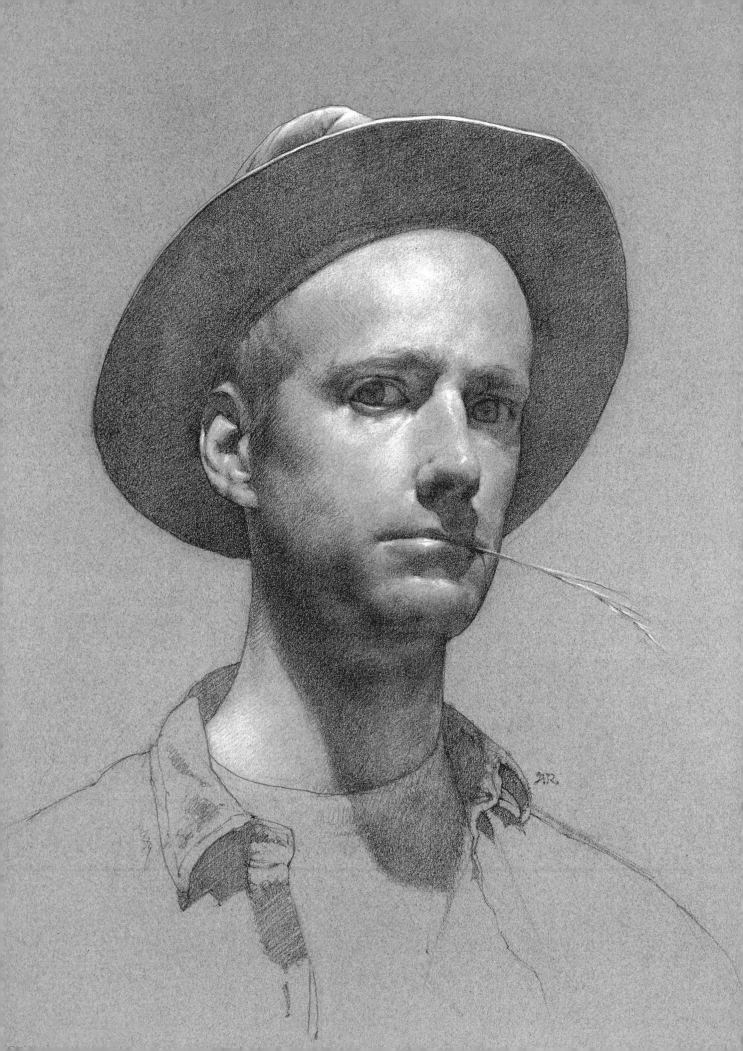

THE DRAWING METHOD

LEARNING TO DRAW is like learning a new language. Drawing has its own vocabulary and, more importantly, its own grammar. The purpose of study is to become so fluent that the nature of the model expresses itself through your pencil effortlessly. This means receiving impressions of the model with an open awareness, and translating them into line and tone clearly and spontaneously. It means being able to handle anything, no matter how "difficult," calmly and easily.

Students often just want to learn "how to draw." But it is far more important for them to learn about *what* they are drawing. When the model poses, the student is presented with a vast quantity of information. He processes and interprets this information, formulating it in terms that he can understand. This formulation then becomes the true subject of his drawing. He doesn't draw what he sees—he draws what he *thinks* he sees. His thought process stands at the very center of his ability to draw. If you wish to learn to draw you must therefore become aware of what you're thinking as you draw. The purpose of this book is to upgrade this process of interpretation and formulation with a step-by-step drawing method.

The drawing method taught here is a basic, three-step method. Although each step will be discussed in some detail, this is a good time to introduce the vocabulary and concepts behind each step. Let's start by assuming that the model has taken a new pose, and I'm about to begin work on a drawing that will take me twenty or thirty hours. I arrange my paper, my drawing board, and the rest of my drawing supplies. I look at the model, and in an instant my eyes gather enough information to keep me busy for days and weeks.

1. *The Block-in.* So as not to be overwhelmed with all the information I'm getting from the model, the first thing I do is ignore just about everything and sketch an *envelope* that mirrors the basic outside shape of the figure. The envelope is the first phase of the block-in, and although it is just a few lines, it plays a critical role in inaugurating the drawing process. I then begin breaking down the envelope into smaller and more detailed lines. At first I do this very broadly, looking for major shapes. Only after I resolve the large shapes do I proceed to smaller ones.

LEFT: *Self-portrait,* 1997
Pencil and pastel on gray paper, 25 x 19" (64 x 48 cm)

Howdy. Welcome to the land of drawing. Hope you can stay for a while (like for the rest of your life). Feel free to visit. Tour the countryside. Don't be shy. You might feel awkward at first, but after a while you'll fit right in. There aren't any highways here, no cars or television sets. Things happen slowly in these parts, one pencil stroke at a time. While the rest of the world races along, we pass the hours quietly honing our perceptions, immersed in the anachronistic art of drawing the human figure. You'll be glad you left the hustle and bustle behind. So come on down. It's peaceful here, and the people are real friendly.

Finally, I end up with the *block-in,* which is a two-dimensional translation of the figure—in other words, the "shape" of the model.

As I work on the block-in, I try to be aware of the *gesture* of the model. The figure is always doing something, whether it is sitting or standing, reading the paper, or talking on the phone. Whatever the action of the figure, all parts of the body participate in a unified way. This action is what we call the gesture. It unifies the block-in and is expressed as a network of invisible curves.

2. *The Contour.* I keep adjusting the block-in until I run out of things to fix, and then I switch over to the *contour.* The contour is the line that exactly describes the silhouette, or outline, of the figure. It is composed of many individual curves, each of which describes a specific convexity in the surface of the body. By the time the contour is complete, after maybe six hours of work, all I've really got is an empty line drawing on the page. It may not look like much, but it represents a lot of research into the exact shape of the figure.

3. *Drawing on the Inside.* The final phase involves the use of shading to fill the contour with an illusion of solid form. I begin by lightly mapping out *landmarks* with small patches of *hatching* and *cross-hatching*; these will eventually disappear into the shading as a whole. I look to see how these landmarks line up with one another along *pathways of form,* which are strings of formal elements organized in wave patterns all over the body. Once I've mapped out the regions of light and shadow, I build up darker values first, with successive washes of cross-hatching. This process is somewhat exploratory and experimental as the drawing is constantly evolving. I develop one part of the drawing within an anticipated value range, and then use that part as a key for building value relationships in the other parts. Then I slowly weave the complex tapestry of form and light out of subtle washes of graphite.

Drawing on the inside relies not only on a careful observation of how light and shadow play on the model, but also on a theoretical understanding of the behavior of light and its relationship with form. These concepts will be treated separately in Chapters 5 and 6, while the actual technique of laying down tonal progressions is covered in Chapter 7.

For drawings done on toned paper, I follow a variation of the above process. On white paper, the landmarks I choose to work with are necessarily darker than the paper itself. But on toned paper, I can use landmarks that are both darker and lighter than the value of the paper. The lighter landmarks help structure regions of the drawing that will be developed with light pastel pencil; just as dark landmarks eventually disappear into the shading as a whole, so will these light landmarks be assimilated into the more thickly built-up lights. The tonal work then proceeds in two parallel realms: one realm darker than the value of the toned paper, and one lighter. The value of the paper is the break-even point between these two tonal structures.

On average, I put in about twelve three-hour sessions for each finished figure drawing. I work at an even tempo, as if I was building a piece of furniture, carefully crafting, shaping, and polishing each part. As you develop a facility with the terms, exercises, and principles contained in this drawing method, you too will be able to work through this process one step at a time, to create beautiful, elaborate, and highly refined figure drawings.

RIGHT: *Woman on a Couch,* 1998
Pencil and pastel on gold paper, 19 x 25" (48 x 64 cm)

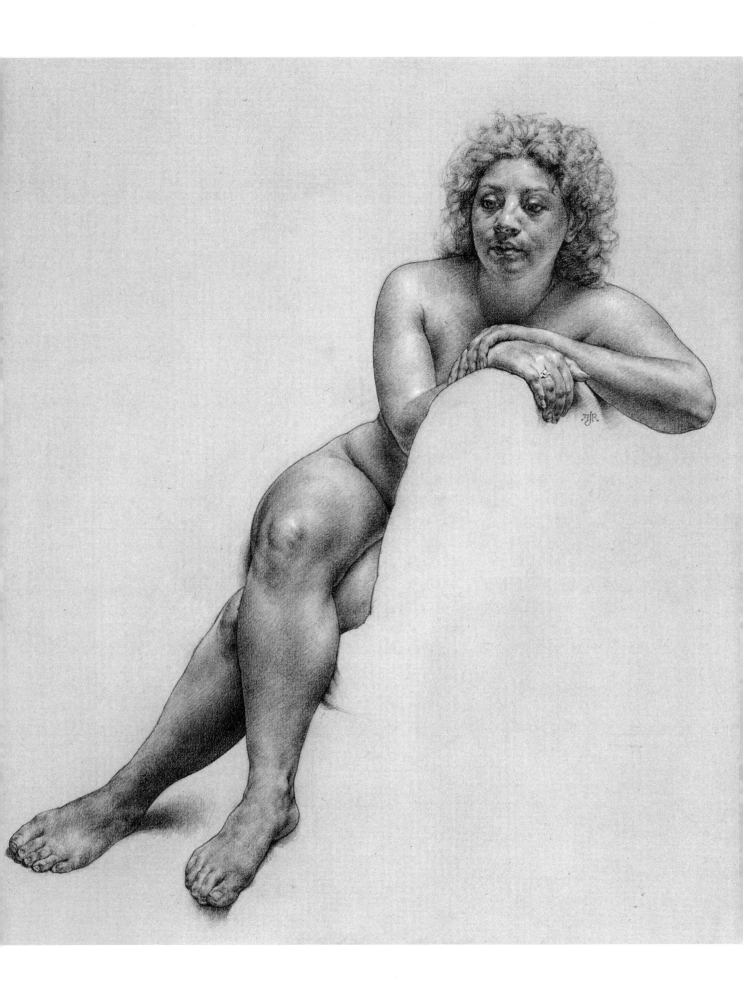

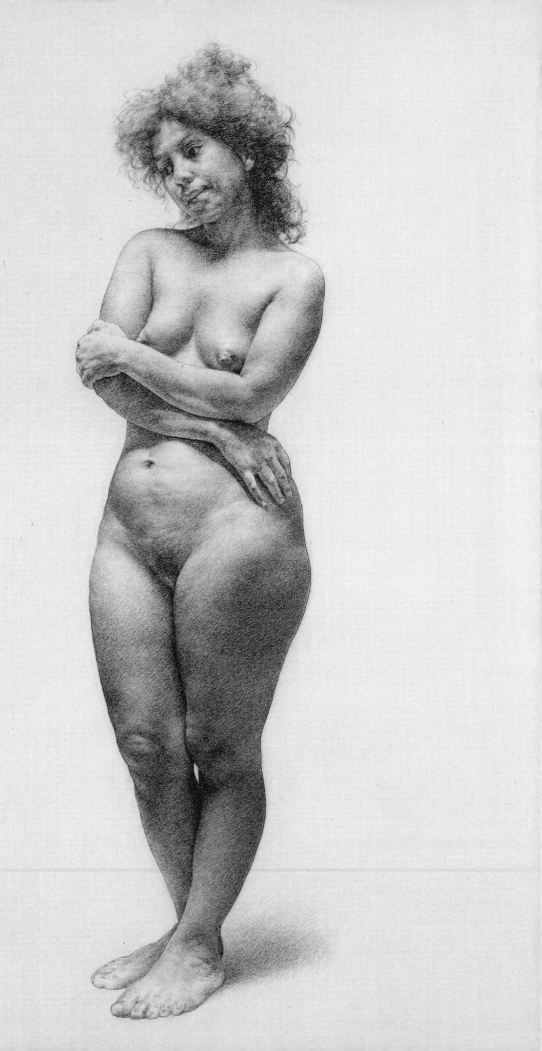

MATERIALS AND BASIC TECHNIQUES

EVERY APPROACH TO DRAWING employs its own combination of drawing materials. The choices you make about paper, pencils, and erasers will greatly influence the style and quality of your drawings. But these choices are only half the equation. You must also develop a rapport with your materials. It is this rapport, as well as the materials themselves, that determines the appearance of the finished drawing.

MATERIALS

Drawing materials of high quality are commonly available in art supply stores at reasonable prices. It's worthwhile using good materials, but it isn't necessary to spend a lot of money on exotic papers and fancy pencils. Practicality is the most important thing.

Paper

There are many different kinds of paper available and it can be a little overwhelming to try to find the right one. Here's a brief list of some of the things you should look for.

- *Designated purpose:* Most papers are designed for certain purposes and are accordingly given designations, such as "bond," "tracing," "layout," and so on. When I work on white paper, I use papers with the "drawing" designation. When I work on toned paper, I use those with the "charcoal" designation.

- *Dimensions:* Standard drawing pads come in several sizes. I recommend 18- x 24-inch (46- x 61-cm) pads, since they are big enough to accommodate reasonably large drawings but not so big as to be ungainly and difficult to manage. Individual sheets of paper don't normally come in standard sizes. Some of the paper I use comes in single 19- x 25-inch (48- x 64-cm) sheets, others as 23- x 29-inch (58- x 74-cm) sheets. I usually buy a half dozen sheets at a time, and prefer to transport them flat, rather than rolled. If you're worried that the paper may be kinked or bent in transit, a piece of corrugated cardboard can be included in the packaging for stiffness and protection.

- *Weight:* Paper comes in a variety of weights, and the heavier the weight, the thicker the paper. In the English system, a paper's weight is designated as the weight of one ream, or five hundred sheets. Thus, a ream of 80-pound drawing paper weighs 80 pounds. In the metric system, the weight designation corresponds to the weight (in grams) of one sheet, one meter square. Thus, paper marked 130 g/m^2 is paper for which a sheet one meter wide by one meter long weighs 130 grams. I prefer to work on 80-pound drawing paper and 65-pound charcoal paper, although I follow no hard-and-fast rules.

- *Texture:* A paper's texture very much influences the kind of drawing that can be done on it. Textures are generally rated as rough, medium (or regular), smooth,

LEFT: *Linda's Drawing,* 1998
Pencil on paper, 24 x 18" (61 x 46 cm)

or plate (very smooth, somewhat glossy). There are pros and cons for each of the various textures. Rough paper holds more graphite than smooth paper, so drawings done on it can have deeper, richer shadows and therefore more contrast between the lights and darks. But it can be difficult to resolve fine details on rough paper, as the texture produces a very grainy look. In drawings done on smooth paper, it's easier to resolve fine detail, but the drawing must be done with very soft pencils if you want to develop dark values. Since soft pencils smudge easily on smooth surfaces, this requires a high level of control and finesse with the eraser. Otherwise, the drawing will quickly take on a dirty, sloppy appearance. Another drawback is that graphite tends to look shiny and metallic when liberally applied to smooth surfaces.

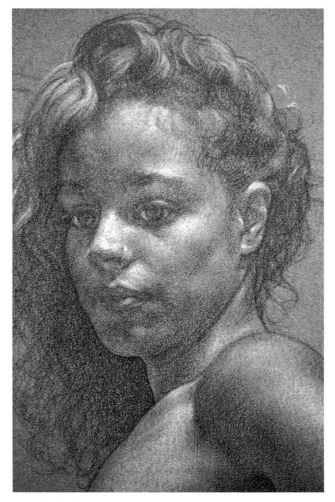

Detail of *All-Star,* 1998
(For full image, see page 102.)

This drawing was done with graphite and white pastel on gray paper.

For all these reasons, I prefer paper in the medium to medium-smooth range. This texture has enough *tooth* (a term for the graininess of the texture) to support a fairly heavy application of graphite without that metallic look, yet it's smooth enough to allow for the resolution of relatively fine detail.

- *pH balance:* Strong acids are used in the production of wood pulp, and many papers made from wood pulp retain a residue of these acids. Eventually, these residues eat away at the paper, causing it to deteriorate. There is, however, *acid-free* paper available with buffering agents that neutralize its acidity. Such paper lasts a lot longer, and I recommend it if you care about your work.

- *Rag content:* Papers made with cotton fiber are called *rag* papers. They are more durable than paper made from wood pulp. Conserved correctly, they can last for centuries. And who knows, drawings done on rag paper may still be around when people are sweating the Y3K problem.

- *Tone:* Most of the time I draw on regular white, or slightly off-white, drawing paper. But occasionally I work on toned or colored paper so I can bring up the lights with a white pastel pencil. The relative darkness of the paper boosts the luminous effect of the light. I avoid intensely colorful paper because I find it to be a little overwhelming, preferring relatively neutral ochres, greens, grays, and blues. Each tone imparts a subtle flavor of its own to the drawing that's hard to describe. Graphite and white chalk on gray paper, for example, tends to have an Art Deco look. The tradition of working on toned paper with dark and light chalk goes at least as far back as the early Renaissance. For the drawings on toned paper shown in this book, I replaced the traditional dark chalk with graphite pencil.

A "good" drawing paper is one on which you like to work. I happen to like the papers listed opposite because they are convenient to my style and manner of working. Once you have worked with them for a time, you will have a basis for comparison if you choose to experiment with other papers.

My standard drawing paper is Strathmore 400 Drawing, medium surface. It comes in 18- × 24-inch (46- × 61-cm) pads of twenty-four sheets and is a good, all-purpose, acid-free, 80-pound (130-g/m^2) wood-pulp-based drawing paper. I've been told that, with proper conservation, this paper may be expected to last two hundred years. Its grain, or tooth, takes the pencil nicely, and it is neither soggy and spongy nor overly hard and glassy. It also stands up to a fair amount of erasing.

For toned papers, I use Strathmore 500 Charcoal, medium surface. This is an acid-free, 18- × 24-inch (46-

× 61-cm), 65-pound (95-g/m^2) rag paper, the back surface of which is nearly as smooth as conventional drawing paper. It is called a "laid" paper, since the pulp is laid into a form and then pressed. The form imparts a regular pattern, something like the pattern of a window screen, to the paper. The paper is durable, has a medium tooth, has the right hardness, and comes in shades of gray, green, gold, and so on. Pads with assorted tints are available, as well as individual sheets.

I also use a recycled, gray-toned paper, also made by Strathmore, which goes by the name of Artagain. Artagain

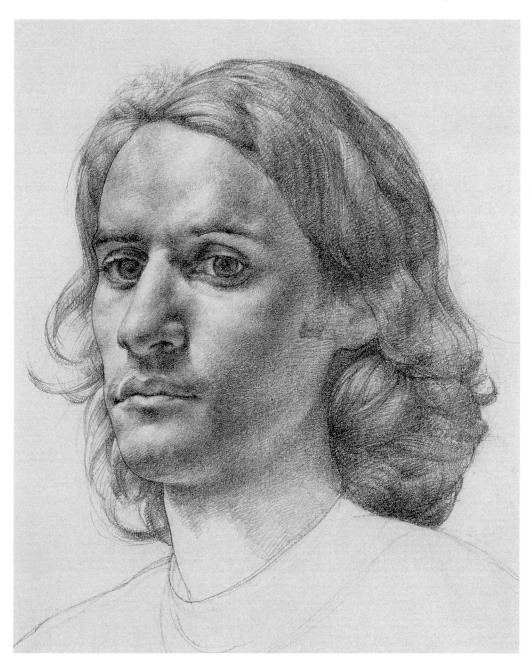

Ed, 1998
Pencil on paper, 24 × 18"
(61 × 46 cm)

This drawing was done with graphite on white paper.

is a 400 series wood-pulp, 60-pound (160-g/m²) paper that contains 10 percent postconsumer and 40 percent preconsumer recovered material (measured by weight). It is available in a variety of colors and shades, and comes in single 19- x 25-inch (48- x 64-cm) sheets, as well as 9- x 12-inch (23- x 30-cm) and 12- x 18-inch (30- x 46-cm) pads.

Drawing board

One of our goals in drawing is dexterity, and one way to improve dexterity is to support the paper with a firm drawing surface. While not absolutely necessary, a good drawing board will cut down on an infinite amount of fumbling. I use a 20- x 26-inch (51- x 66-cm) piece of ½-inch (1.5-cm) foam core, cut down from a 30- x 40-inch (76- x 102-cm) sheet. Foam core is lightweight and rigid. It has an antigravity feeling—almost like a thin, rigid cloud—and a nice, drumlike resonance. If I'm working on a single sheet of paper, rather than from a pad, I lay another half dozen sheets down between the sheet I will draw on and the drawing board. The middle sheets serve to slightly cushion the drawing surface.

Clips

Clips hold the paper or pad onto the drawing board. I use Bulldog brand clips in the largest size available.

Pencils

I use two different kinds of pencils: regular graphite drawing pencils and pastel pencils. Standard graphite drawing pencils were used in all the drawings reproduced in this book; pastel pencils were used to bring up the lights in the drawings done on toned paper. Perhaps the most important thing to know about pencils is that they work best when kept very, very sharp.

- *Graphite:* Graphite drawing pencils are available in precisely calibrated grades of hardness and softness. In this grading system, "H" means hard and "B" means soft. There are nine grades of H pencils: H, 2H, 3H, and so on, all the way up to 9H. The higher the number in front of the H, the harder the pencil. Thus, a 9H is the hardest pencil in the entire grading system. There are also eight grades of B pencils: B, 2B, 3B, and so on, all the way up to 8B. The higher the num-

ber in front of the B, the *softer* the pencil. Thus, an 8B is the softest pencil. Right in the middle, between the Hs and the Bs, is the HB pencil. There is also an "F" pencil, which is softer than an HB and harder than a B. This variety allows you to work in an extended value range, from very dark to very light.

Relatively speaking, harder pencils are easier to control. The harder a pencil is, the lighter and finer its lines will be. Hard pencils feel scratchy on the paper, hold a point longer, are cleaner and drier, and erase more completely than soft pencils. The softer a pencil is, the more difficult it is to control. Soft pencils make heavy, thick lines. They feel silky on the paper, lose a point quickly, are dirty and greasy, and erase less completely than hard pencils.

I am often asked by students which pencils to use in a drawing. This is a little like asking which gears to use in your car. You should change pencils the way you change gears: at need. A basic rule for knowing when to move to a softer pencil is that you should never force a pencil to do more than it wants. Go to a lighter pencil, for example, if it seems that the marks you're making are too heavy and gross. When working on white paper, I generally use a 2B pencil to draw the envelope, block-in, contour, and for the beginning of the tonal lay-in. I then use softer pencils (3B through 6B) for the latter stages of a drawing, to push the dark values into a deeper range. I usually find 2B pencils good for working in the light and for microsurgical adjustments anywhere in the drawing, but if necessary I use something harder, like an HB.

Having said all this, my recommendation for anyone new to drawing is to start with an HB pencil. See how much tonal range you can develop with this one pencil. Again, the most important thing is to keep the pencil sharp.

- *Pastel pencils:* Some of the drawings in this book were done with a combination of graphite and white pastel pencils. (In a few cases, I experimented with colored pastels, such as pale yellow, pale orange, pink, and coral red.) I find that Conté brand pastel pencils work best. These are hard, nonoily pastel sticks encased in wood. In other words, they are pastels in the form of a pencil. Pastel pencils are fragile; if

dropped on an uncarpeted floor, the pastel stick in its wooden casing may fragment, so they need to be carefully handled. Furthermore, sharpening pastel pencils is an art in itself. They should be given long, smoothly tapered, acute points. Since they are a little too fat to fit into a conventional pencil sharpener, they need to be sharpened with a single-edged razor blade. (Please note that sharpening pastel pencils can be dangerous. Always sharpen with the blade facing *away* from the hand holding the pencil.)

Erasers

I use two categories of erasers when drawing: kneaded erasers, which have the consistency of bread dough and can be stretched and molded into different forms, and "soap" erasers, chunks of white, rubbery plastic that resemble little bars of hand soap.

- *Kneaded erasers:* Kneaded erasers are like pieces of taffy. They come as small square or rectangular bars wrapped in cellophane, and part of the bar should be torn off and kneaded until it becomes soft and pliable. One end of the blob should be twirled into a point between the thumb and forefinger. This part of the eraser can be used for delicately picking out small glitches and cosmetic irregularities, and for lightening lines and chunks of shading. Be sure to frequently retwirl the eraser's point or it will get loaded with graphite and redeposit spots on your drawing.

- *Soap erasers:* Soap erasers are good for cleaning up line work and getting rid of big things. They cut a large swath, taking out everything that stands in their way. Soap erasers should be used with care when taken inside a drawing; if dragged across an already heavily shaded area, they can push the greasy graphite into the tooth of the paper, leaving a smudgy streak. In view of this, I try to make all major adjustments to my drawings early on, before I load them up with a lot of shading. A soap eraser can also be trimmed on one end with a knife, giving it a chiseled edge. This must be done carefully—if the edge is too sharp, the tip of the eraser will be too wobbly, if it's too blunt, the eraser's action will be clumsy. To clean the eraser, rub it on the bottom of the page, away from your drawing. Sweep away the resulting crumbs with a large, soft brush, trying not to drag the brush across heavily shaded areas.

Other materials

When I sit down to draw, I put the bottom edge of the drawing board in my lap and rest the back against a stool placed in front of my chair. To keep the heel of my hand off the paper, I use a *bridge* as a hand rest. You can easily make a bridge from an 18- x 4-inch (46- x 10-cm) piece of ½-inch (1.5-cm) foam core. Make "feet" from two 2-inch (5-cm) squares of the same foam core and glue them to the underside of the bridge at either end.

I usually keep a stool or small table next to my chair when I'm drawing. This is where I put my pencil sharpener, a bunch of spare pencils in a small, lightweight pencil box, a pencil extender. today's coffee cup, yesterday's coffee cup, a dessert plate and crumpled pastry wrapper, and other essential drawing items.

It should probably be pointed out that food and drink, especially sugar-drenched pastries, glazed cinnamon rolls, and anything that drizzles grease or ketchup, while perhaps necessary for some, definitely do not belong in the high security, "clean room" environment in which the drawing process occurs. I recommend a little security routine before, and periodically during, the drawing session. This includes washing hands, checking sleeves and cuffs for mayonnaise, checking the beard for stowaways, and a mild, general shakedown to remove all crumbs.

I would also recommend a portfolio for storing and transporting drawings. I prefer a standard, black, 20- x 26-inch (51- x 66-cm) artist's portfolio with flaps. Drawings in the portfolio should be interleaved with glassine, a paper that looks and feels kind of like wax paper. Glassine prevents the drawings from rubbing and smudging against one another.

Whatever materials you use, they should be of high quality (but not flashy), and lightweight, simple, and as easy to transport and store as possible. Try to develop routines for getting things in and out of the car, for setting up in the studio, and for working efficiently. The entire technical aspect of the drawing process should fade into the background when you actually sit down to draw.

BASIC TECHNIQUES

Drawing materials have minds of their own. You can't boss them around. Sensitive handling can result in beautifully rich textures and lines. But if your materials are not doing what you want them to, it's not their fault. It's because you haven't learned how to handle them in the right way.

The basic techniques of drawing as demonstrated in this book involve the making of lines and patches of shading. Indeed, on one level that's all a drawing is: line and tone. With the pencil we produce lines in a variety of lengths, curvatures, orientations on the page, and degrees of darkness, lightness, hardness, and softness. Likewise, we use the pencil to produce patches of shading with a method known as *hatching,* and these can be made in a variety of sizes and shapes, degrees of darkness, and gradations of tonal change.

The pencil is the tool of the draftsperson, like the scalpel of the surgeon and the arrow of the archer. Learning to use a pencil is like learning to use a fork. If you could remember how long it took, when you were a child, to learn to do things that required coordination, like eating spaghetti or peas, you might have more

patience with yourself when it comes to learning how to use a pencil. Like a musical instrument, the pencil can express the most delicate gradations of feeling, but we have to develop this ability through practice. The techniques described below can be practiced almost anytime, anywhere—as you are talking on the phone, waiting for a bus, or watching television.

MAKING LINES

From the moment the drawing begins to appear on the paper, lines are there. They are the basic components of the envelope, the block-in, and the contour. They also have an invisible presence in the figure as lines of movement, thrust, and pressure. And, like the cells that compose all our tissues, they are the individual elements that make up all washes and modulations of shading. They are the fundamental building blocks of the drawing.

One of the beauties of drawing is that it employs a means of expression that everyone has at hand. We've all been making lines—with crayons, pencils, magic markers, and ballpoint pens—since we were wee, tiny tots. All we need now is to put these skills in order, to employ them consciously and carefully. This kind of work has more to do with paying careful attention to what we already know than with learning anything new. Everyone can make lines with a pencil. And everyone can train him or herself to draw these lines intentionally, according to certain arcs, lengths, directions, and with definite degrees of darkness and lightness and hardness and softness. That's all there is to it.

You might say, "Well sure, I can draw lines. But that's not all there is to learning how to draw." And I would reply that you are quite right. But is the bottom rung of a ladder any less important simply because there are other rungs above it? Those who are beginning the process of learning should first tackle those problems that pertain to their status as beginners. In this way they will accomplish two very important things: they will advance in the right direction, and they will gain confidence. They will also begin to form a perspective and understanding of the art of drawing.

TIP

All technical issues culminate at the very point of the pencil and its exact location in the drawing. This is where everything in the drawing actually happens. Get into the habit of focusing your mind on the point where the drawing is coming into realization. As often as you sharpen your pencil, try to sharpen your focus; direct it to the point of the pencil. After sharpening your pencil, hold it up before your eyes and actually look at the point for a moment. Imagine yourself standing on that tiny peak, as if you were standing on top of a mountain. The pencil is what connects your mind to the drawing, but in order for it to do that your mind has to be on the job site; it must be present.

TIP

How do you hold your pencil? When you do the block-in and shading, hold it lightly and as far back as possible, between the thumb and the first two fingers. When you carve out the contour, hold it closer to the point, so that its angle relative to the paper is more vertical.

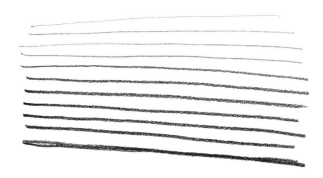

Lines of various weights

Lines have four basic characteristics—length, direction, curvature, and weight—and can vary in a number of ways. Don't unconsciously confine yourself to a limited linear repertoire; you can use any kind or style of line while drawing.

Each stage of the drawing method uses different types of lines: lines used in the envelope and block-in are different from those used in the contour, which are different from those used "on the inside" and in hatching. Each type of line has its own function and character.

- *Lines for the envelope and block-in:* These lines serve to locate and describe the general shape of the figure and its parts. They should be light, breezy, and sweeping, with each "line" actually composed of a number of lines, so that the envelope and block-in have a kind of thatched quality. They are generally straight, but sometimes have a slightly attenuated curvature.

- *Lines for the contour:* The lines of the contour, on the other hand, are precisely designed to define the exact outline of the body. They always curve, and begin and end at specific points. Each segment of the contour is composed of only one single, definite line, which is made by a single, concentrated movement of the pencil. It is not uncommon to erase and redo one of these lines twenty times over.

- *Lines "on the inside":* These lines indicate places where the surface of the form overlaps itself to create creases and seams, such as the line where the lips meet. These are also, in a sense, contour lines, but since they exist within the realm of continuous, edge-free, tonal modulation, their character is different from the clean,

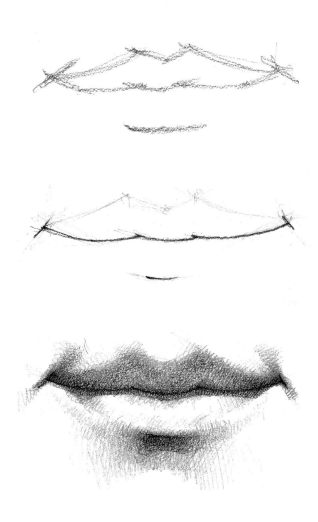

Top, lines used in the block-in; *middle,* lines used in the contour; *bottom,* lines used "on the inside" and in cross-hatching

Detail of *Piano Student,*
1998
(For full image, see page 49.)

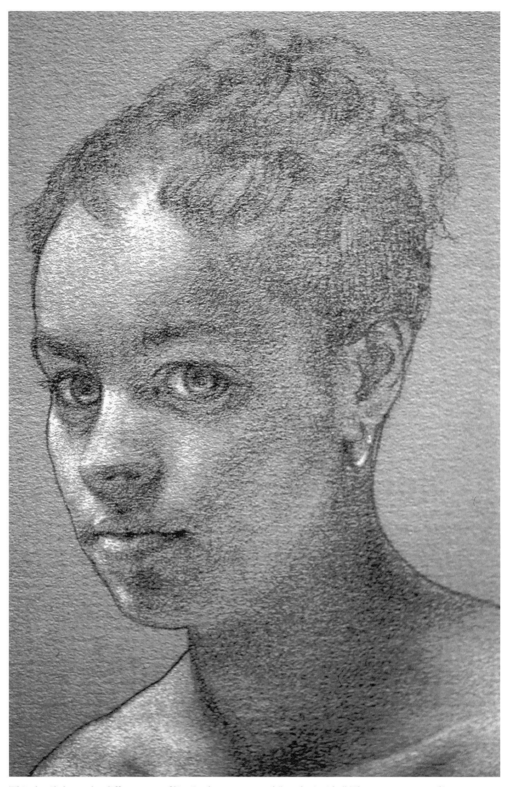

This detail shows the different use of line in the contour and "on the inside." The contour, or outline, is a pretty heavy line, especially up around the forehead, the cheekbone, and the right shoulder. In comparison, the lines on the inside are lighter and softer. The line where the lips meet, for example, is as dark as the contour but dissolves slightly at its edges into the shadow around it. Notice also the underside of the nose in the reflected light. The line weight there is pretty light, as is that of the outer edges of the lips, the eyebrows, and the edge of the hair. These are favorite places for beginners to inscribe very heavy lines. Finally, compare the jawline with the contour of the forehead and cheekbone that I first pointed out; the jawline is so light and fluffy that it hardly deserves the name "line."

crisp contour lines of the outline. Lines on the inside take on a certain delicate softness. They are often a bit lighter than one might expect, and slightly out of focus. There isn't any absolute rule as to how hard or soft a given line should be on the inside. It's a matter of judgement and sensitivity. Lines on the inside may also be long, thin patches of hatching—linear shadings rather than single lines.

- *Lines for hatching:* These are by far the most plentiful lines in any drawing. They're not meant to stand out, but to combine and merge with one another so as to suggest washes of shading. They're usually straight and relatively short. They differ from one another in length, direction, and weight, and yet they are as similar to one another as stones in a gravel driveway. Unlike the lines of the contour, hatching lines are not made separately and individually. They're made in batches, through a rhythmic movement of the pencil.

HATCHING AND CROSS-HATCHING

Hatching is a shading method that employs lines in series, arranged in shaped progressions, and either parallel or radiating. Hatching is a rhythmic activity; the pencil moves like a sewing-machine needle. The trick is to get the lines evenly spaced, gradually increasing or decreasing in length, and in the right value range and progression. This is easier in some situations than in others, although no one, no matter how good, produces hatching lines

with absolute, machinelike precision. Right-handed people hatch most easily with lines running on a diagonal between the lower left and upper right. Lefties work more comfortably on the upper-left, lower-right diagonal. With a little effort, the hand can learn to create hatching in all orientations. The direction of the gradation of light, the sense of form, and the two-dimensional shape of the patch of shading all affect the choice of direction in which hatching lines should be drawn.

Cross-hatching is hatching on top of hatching, with the layers of hatching crossing at an angle. There's no limit to the number of layers of cross-hatching that can be applied in the drawing. To "mist" a drawing with value, cross-hatching can be done very softly, as if you were applying washes of value with a brush rather than individual lines with a pencil. A finished drawing is a composite of many such "mistings" of value, carefully fitted into the contour.

NOTE

The patient elaboration of value with a very sharp pencil induces a mental state in which you feel as if you are actually sculpting the surface of the body within the virtual reality of the drawing. With practice, you can develop an acute sensitivity to subtle variations in the surface of the form, as if there were nerve endings at the point of your pencil.

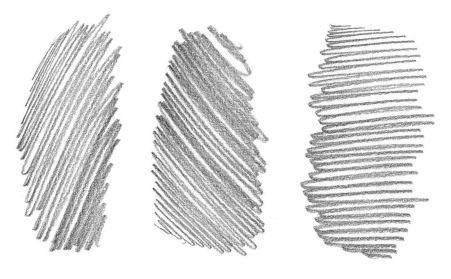

Here you see a few simple patches of hatching, each with a different line direction. As you can see, there's nothing at all mysterious about them.

Left to right: hatching; cross-hatching composed of two layers of hatching; cross-hatching composed of three layers of hatching. Notice that with each successive wash of hatching the texture becomes more uniform.

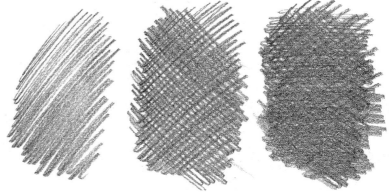

Mouth Study, 1997
Pencil on paper, 17 x 14" (43 x 36 cm)

In this study, many layers of hatching are matted one atop the other at only slightly different angles. Patches of hatching can be layered at any angle from zero to ninety degrees.

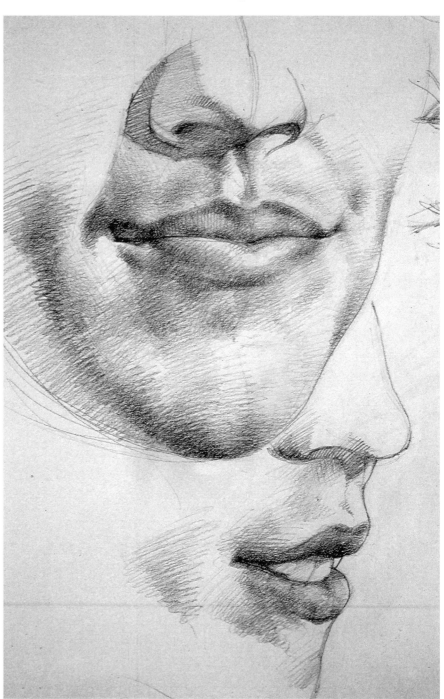

The drawings of the masters show us that their great, creative intelligence was not primarily concerned with types of paper and simple, mechanical methods of moving the pencil. The minds of the masters were devoted to a much higher order of vision. But at some point in his or her life, every great artist had to learn the simple things, the materials and basic techniques of drawing. Now the real work begins, of seeing and understanding.

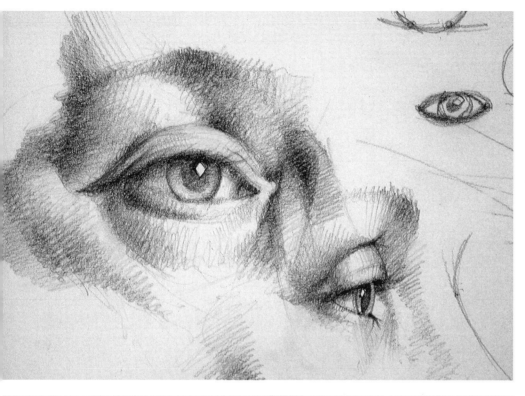

Slinkies, 1997
Pencil on paper, 14 x 17" (36 x 43 cm)

Remember slinkies? Well, this drawing is loaded with them. Multiple washes of slinky-like hatch marks build the form. The point of the pencil moves like a sewing machine to create these patches: backandforthbackandforthbackandforthbackandforth. Once your drawing engine gets warmed up you'll find that it likes to run at a certain speed, moving rhythmically up and down, left and right, and diagonally across the page.

Arm Study, 1998
Pencil on paper, 4 x 6" (10 x 15 cm)

Cross-hatching weaves multiple layers of the form into one another. Through practice, and a careful study of form and light, you will develop a sense of how to create the curving, multi-faceted surface of the body with such patches of shading.

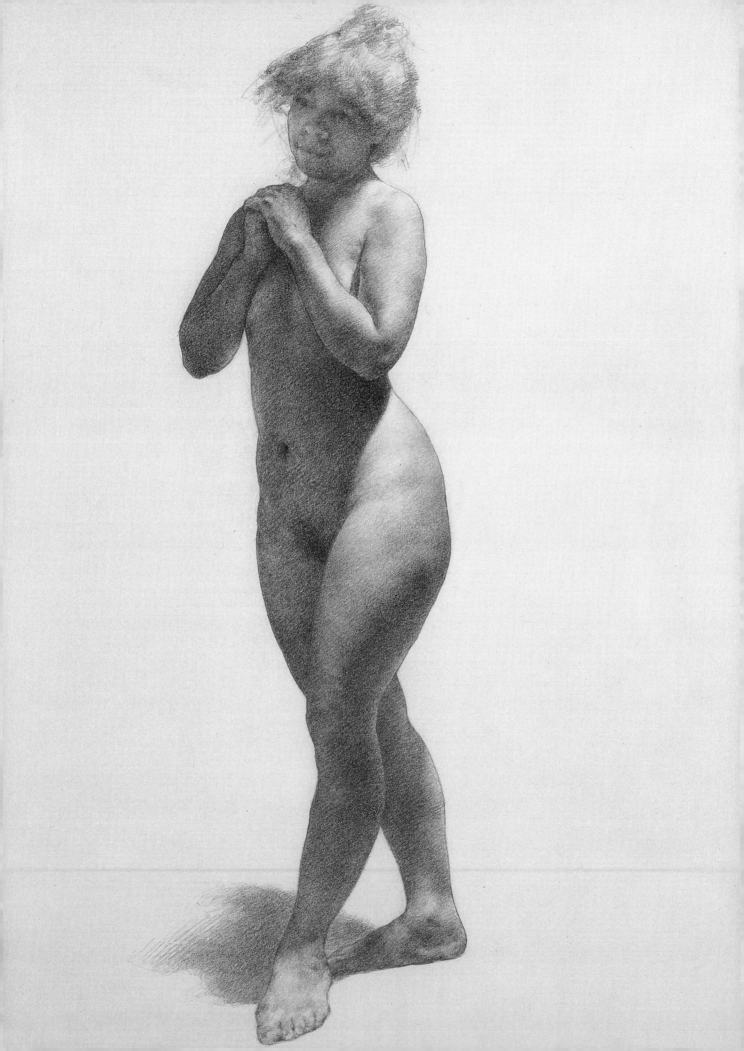

THE BLOCK-IN

THERE ARE TENS OF THOUSANDS of pencil strokes in a fully developed figure drawing. How are these lines organized? What keeps them from scattering across the paper like ants that have lost their anthill and their little ant queen? They don't just magically appear on the paper all at once, in all the right places, and in all the right degrees of darkness. An invisible organizational principle holds them together. Without this principle all the graphite would just amount to so much nonsense. Consequently, we begin our study of drawing with the block-in, an exercise that organizes the drawing, and the drawing process, from the ground up. It's the bedrock of this drawing method.

The block-in is the simplified two-dimensional shape of the model. It's as if the three-dimensional model we see posing had been photocopied, cut out, and pasted onto the surface of the paper. It is constructed of line segments that connect points located along the outline of the figure to form an angular, irregular, geometric shape. The block-in is probably different from anything you've ever worked with before. It's meant to be different. It's meant to provide you with an entirely new perspective on figure drawing—a new thought process.

Many of us possess inclinations and ideas that prevent us from seeing, much less drawing, the actual shape of the model. For example, many students unconsciously project the stick figure into their drawings as a kind of inner armature. According to this mode of thought the human figure is built upon a simplified skeleton of straight lines. These lines are subsequently padded with "muscles," like hot-water pipes wrapped with thick, spongy insulation. The resultant shape is supposed to look like the human form. When it doesn't, the student asks, "Why not?" The problem here is that the drawing is derived from incorrect assumptions. Stick figures are all right as symbols of human beings, but they can be very misleading when used as the basis of figure drawings. As a result, the student's approach to the *shape* she's drawing on the page becomes incidental. It's an afterthought that isn't based on observation. No wonder it doesn't look like the model.

The block-in, on the other hand, is designed to be built around direct observation of the model. As a result, you will begin to *consciously experience the actual appearance of the model.* What a concept. You will begin to *see* the model you're drawing, rather than your own misconceptions. You will see that the shapes you're drawing are consequential, and that you must occupy yourself with their widths and heights, their degrees of overlap, and their many other qualities and relationships. By renovating your thought process, the block-in will reveal your ability to draw the subtle, organic, and unified shape of the human figure. This is an ability that we, each one of us, already possess, but it's been buried deep in our minds, as if under boxes of old newspapers and layers of dust.

LEFT: *Obverse,* 1997
Pencil on paper, 24 x 18" (61 x 46 cm)

NOTE

While the block-in might seem unusual, it is really a very simple, practical way to begin a drawing. But it's difficult to change one's way of thinking. The mind is a huge mass of memories and experiences, dating back to earliest childhood. It doesn't change its course just because some nice new idea appears on the scene. But its course can be changed if a force, even a very small force, is applied consistently, at right angles to its customary path. Here, the operative word is *consistently*. For fifteen years, every drawing I've done has begun with a block-in. And all this time I've been changing, reformulating, and cleaning the house of my mind with this little exercise. So even if the block-in seems awkward or uncomfortable at first, keep at it. Eventually it will change the way you think about drawing.

THE ENVELOPE

The first phase of the block-in is an exercise known as the *envelope*. The envelope is a general estimate as to the shape of the whole pose. It's a large, simple shape constructed of no more than six lines. The points at which the lines connect correspond to the most outwardly projecting points on the figure, such as the top of the head, an elbow, a big toe, and an outwardly thrust hip. By connecting these points with lines, a shape is created that serves to *envelop* the pose. The envelope is like the shell of an egg. The drawing develops inside it.

The envelope doesn't have to fit like a glove. In fact, its points are almost inevitably out of place. It's an estimate. It conveys important information about the proportion, orientation, and location of the drawing on the page. In a general way, it tailors the wide-open space of the page to the specifications of the drawing, helping it to find its place and overall dimensions.

Constellation, 1998, with overlay
(For unobscured image, see opposite.)

The opening phase of the drawing process: the envelope. Notice how the points of the envelope correspond to the most outwardly projecting points of the composition: the tops of the models' heads, an outwardly thrust knee and foot, a curving back.

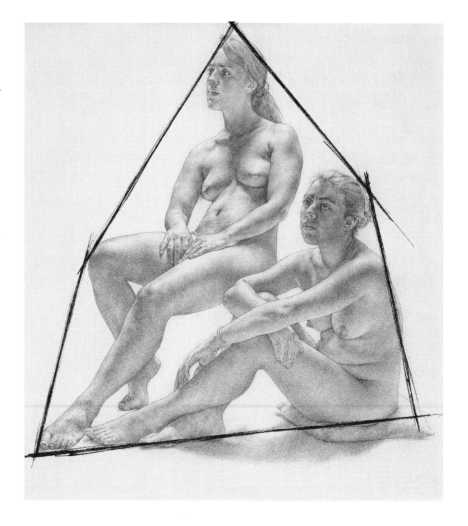

Though the most outward, projected points of the pose are selected for use in constructing the envelope, it is often the case that bits and pieces of the figure still end up beyond the confines of the shape. If that happens, don't worry. The envelope is like the concrete foundation of a house. After the foundation is poured and the bulk of the house is built, porches, decks, and wooden steps are sometimes attached. In like manner, the envelope serves to anchor the drawing in general, but it needn't enclose every single detail.

The envelope is vastly less complex than a finished drawing. Nevertheless, as anyone who has practiced it can tell you, it is a very deep exercise. At first, when you begin to work with the envelope, you may find it quite frustrating. However, if you persist, a change will occur. When I first began studying, my teacher Ted said that if we practiced the envelope for a year we would save ten years of study. I gave it a shot, and two years later I was teaching figure drawing. In my experience, the practice of the envelope broadens, deepens, and empowers the visual capacity of the mind, and is the basis of all subsequent drawing activities in this method.

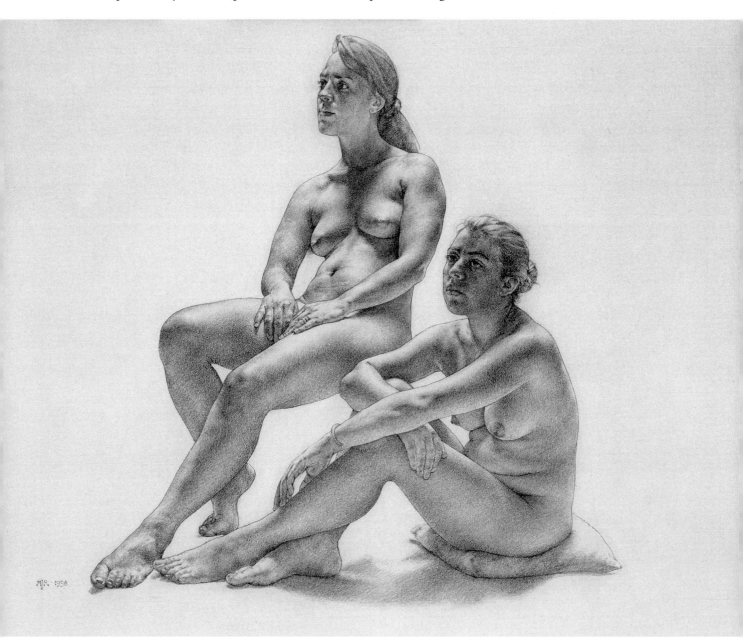

Constellation, 1998
Pencil on paper, 18 x 24" (46 x 61 cm)

THE BLOCK-IN

After the envelope is constructed, it is broken down and eventually becomes the *block-in*. The breakdown of the envelope is a very important process as it helps us to develop a crucial skill: the ability to see and work broadly. With a few sweeping strokes of the pencil, the whole envelope can be subdivided into large pieces: big "sub-envelope" shapes. For instance, the sub-envelope shape of both legs, taken together, might be carved out with three or four lines. Shapes for the arms might consist of triangles or quadrilaterals appended to a core torso shape. These shapes do nothing to express any kind of detail, but they help tremendously in our ability to scan from point to point across the drawing as a whole.

Many students get the idea of how to make an envelope, but don't understand how to proceed to the block-in. Instead of breaking down the envelope into major shapes, they begin to fill it with details, drawing a little head, facial features, hair, jewelry, a neck, and so on, all the way down to the feet. They do a little figure drawing inside the envelope, from the face down. They seem to see nothing but individual and apparently unrelated events: an eye here, a nose there, and, far away, a belly button. This is because beginners are often unaware that every part of a drawing should be related to every other part, as well as to the whole, by way of an underlying structure. Individual details must be subservient to and dependent upon the greater, underlying structures on which they are built, like the cells that together compose the human body. We therefore begin the figure drawing by attending to the underlying, dynamic structure of the whole shape. This is one of the principal aspects of the envelope. It is one shape, simple and whole. As you break it down, make sure you continue to build this internal structure into the block-in.

Once the sub-envelope shapes have been carved out of the envelope, these too are broken down and refined, first in a general way and then more and more specifically. Line segments grow shorter and more numerous. Gradually, an accurate block-in—the abstract, two-dimensional, outside shape of the whole figure and all its parts—emerges.

STEP-BY-STEP
THE BLOCK-IN

Breaking down the envelope. The large envelope shown on page 28 has been broken down into individual "sub-envelopes" for each of the two figures. These shapes are already beginning to develop "personalities."

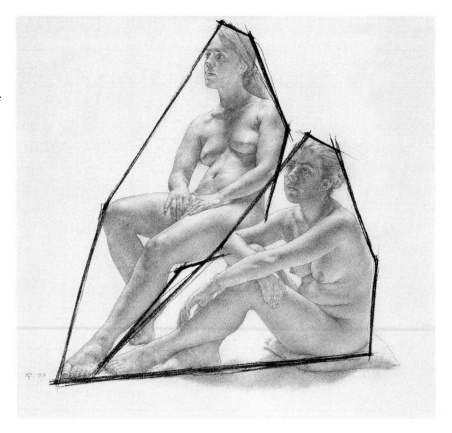

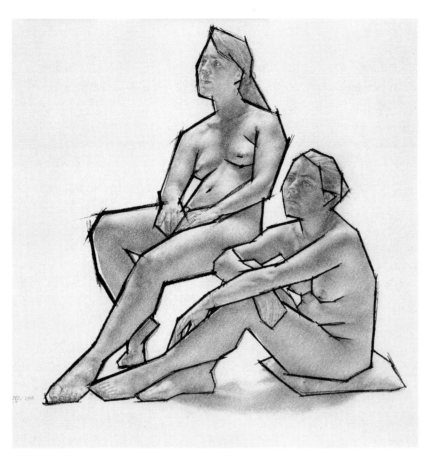

The intermediate block-in. Here, the envelope has been broken down into strong, clear, dynamic shapes. These will serve as the underlying abstract foundation of the drawing, and will impart a powerfully energetic structure.

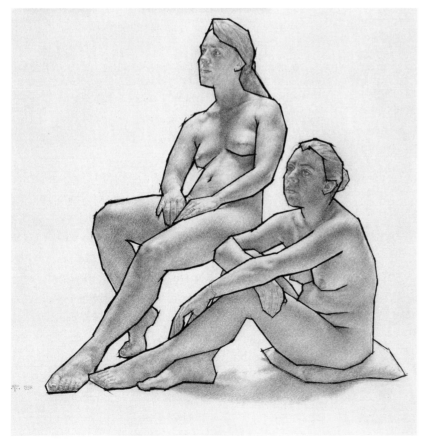

The advanced block-in. As the block-in progresses, the shapes become more specific and curvilinear, less abstract and angular. The plasticity of the form and details of the structure begin to emerge as the actual shapes of the bodies come into focus.

USING MEASUREMENT

As you launch into the earliest phases of your drawing, you will immediately be confronted with the question of proportion. How long should each line be? How much distance should there be between the point at the top of the model's head and the one at her left foot? What is the tilt of the line connecting these two points? Are the shapes you've drawn for the head and foot proportionate with regard to one another?

There are no preset proportional formulae in this drawing method. We don't expect the figure to be so many heads high, nor the head so many eyes wide. We rely on careful observation. This, I believe, is what the great masters did. We, too, must hone these skills in ourselves. In this method, we begin developing a sense of proportion through two basic exercises: estimating

the distance between points (called point-to-point measurement), and estimating the tilts of the lines connecting those points.

POINT-TO-POINT MEASUREMENT

One of the two most basic skills cultivated in this drawing system is the ability to measure the distance between any two points on the model and then check it against your drawing, called *point-to-point measurement*. This simple activity is practiced as follows:

1. Locate a point on the model and establish a point on your drawing that corresponds to it.

2. Using your eyes, scan from the point you chose on the model to a second point, also on the model, registering an impression of the distance between the two points. Ask yourself, "How long did it take me to get from here to there?"

3. Return to the drawing and relocate the first point you chose. From that point, move your eyes in the drawing the same way you did when you scanned between points on the model. Estimate the position of the second point in the drawing according to your impression of the distance your eyes traveled on the model.

Repeat the exercise many times, scanning in various directions to check your drawing. You will find that an underlying proportional regularity begins to reign in your drawing.

Point-to-point measurement is not only important for gauging distance *around* the form; it's also important for measuring shape *across* the form. The block-in is above all a study of shape, and one way to reproduce each shape accurately is to measure its changing width, such as the width of an arm at various points along its length. This process of measuring the distances between points situated on opposite sides of a shape is called *caliper vision.*

Imagine an island, the coastline of which is pretty well mapped out, but the interior of which is unexplored. For many students, that's kind of what the human figure is like. They know the outline okay, but the interior—all that stuff contained within the outline—is virtually

NOTE

Students tend to feel a lot of anxiety around the idea of proportion, perhaps because they believe that only a select few possess the special ability to judge proportion correctly. Having postulated the existence of this mysterious power, they come to the depressing conclusion that they don't have it. Otherwise their drawings would have the seemingly miraculous perfection of the work of the masters. Not. I think that we are all born with an innate, undeveloped sense of proportion. As we grow up, we develop this sense in accordance to the demands of our daily life. Thus we learn, from a very young age, how much hot water to put in the bath to make it the right temperature, how much milk to pour into the bowl with our cereal, how loudly we need to yell to get ourselves heard. We get feedback from family, neighbors, teachers, and our own senses. We gradually, as if by natural law, conform ourselves to the age-old dictum: moderation in all things. Since it takes time and a great deal of experience to acquire a sense of proportion in the rest of our lives, it shouldn't be a surprise that it takes a while to do the same in drawing.

unknown. In other words, students habitually run their eyes along the outline, around the form of the model and the drawing, but they rarely cross-reference the different sides of the model and drawing by scanning "across the form." This is an imbalance in the student's mode of seeing, and caliper vision is the remedy for this imbalance. Caliper vision helps to relate the sides of the form to one another, and in so doing helps to define the dimensions of the interior. Even though you're not yet drawing the interior, every decision you make while building up the outside shape will profoundly impact the latter stages of the drawing process.

Point-to-point measurement in general, and caliper vision in particular, are exercises in an all-important way of seeing that, for lack of a better term, I will call *relational seeing*. Relational seeing helps us relate the parts of the drawing to one another. The human body is knit together; it is a single, integrated organism. If we desire our drawings to resemble our models, then they too must become integrated. Caliper vision helps us relate the previously unrelated sides of the block-in shapes to one another and, as a free bonus, it begins to open up the interior of the drawing—that unknown, unexplored continent.

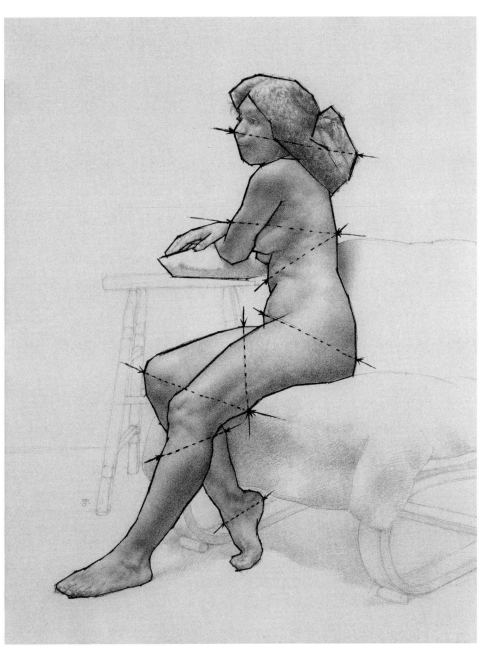

Pensive, 1998, with overlay
(For unobscured image, see page 75.)

Here are a few examples of caliper vision measurements. (The dotted lines indicate movements made with the eye, not actual lines made on the drawing.) Note that you can measure not only across individual forms, but also across combinations of forms. This knits the shape together.

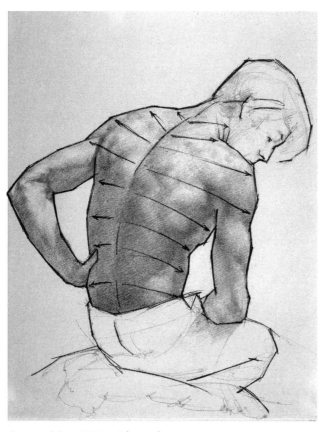

Beamer Man, 1997, with overlay

There's nothing wrong with the use of elements on the inside of the shape as a means of regulating the block-in as a whole. In this block-in, certain flights of caliper vision made scheduled stopovers along the *centerline* of the back. The centerline is an imaginary, nonexistent line that runs through the middle of both the front and back surfaces of the body. Though it's called the *center*line, it is almost never in the actual center of the shape as drawn on the page. Only in an absolutely symmetrical pose, in which the model faces either directly toward or away from you, is the centerline dead center. The real usefulness of the centerline is actually its *deviation* from the center of the shape. Nearly always, a model will take a pose that appears to turn either toward or away from you, in which case the distances between the centerline and the two sides of the form will be unequal. Caliper vision can be used to compare these two distances, helping you develop the degree to which the model is rotated in space. (*Note:* Lines used to indicate the centerline and other landmarks on the inside of the shape should be kept very light—just dark enough to be useful for reference, but not so dark as to indelibly mark up the drawing.)

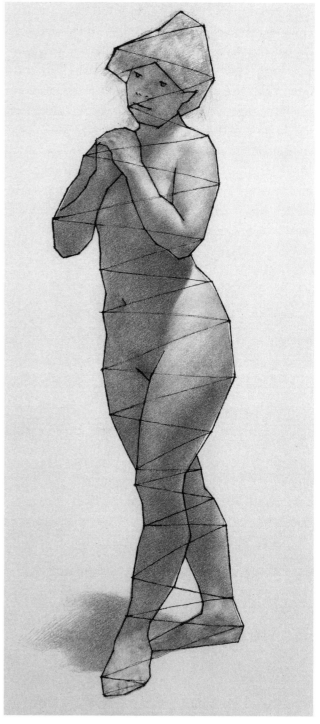

Obverse, 1997, with overlay
(For unobscured image, see page 26.)

Here you can see how to lace up the two sides of a shape with transverse point-to-point measurements. These measurements wouldn't actually be drawn in, but are just used to show you how to move your eyes while drawing. Our eyes move very quickly along the points of the block-in, like the metal ball in a pinball machine. I couldn't possibly count the number of measurements I make in a drawing. I imagine there must be thousands, if not tens of thousands, in all directions. Those shown here are but a small fraction of the total.

Triangulation

The point-to-point measurements we make by eye are inherently fallible. But when we make many such measurements, and when we compare and cross-reference them with one another, we begin to root out the errors in our drawings. This process of using two or more previously established points to locate a single, new point is called *triangulation*. Triangulation is much more accurate than isolated point-to-point measurement. As the saying goes, "In the multitude of counselors there is safety." The block-in is a unified, interconnected, inter-referenced structure; this is its strength. It is a constellation of points all located with regard to one another by way of triangulation.

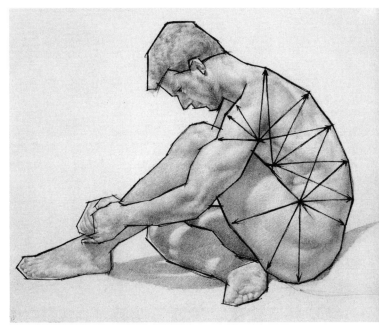

Potential, 1996, with overlay
(For unobscured image shown in reverse, see pages 2–3.)

The more point-to-point measurements you make, the more they will reinforce each other. This diagram shows mutually reinforcing measurements originating from three reference points within the block-in, one just above the model's hip, another at his midriff, and the third just under his arm.

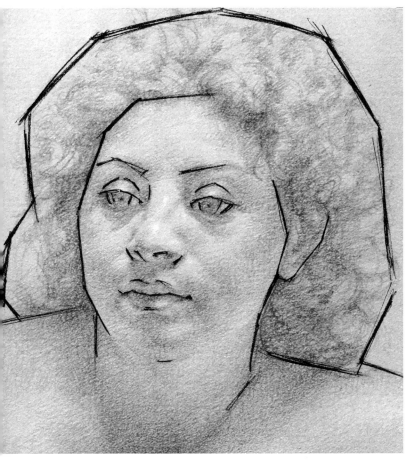

Detail of *Woman on a Couch*, 1998, with overlay
(For full, unobscured image, see page 13.)

To block-in the head, face, and features, begin just as you would for the figure as a whole. Start with the large general shape of the head, then the shape of the face within the head. (The shape of the face is broken out of the larger shape by the insertion of the hairline.) To find the rest of the features, triangulate from reference points in the head, ear, hair, and face shapes.

The features should be blocked in according to the "less is more" philosophy. The purpose of these shapes is simply to guide your efforts later when you're adding tone. In this example, notice the marks used to indicate the underside of the nose. There are four of them, two each for the outside and inside contours of the nostrils. They are concise abbreviations, like stenographic marks. They communicate a lot of information about the nose, including its general position with regard to the mouth and eyes, its width at the base, the underlying curvature of the head, and the degree to which it is turned away from the viewer. Also notice that they, and all the other marks used to block-in the features, are buried in the shadows. That way they don't get in the way later on.

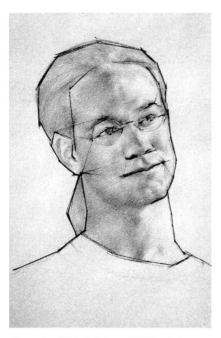

Portrait of Chris Dixon, 1995, with overlay

Here is another example of blocking-in facial features. The first feature I developed in this case was the ear. The ear helps to divide the proportions of the height of the head, and says a lot about whether the head is rocked back or forward, as well as how it is turned and tipped.

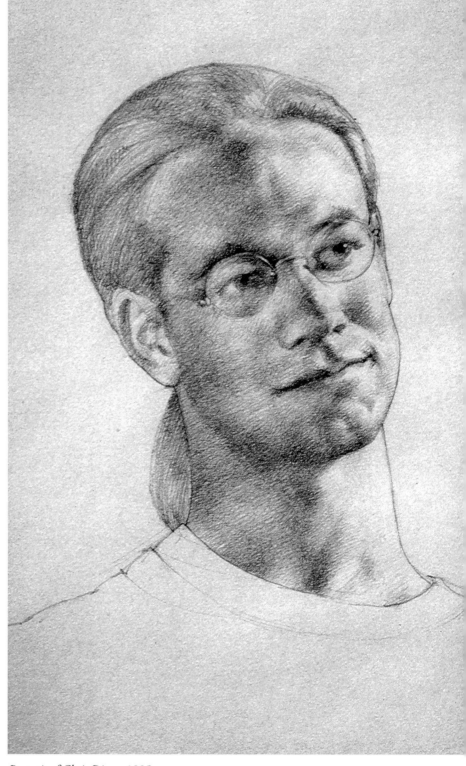

Portrait of Chris Dixon, 1995
Pencil on paper, 17 x 14" (43 x 36 cm)

TIP

When blocking-in things like eyeglasses, it's best to draw the shapes lightly at first. Within certain reasonable limits, it is always easy to push the values in a drawing darker while it can be difficult to lighten them up. But having said this, I might also mention that you shouldn't be excessively timid with the pencil either. That's no fun. It's like going to the beach but never going swimming. We learn to draw by drawing, and we learn faster by drawing with a certain abandon. After all, drawing isn't skydiving. You can't really hurt yourself drawing the figure.

TILT MEASUREMENT

The second of the two basic abilities cultivated in this drawing system is measurement of the *tilts* of the lines. Tilt and distance are intrinsically connected to one another. It does you little good to know the distance between two points if you don't also know the tilt of the line connecting them. To help you recognize a line's tilt, follow these directions:

1. In an upper corner of your paper, draw a *compass rose.* This is a circle with a pair of horizontal and vertical lines that intersect at its center and extend a little bit beyond the circle's perimeter. Fashion a small arrowhead at the top of the vertical line and write the letter "N" next to it, for north. The compass rose will serve as your basic "tilt measuring station."

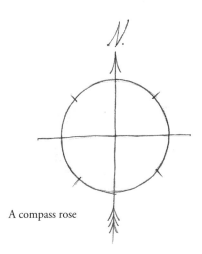

A compass rose

2. Hold up your pencil to the model and tilt it so that it reproduces the tilt of a line on the model. Then carefully bring the pencil down to the compass rose without altering its tilt and imprint in your mind the exact tilt of the pencil as you see it superimposed over the compass rose. Lightly sketch this line through the center of the compass rose.

3. Find the corresponding line in your block-in and hold your pencil parallel to the tilt of the line. Carefully move the pencil, without changing its tilt, to the compass rose and compare it to the line you sketched in step 2. Are the tilts of the two lines the same? If not, adjust the line in your block-in until it has the correct tilt.

The use of a compass rose objectifies and makes conscious the process of measuring tilts. Once the process has become conscious, it then needs to become habitual and automatic. This isn't a "been there, done that" drawing method. It's more like a "went there, stayed there, did that, still doing that" kind of thing. When you're in drawing mode, tilt measurement should be as natural as breathing and as present as consciousness itself. Every pencil stroke has tilt. Fortunately, tilt awareness isn't difficult to acquire and quickly becomes programmed into the deep layers of the drawing mind.

The individual line segments of the block-in are just that—individual line segments. The trick, or the art, is to put them together in a way that expresses a living presence. In any given pose, each part of the body has its own characteristic degree of inclination. The shapes of the hair, the head, the neck, the shoulders, and so on, must therefore each be tipped in space at a particular angle. When the tilts of the lines are good, so are the orientations of the shapes, which then combine to convey the subtle dynamism of the model. As the notes in a piece of music are related to one another, each according to its pitch and duration, so too are the lines in the block-in, each according to its tilt and length, thereby conducting the "music" of the figure.

Two step-by-steps are provided on the following pages to review the entire block-in process.

THE BLOCK-IN

These illustrations show the various stages of the block-in process as done for *Music* (1998). An unobscured reproduction of *Music* is shown on page 64.

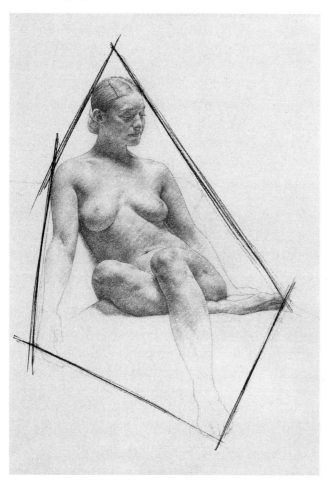

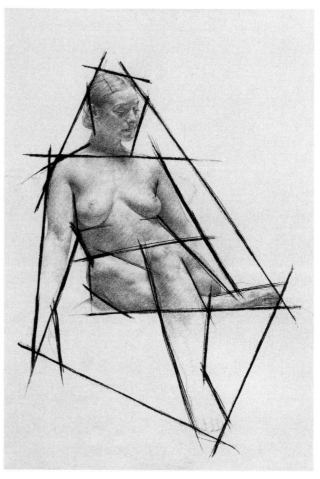

The envelope. Notice that this envelope leans to the left. Though just a simple, abstract shape, it conveys definite information that can be used in the drawing. The model is not a conventionally posed, generic mannequin. She's a unique individual in a particular pose. In this approach, conventional shapes, such as eggs, cylinders, and cones, are not used as building blocks since they introduce a mechanical quality into the drawing. Our interest is to develop a drawing with character: the specific, undiluted character of the model. So we avoid the use of character-negating elements.

Breaking down the envelope. In the earliest phase of the breakdown, it is important to maintain a very broad and abstract view of the figure. Here I have established large, axial relationships, such as the axes of the shoulders and the knees, and the basic pitch of the arms and sides of the torso.

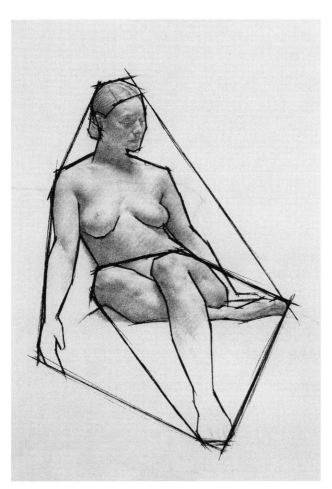

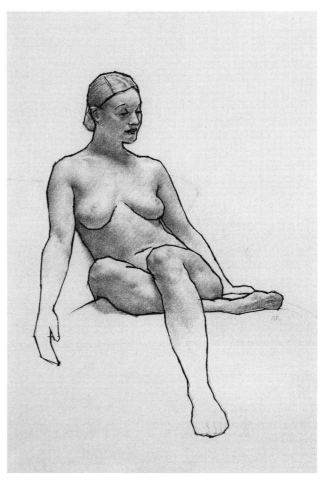

The early block-in. As you continue breaking down the
envelope, start looking for large sub-shapes, such as the shape of
the model's crossed legs shown here. This will help you budget
the space within the envelope, allocating large chunks of it to
different parts of the drawing. At a certain stage in the process,
most of my block-ins look like this—kind of rough and scruffy.
Please note that this drawing was made for the sake of
reproduction, and has fewer gross errors than there would be in
one of my "normal" block-ins. One of the ideas behind the
block-in is that it provides an opportunity to make mistakes in a
safe environment, at a stage in the process when they're still easy
to correct.

The finished block-in. In this finished block-in you can see
directional changes, reflecting the subtle, gnarly quality of the
actual surface of the human body. People are not really smooth.
Many slight angular shifts (very small changes of tilt) are typical
of the outline and surface of the figure. Practicing the block-in
sensitizes our perception to such shifts, and gives us a language
in which to express our ever-deepening vision of the figure.

THE BLOCK-IN

The following illustrations of *A Quiet Afternoon* (1998)
provide another example of the block-in process.

The envelope. As we possess a sense of taste and can distinguish many fine nuances in the flavors of the foods we eat, so we possess a sense of shape and can distinguish nuances in the shapes we see. One way to recognize the quality of a shape is through an examination of the tilt of its constituent line segments. In this envelope, baseline A–B, for example, is *not* horizontal—it angles up to the right. Notice also the tilt of the long axis of the whole shape C–D, which is not quite parallel to the baseline. We measure the tilts of these lines by eye, comparing them to the horizontal and vertical axes of a compass rose. As far as the whole shape is concerned, it too is angled: bulky and high on the right side, tapering and dropping off on the left.

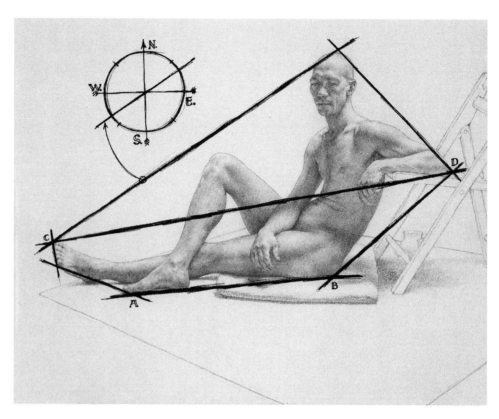

The early block-in. In this phase, the shapes are still clunky and awkward. Don't be discouraged if your block-in is not pretty. Hammer out the drawing. Unremitting, persistent effort will bend a stubborn, ungainly sketch into a graceful finished drawing. In practicing the block-in we develop drawing muscles. We become tough, hardened drawing veterans. Meanwhile, remember to check your tilts constantly.

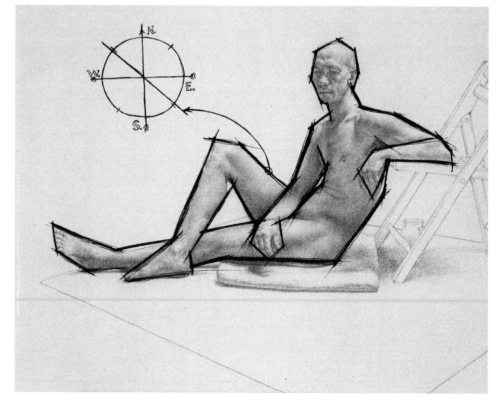

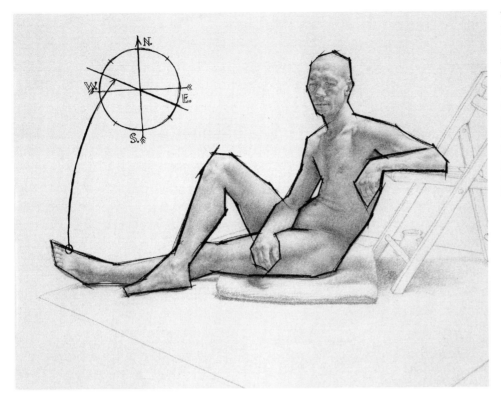

The intermeditate block-in. Here you can see some slight but important changes. Long line segments have been broken down into two, and sometimes three, shorter lengths each. The evolution of the shape proceeds methodically, with individual line segments subdividing again and again. Throughout this progression, checking the tilt of each line remains an indispensable necessity.

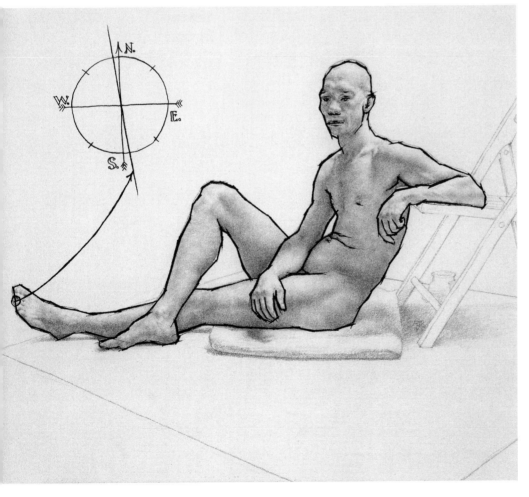

The finished block-in. The process of division and differentiation has resulted in a rocky, chiseled, angular shape. This is the substructure of the drawing, like the system of girders that holds up the smooth skin of the Statue of Liberty. Remember that each and every line segment, no matter how small, needs to be checked for tilt. After a while, checking tilt becomes an autonomic drawing function. It's like keeping your eyes open while walking around the house. You don't think about it. Your brain stem just takes care of it for you.

A Quiet Afternoon, 1998
Pencil on paper, 18 x 24" (46 x 61 cm)

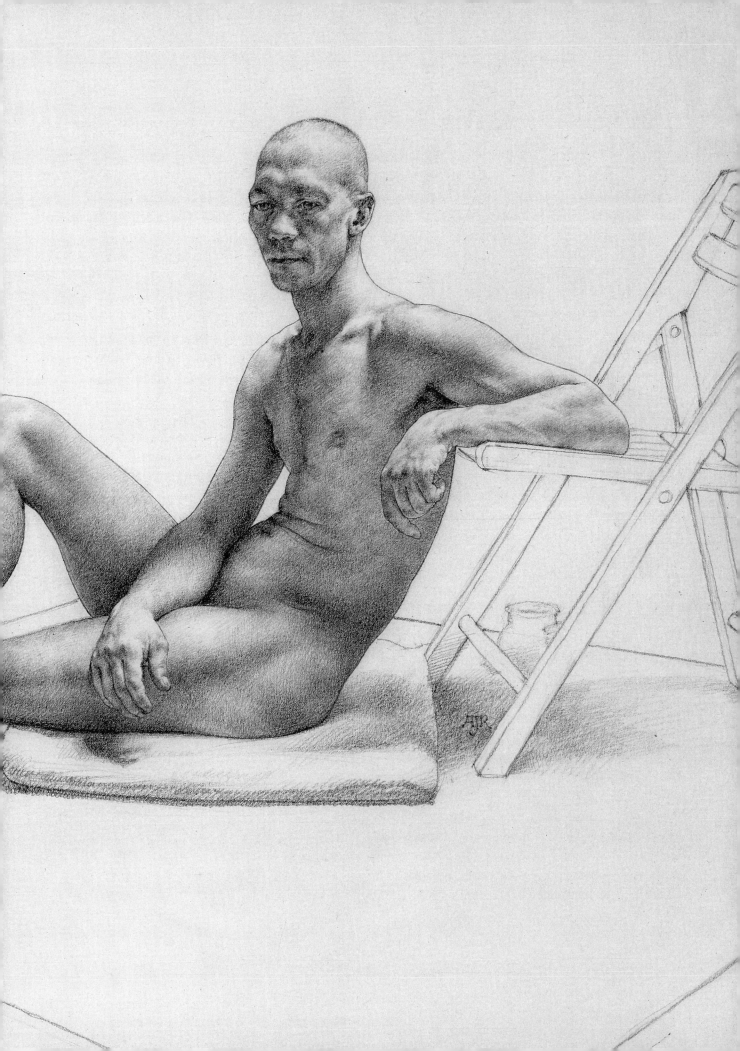

Nonparallelism and the Two Sides of the Form

The processes of point-to-point and tilt measurement are exacting, objective, and mathematical. Like accounting, they comprise a very attentive balancing of the drawing's books, trying to get everything figured out to the penny. But there is also a second, more abstract, activity involved in the block-in. This activity focuses on the relationship between the sides of the block-in shapes, and is based on the precept that the two opposing sides of the form are *never* parallel. This is the principle of *nonparallelism.* It is the key to a more profound way of seeing and drawing.

Comparing the two sides of the form has to do with measuring and comparing the angular relationships between lines on opposite sides of a shape. Like the other forms of measurement used in this drawing method, the comparison of the two sides of the form is something you do by eye. It sounds complicated, but actually it's very simple. You simply look at two line segments situated on opposing sides of a shape and judge their relationship to one another. The purpose of the comparison is to insure that the two sides are not parallel, and that the shape you're building is asymmetrical.

The shapes of the body are like the members of a family: they have a degree of independent identity, but they also contribute to a selfhood larger than just their own. They bond readily with each other. The block-in consists of a number of such semi-independent sub-shapes. In themselves, these sub-shapes are incomplete, and thus pretty difficult to grasp with the mind. For instance, the shape of the arm between the wrist and the elbow doesn't make much sense alone. It needs its context to make sense: the hand, the rest of the arm, and the shoulder. This is why it is so important to build the sub-shapes in the block-in incrementally, carefully measuring the tilt of each line segment. Otherwise the tendency is to substitute a preconceived "arm shape" in place of the carefully observed, perceived shape.

The shapes of the block-in progress, that is, they flow into one another. They open, lock, and wedge into each other with a logical, successive movement. For instance, the shape of the shoulder flows into that of the upper arm, which in turn flows through the elbow into the shape of the forearm, and so on, all the way into the tips of the fingers. As a general rule, the progression in the limbs is from wide to narrow, outward from the central core of the body into the extremities. This direction of flow is more ambiguous in the torso, neck, and head, where shapes seem to progress in both directions. But the important thing is to begin to see and get a feeling for the way shapes lock into one another.

As a result of their asymmetry and nonparallelism, shapes in the progression are somewhat irregular. This irregularity gives the progression a certain syncopated rhythm. As the eye follows the progression, it picks up on these rhythms and recognizes them as belonging to the class of living things. The patterns of orderly form found everywhere in nature always have this kind of "imperfection," an imperfection that amplifies, rather than diminishes, the mysterious beauty of nature.

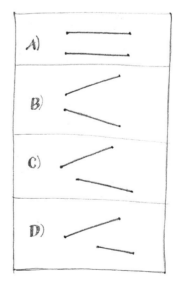

These diagrams illustrate four levels of symmetry and asymmetry. Please note that when building the block-in, you should try to use line segments from category D.
A: parallel, symmetrical, and of equal lengths;
B: nonparallel, symmetrical, and of equal lengths;
C: nonparallel, asymmetrical, and of equal lengths;
D: nonparallel, asymmetrical, and of unequal lengths.

Most manmade objects are constructed from rectangular units, like cement blocks, bricks, and two-by-fours. Our normal design concepts are saturated with right angles and parallel lines. Notice this book's rectangular format, for example, and the regular horizontal and vertical orientation of its blocks of text. But nature is free from such design limitations. And as a natural creation, the human body has a complex, organic structure. So in attempting to draw the figure, we have to surpass our narrow design concepts. We have to build our drawings with asymmetrical, nonparallel, organic shapes—shapes that don't correspond to our preferred way of thinking. That's why we work with the principle of nonparallelism in the block-in.

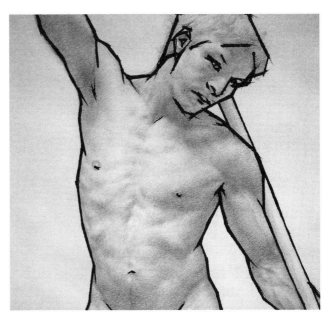

Detail of *Man with a Pole,* 1998, with overlay
(For full, unobscured image, see page 119.)

The forms of the body wedge into one another like colliding tectonic plates, sending up ripples as if they were mountain ranges, and these forms must be echoed in the block-in. In this detail, the tapering shape of the upper torso wedges into that of the pelvis, while the echo of the tapering shape of the hips can be seen in an ascending wave pattern pushing up into the sternum. The shapes of the arms evolve out of the shoulders like heavy, twisting ropes spliced deeply into the rib cage. The neck is rooted into the rib cage and shoulders by a series of deep diagonals. These diagonals branch into the shapes of the head.

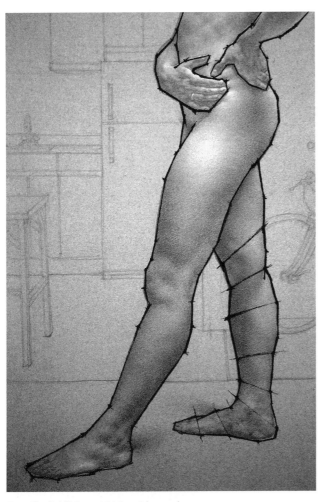

Detail of *All-Star,* 1998, with overlay
(For full, unobscured image, see page 102.)

In this detail, the breakdown of the model's right leg provides an example of shape progression. The eye follows a shape progression like a marble bouncing down a flight of stairs. You will gain an understanding of shape progression as you learn to see the individual sections of each shape; you will learn to see the sections of each shape as you start seeing how the two sides of the form correspond to one another.

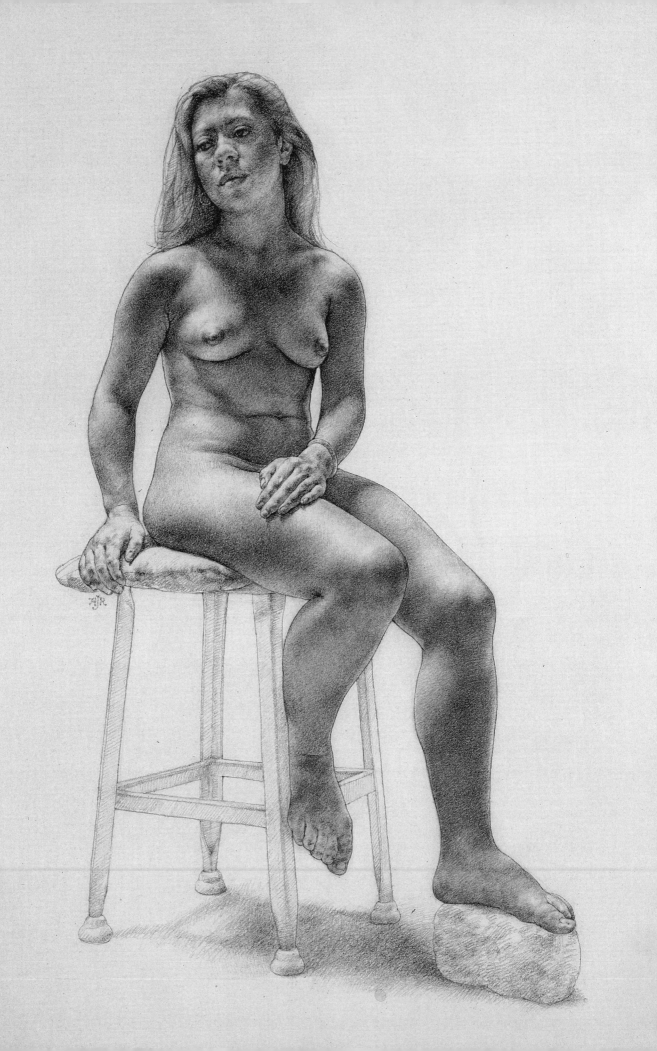

UNDERSTANDING GESTURE

GESTURE IS LIFE AND MOVEMENT. It is the energy inherent in the form of the model, a living energy coursing through his or her whole body. This isn't called *life* drawing for nothing. We must literally and figuratively draw upon our own living energy, and that of the model, when we draw the figure. The people in our drawings should appear as if they are breathing, as if their hearts are beating. Gesture is the heart and soul of figure drawing. It animates our drawings. Without it, they are lifeless and meaningless.

Gesture is not a technique, or a "thing." It is not one of the steps to this drawing method, per se. Rather, it is something you should learn to recognize in the model and express as you are building your block-in. In fact, the two principles of block-in and gesture are inseparable. In the first stage of the block-in, the envelope, gesture is expressed through the angular pitch of the irregular, dynamic envelope shape. As the envelope is broken down, gesture is expressed in the tilt and progression of the large sub-envelope shapes. And in the block-in itself, the expression of gesture is further refined. The block-in is the visible shape of the gesture. The gesture is the dynamic energy inherent in the block-in.

Gesture is the model's action, and is expressed in the fullness of the form of the body and its motion. Sitting, standing, and leaning are actions of the model, but there's much more to gesture than that. For example, even if a model is posing very quietly, and is keeping very still, she's still sitting in a particular way—this is a manifestation of her body language and tells us a lot about what she's like as a person. And beyond that, the model isn't just sitting. She is also actively living. Life is expressing itself in every part of her body, visible in each

NOTE

The difference between a drawing with gesture and one without it is like the difference between a house that has a big, noisy family living in it and one that's been deserted for a long, long time. In the one there is sound and light. There are people. Someone's cooking at the barbecue out in the backyard. You can see the smoke rising from the grill and smell hamburgers and corn on the cob. There are cars parked out front, and the little flag is up on the mailbox. In the house across the street, all is dark and silent. The front porch is busted. The paint is peeling off the windowsills. The "for sale" sign is crooked. There's a feeling of emptiness.

LEFT: *Mademoiselle M.,* 1998
Pencil on paper, 24 x 18" (61 x 46 cm)

Gesture cannot be examined objectively; it must be experienced intuitively and empathetically. The drawing should mirror not only what the model is doing, but also what she's feeling: in this case, the pressure of her hand on the pillow, the tilt of her head, the work of her back muscles in maintaining the pose.

part's unique shape. All living forms have this quality. The outward spiral of a seashell and the burgeoning form of a shoulder both manifest this fluid, dynamic process. The process of growth gives concrete form to gestural energy. The form of the body is like visual music. It "moves" even when it's perfectly still.

Getting the idea of gesture, and seeing and feeling it when you look at the model, is the first step toward getting it in the drawing. You need to empathize with the model, to feel what it's like to be doing exactly what the model is doing. Try to visualize yourself in the model's pose. It doesn't make any difference if the model has a different body type than yours. Try to feel what it's like to have that kind of body. Once you get the feeling of the pose in your own body, you can put it into the drawing. The energy in the gesture of the model passes through you and into the drawing by way of your empathetic response.

"Action" and "movement" are alternate names for gestural energy. Although there are many actions in each pose (each limb, each finger, each lock of hair has its own action), we still think of the action as being unified. The action affects every form in the body and each part of the body should show its effect.

Detail of *Moon Maiden,* 1998
(For full image, see pages 54–55.)

For any pose, each form of the body should play its own part, in its own way. Here, the model's right foot is compressed into the blanket while her left foot rests lightly, as if there was nothing in the world to worry it or disturb its peaceful repose. The actions of the two feet are different from one another, yet have a logical and harmonious relationship.

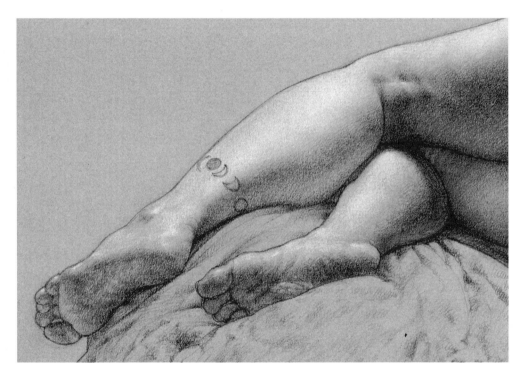

ACTIVE AND PASSIVE SIDES OF THE FORM

All movement in the body is accomplished by an alternation of muscular contraction and relaxation, a dynamic relationship that must be translated into your drawing for it to be *gesturalized.* When muscles contract, parts of the body flex, causing one side of the form to bunch up. At the same time, the other side stretches out. Opposite sides of the form are always different from each other. In the contracting, bunched-up, *active* side, shapes collide and line segments meet each another at acute angles. On the stretched-out side, also called the *passive* side, shapes attenuate and line segments meet one another at shallow angles. For each pose, there are many pairs of active and passive relationships. In a seated pose, for example, the back is passive while the abdomen is active; the tops of the knees are passive while the backs are active, and so on throughout the various aspects of the pose.

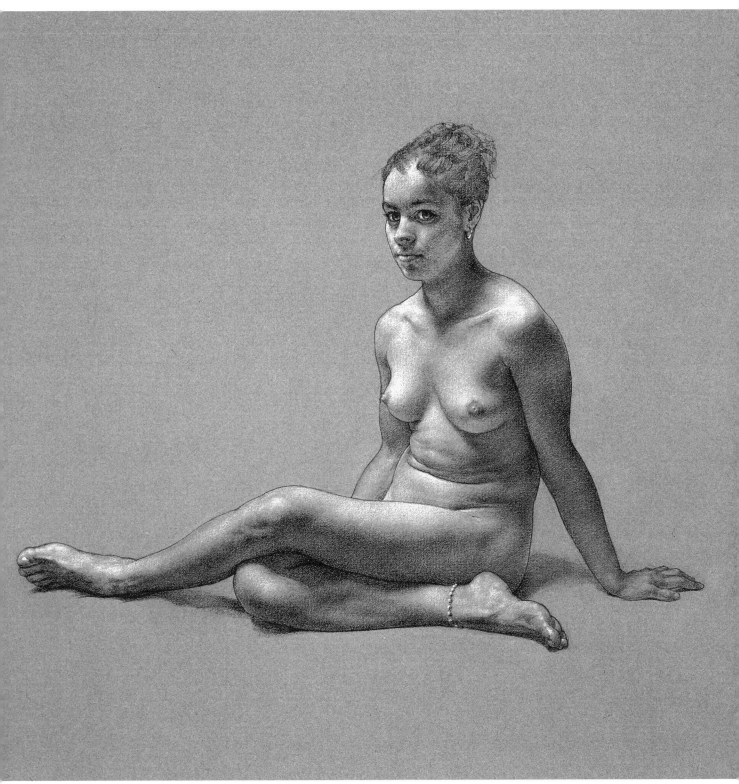

Piano Student, 1998
Pencil and pastel on green
paper, 25 x 19" (64 x 48 cm)

Notice how the pose affects each part of the model's body: contraction (in the model's abdominal muscles), stretching (in the biceps of her left arm), bunching (in her left shoulder), and compression and overlapping (in her legs). The natural attitude of the head depends on the curve of the neck, which in turn proceeds out of the curve of the back. Though we cannot see the back in this pose we do need to feel its participation. The same is true of the model's right leg, which branches out of her lower back. Through the work of drawing we develop a sense of the way unseen parts of the body connect to seen parts. The model's right hand (which we can't see) rests on the model stand palm down. Though it is hidden from view, we shouldn't have any trouble imagining its presence in the drawing; we should sense and feel its action in the far arm, in the tip of the shoulders, and in the curve of the back.

Detail of *Piano Student,* 1998
(Full image on previous page.)

In this detail you can see the active side of the torso, in which the forms of the abdomen bunch up and converge. On the passive side, which is hidden from view, the forms of the back relax and stretch.

Detail of *A Quiet Afternoon,* 1998
(For full image, see pages 42–43.)

In this detail, notice how the back is stretched out (passive) while the abdomen is contracted (active). One side of the wrist and hand is relaxed, while the other side bunches up. Forms on the active side of a figure should be short and full, meeting each other at steep angles and often at creases and folds. On the passive side, forms lengthen and attenuate. They straighten out almost to the degree that their juncture points disappear as they stretch over the underlying curve.

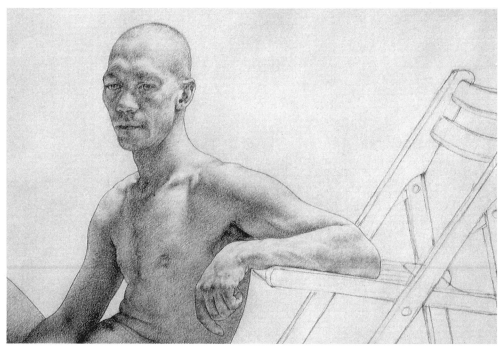

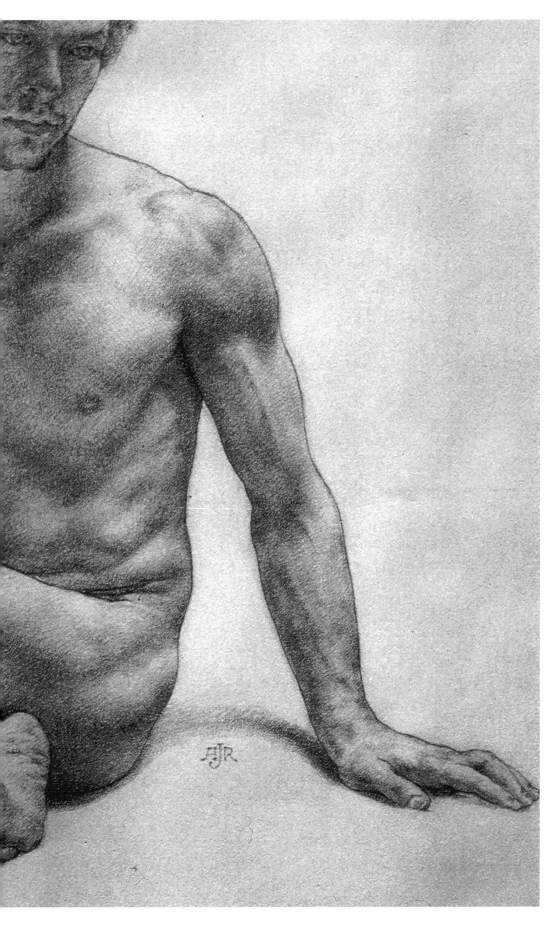

Detail of *Rock Climber,*
1998
(For full image, see page 56.)

In this detail, the forms of
the model's arm are
compressed and the
shoulder is bunched up.
The muscles are working
and the skin is taut.

THE INNER CURVE

In order for the block-in to be gesturalized, its shapes must not only reflect active versus passive shapes, but must also progress along a fluid, underlying, curvilinear path. This inner path is called the *inner curve,* and is the inner axis of the block-in shape. The key to getting gesture into the drawing lies in seeing the inner curve, and in developing its influence in the shapes of the block-in, the contour, and on the "inside" of the form.

The inner curve is an imaginary line that runs through the forms of the body like a thread inside a string of pearls, or like the trajectory of a moving object.

We don't actually see it; we infer it. It flows like a river, subtly and constantly changing direction, never traveling in a straight line. And like a river, it never makes any abrupt, angular changes of direction. The shapes of the block-in progress and merge into one another along its invisible, curving path. They conduct the curve as if it were a kind of electricity, a *gestural current,* expressed in the fluid interconnection of shapes as they progress into one another. The resulting shape progression carries and directs the gestural movement the way banks channel a stream.

Twilight, 1998, with overlay
(For unobscured image, see page 67.)

The gestural curve never makes any hard, angular directional changes; its movement is always flexible and smooth. It moves like water, or the wind. Here, the primary gestural curve makes a big "C," which is interrupted and tempered by secondary, recessive curving movements. The gestural movement is always a synthesis, a balance of forces, some originating within the figure and others acting on it from without. The primary curve is expressed in the model's left arm, head, and back. It skips the legs and reappears in the extended right foot. The curves of the legs run counter to the principle curve, pushing up where it curves down. Likewise, the curve of the model's right arm drops down as the primary curve rises up through the upper body and left arm.

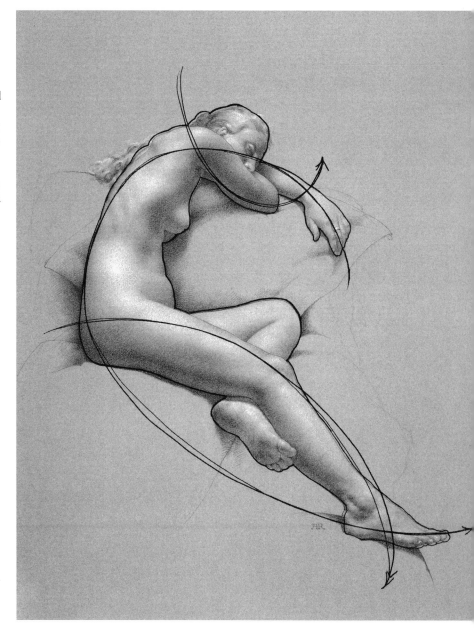

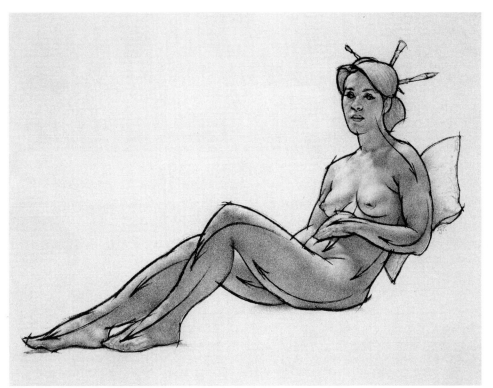

Paintbrushes, 1998, with overlay
(For unobscured image, see pages 4–5.)

Here you can see the fluid, dynamic movement of the gesture. It courses like a river through the form of the body. As a river carves its path through the earth, shaping the land, so the generative action of the gestural movement shapes and molds the pliant form of the body. The shape of the body is an expression of its action.

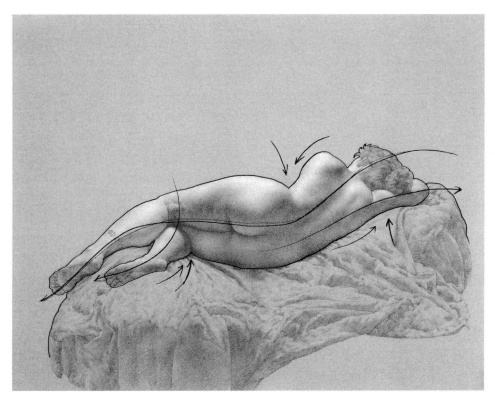

Moon Maiden, 1998, with overlay
(Unobscured image on overleaf.)

In this reclining pose, the inner curve is like a long, flexible rod laid out on an uneven surface, bent by the force of gravity. Notice the displacement of the two sides of the shape: the model's right side is displaced upward toward her outstretched elbow while her left side slides downward. This is an excellent example of nonparallelism and its relationship to the gestural action. The block-in and the gesture are really functions of one and the same thing. The block-in is the outward shape of the energy; the gesture is the inner energy of the shape.

Moon Maiden, 1998
Pencil and pastel on gold paper,
19 x 25" (48 x 64 cm)

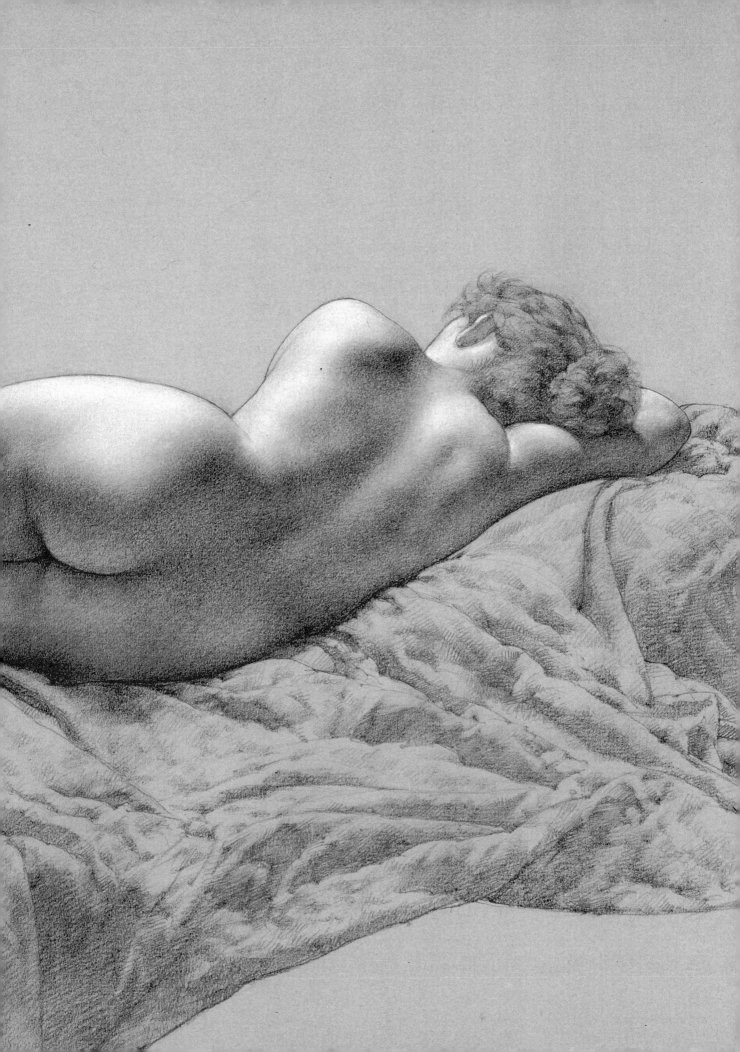

There are two fundamental errors that students often make when defining the inner curve. The first is defining the inner axes of the parts of the body as straight (ack!!!) lines, and the second is connecting these straight axes at the joints with hard angles. These two errors combine to form a syndrome called "the broken stick configuration."

Happily, the broken stick configuration is a drawing malaise that is easily cured. The cure requires two different medicines, the first of which is "taken internally." It is the realization that no part of the semi-rigid skeletal structure of the body is straight; even the bones themselves are complex, curvilinear forms. Additionally, the bandlike soft tissues of the body wrap the skeletal armature so as to soften all contours. Our bodies are like mobile, uphol-stered, wicker furniture. There's a degree of flexibility in the frame. The cushioned padding flows over and around the flexible frame in a continuous, fluid curve.

The second medicine is "applied to the surface," in the block-in. As the progression of sub-shapes in the block-in is threaded onto the inner curve, progressions around corners on the passive side should imitate the curves of the track of a high-speed train. Instead of abrupt directional changes, shapes should begin to change direction well before the joints, then turn slowly through the joints and continue along the curving path for some distance afterwards. Also, remember that block-in lengths are stretched on the passive side, and contracted on the active side.

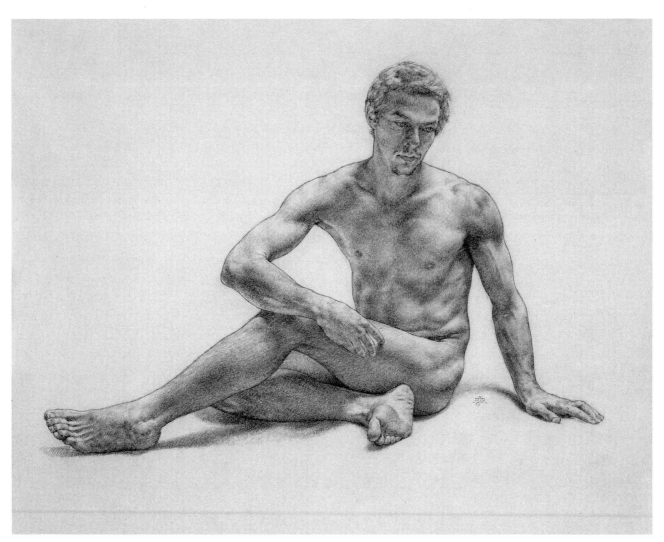

Rock Climber, 1998
Pencil on paper, 18 x 24" (46 x 61 cm)

Notice how this model's torso twists as one large, flexible mass. The twist continues up into the neck and down into the legs. The stretch of the model's right shoulder and the bunching up of his left shoulder displace the head and neck toward the right. The pose subtly shifts parts of the body into atypical alignments. If our ideas of the body are stiff and rigid, we may miss getting the living quality of the movement.

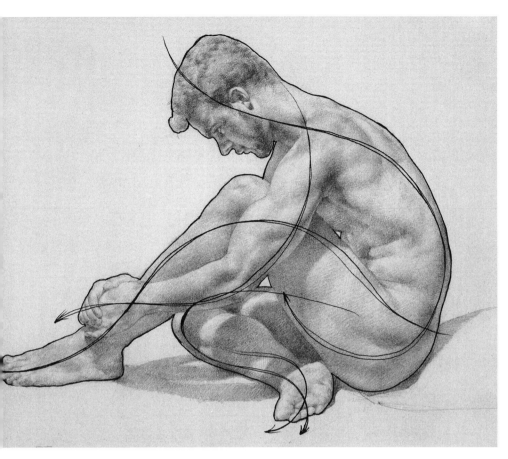

Potential, 1996, with overlay
(For unobscured image, see
pages 2–3.)

A certain amount of "banking" occurs as the inner curve passes through tight corners. Banking is what racecars do when they take curves at high speeds. They swing out and up on the banked curves of the racetrack. It's the result of centrifugal motion. I'm using the image metaphorically, to describe something we often see when drawing the figure: an outward exaggeration of the curve of the passive side of a form. Banking of the inner curve can be seen here in the model's back, left arm, and legs.

NOTE

Much of learning how to draw has to do with feeling the momentum of the gestural movement. The pencil cascades down the sides of the shape, springing down the form like a mountain goat leaping down the side of a mountain. Each time it lands, it rebounds in a different direction. Of course, this action would be wildly out of control if it weren't governed by an exacting study of proportion. We must learn to draw vigorously, but at the same time carefully and accurately. Unbridled vigor not restrained by carefulness degenerates into recklessness. The art of drawing is both intensely energetic and extraordinarily precise. That's why the great masters are called "great." They had not only an amazing amount of control and precision, but also phenomenal power and energy.

The illustrations that follow should give you a clearer idea of how gesture is expressed in figure drawing. Take some time to find the active and passive sides of forms, the inner curve, and the "something" that gives each drawing its vitality, making it come to life. But also keep in mind that drawing gesture is not about following rules. It's about finding something that's very subtle and hidden, but at the same time maddeningly obvious and present. As with everything in this book, these are just suggestions and pointers, as if I were saying, "I think the treasure is hereabouts somewhere." After all, I'm looking for it, too.

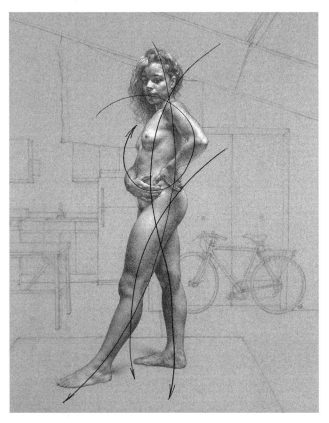

All-Star, 1998, with overlay
(For unobscured image, see page 102.)

Though there's usually only one, central inner curve in the pose, which serves as the principal motif of the drawing, sometimes a few curves combine—kind of like a musical chord—to form the gestural backbone of the pose. If this pose were a musical chord, the curve of the arch of the back would be one of the principal notes. It would combine with the curve running in the opposite direction, which passes through the neck and leg. A third movement loops through the arms.

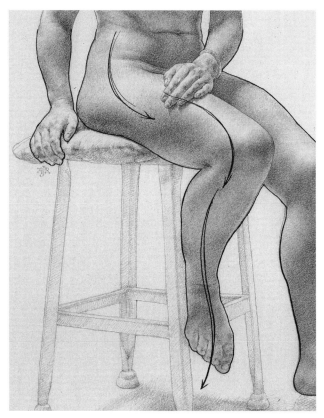

Detail of *Mademoiselle M.,* 1998, with overlay
(For full, unobscured image, see page 46.)

When the inner curve encounters an obstruction, it flows over it like water flowing over and around a stationary object. Notice here, for example, how the seat and rung of the stool bump up the gestural movement.

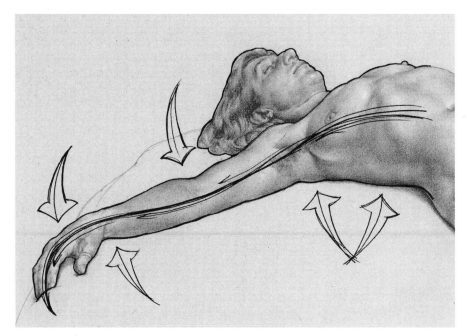

Detail of *Figure in Space,* 1998, with overlay
(For full, unobscured image, see pages 144–145.)

The path of the inner curve is like the flight of a bird. Its trajectory is bent by updrafts and downdrafts. When a person lies on a hard, flat surface, the natural curves of the back get straightened out. As a result, the rib cage gets shoved up toward the ceiling while the neck and small of the back sink down toward the floor. In this drawing, there's a feeling of upward thrust in the rib cage, whereas the outwardly flung arm expresses drooping relaxation, settling down into the elbow. Likewise, the wrist pushes up a little bit, but then the hand hangs limply off the end.

The hand is the gestural organ par excellence. It is one of the most expressive parts of the body. Due to its mobility, it is practically like a little body all by itself. On account of this mobility, and its anatomical complexity, it can be one of the most intimidating parts of the figure for new artists. My way of simplifying the hand is to see it as part of the gestural expression of the whole arm: the shapes of the hands are outgrowths of the gestural shapes of the arms. Here are some "tricks" that should help:

1. "Draw the mitten!" In other words, draw the envelope shape of the whole hand before starting in on the fingers. This may not seem to work very well at first, but after some practice it will help greatly.

2. Look at the shape of the fingers on each hand as a unit. Carefully judge the shape's length and how it relates to the length of the hand as a whole. For example, look at the detail shown at right. In the model's left hand, we see a great deal of the back of the hand and very little finger, whereas in her right hand we see half the length of the whole hand in the fingers.

3. Think of the two opposite sides of each finger as proceeding out of the two sides of the shape of the arm. Each finger has a different way of expressing the flow of the movement in the arm.

4. Observe the way the shapes of the fingers taper. Fingers that don't taper look like sausages neatly lined up on a meat counter.

5. Lastly, try to reconcile the length and width of each finger. Too much width and your fingers will look pudgy. Too little width and they will look wafer thin.

Getting the proportions of the shapes of fingers and hands is something that we simply have to work on. The darkest hour is just before the dawn. It may seem like you're getting nowhere, but if you stick with it you'll succeed.

Class Demo: *The Hand,* 1996
Pencil on paper, 14 x 17" (36 x 43 cm).

Everyone knows that the knuckles are like little knobs, and that connecting these knobs are little metal shanks, right? Sorry! Between the knuckles the form of the fingers is full, and the knuckles themselves are full forms that wedge into the full masses between them. The basic structure of the form is woven with crisscross diagonal movements around the inner, curving, gestural axis.

Detail of *All-Star,* 1998, with overlay
(For full, unobscured image, see page 102.)

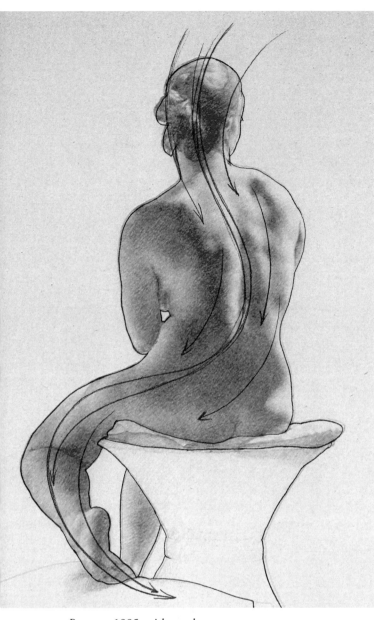

Ramona, 1995, with overlay
(For unobscured image, see page 83.)

Here, gestural currents alternate from side to side, spiraling around the central inner curve.

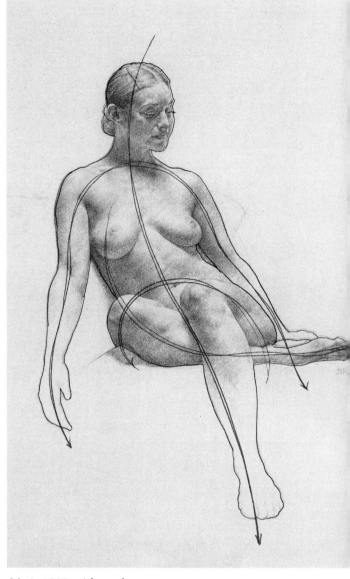

Music, 1998, with overlay
(For unobscured image, see page 64.)

The fundamental inner curve of the pose usually follows the axial skeleton: skull, vertebral column, rib cage, and pelvis. It is the principal motif of the pose, like the principal theme in a piece of music. The curves of the arms and legs harmonize, sometimes merging, sometimes diverging, echoing and elaborating the principal motif.

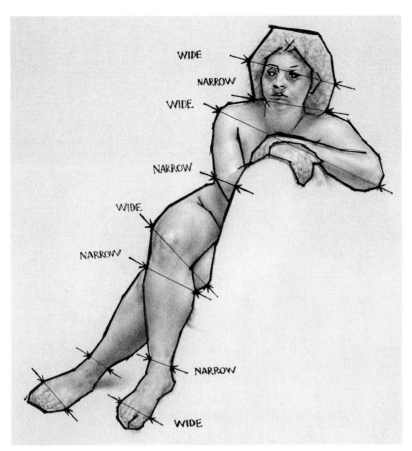

WIDE
NARROW
WIDE
NARROW
WIDE
NARROW
NARROW
WIDE

Woman on a Couch, 1998, with overlay
(For unobscured image, see page 13.)

In nature there are cycles: day and night, high tide and low tide, summer and winter. In the human body there are also cycles: we breathe in, we breathe out; the chambers of the heart dilate and contract. Rhythm also exists in the shapes of the body. They expand into places of maximum width, then contract into places of minimum width, then widen again and narrow again, and so on. This action is like that of a bellows, pumping energy into the drawing. As the eye follows the inner curve, it experiences this alternation as one might experience a piece of music that swells and diminishes in volume, speeding up and slowing down, hovering sometimes in the treble range, and then swinging into the bass. Variation is one of the fundamental components of aesthetic experience. After all, variety is the spice of life.

TIP

Hair is composed of locks: full forms that curve and wedge between one another. In this drawing method, hair is formal, gestural, and less "hairy" than when drawn with myriad individual filaments. In the drawing at right, for example, the model's hair wraps around his head in a turbulent cascade, its forms interweaving, tapering, and spiraling. Hair should not be drawn with long, evenly spaced, parallel curves or it will look like carefully combed spaghetti. Instead, the forms of hair should always be nonparallel; the softness and beauty of hair depends on the orderly disorder of its gestural exuberance. The edges of the shapes need to be carefully regulated so as not to be too "liney" and hard, nor too mushy and soft.

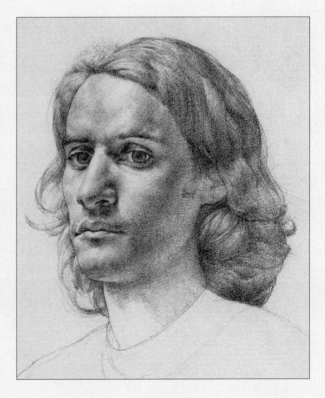

Ed, 1998
(Larger reproduction on page 17.)

Sketch: *Leaning Male Figure,* 1994
Pencil on paper, 17 x 14" (43 x 36 cm)

We have to work hard to see and appreciate the gesture in "normal" poses, and consequently our sensitivity to gestural movement is developed more in studying them than in studying poses that seem extraordinarily active. Always look for the *natural* movement of your model. Poses that pass for ordinary, hardly attracting any attention at all, can have a poignantly expressive quality.

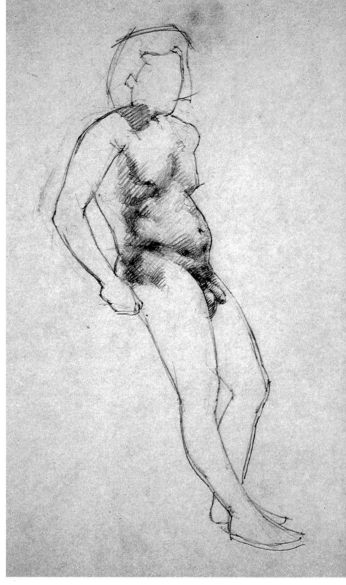

Sketch: *Seated Female Figure,* 1994
Pencil on paper, 17 x 14" (43 x 36 cm)

This was one of those sketches in which I felt as though I had tapped into the gestural presence of the model—as if I was tape recording a program off the radio. I wasn't creating a drawing so much as I was receiving one. It was a twenty-minute pose and I worked as quickly as I could, barely able to keep up with the impressions flooding my mind. What I'm trying to explain is that gesture is an energy that can get *into* you from the model. When this happens, you're simply moving the pencil on paper, trying to stay with the gesture's invisible guidance. You can feel it intuitively. It's a very subtle energy and almost any thought or feeling can drown it out, so it's very easy to lose. All I have to say is "I don't believe it's really there," and my connection with it is instantly severed. When all is said and done, we learn to draw so that we can be open to such unfathomable inspiration.

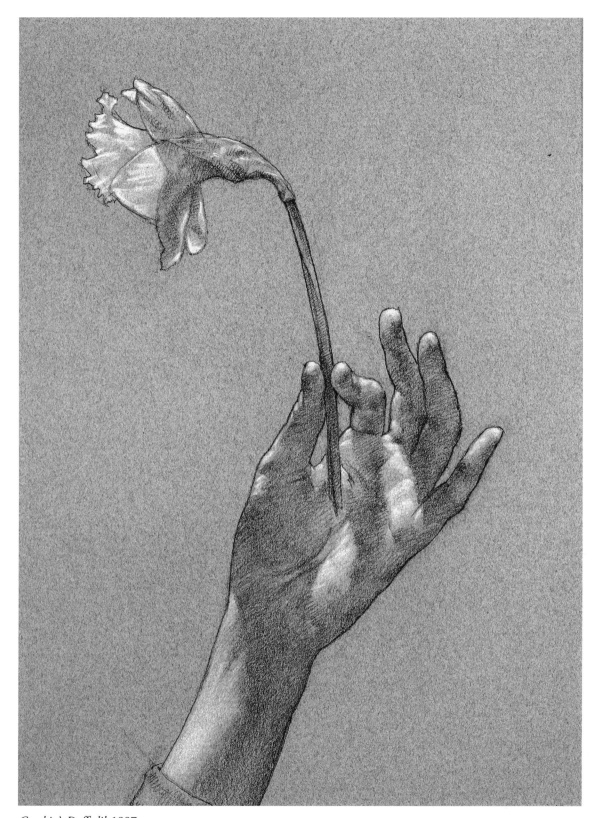

Cynthia's Daffodil, 1997
Pencil and pastel on gray paper, 25 x 19" (64 x 48 cm)

In this drawing, the gestural curve of the arm continues through the stem of the daffodil and into the blossom. It flowers in the hand and in the petal-like fingers, each of which has its own gestural action. Even the ring and middle fingers are bent and pitched at slightly different angles.

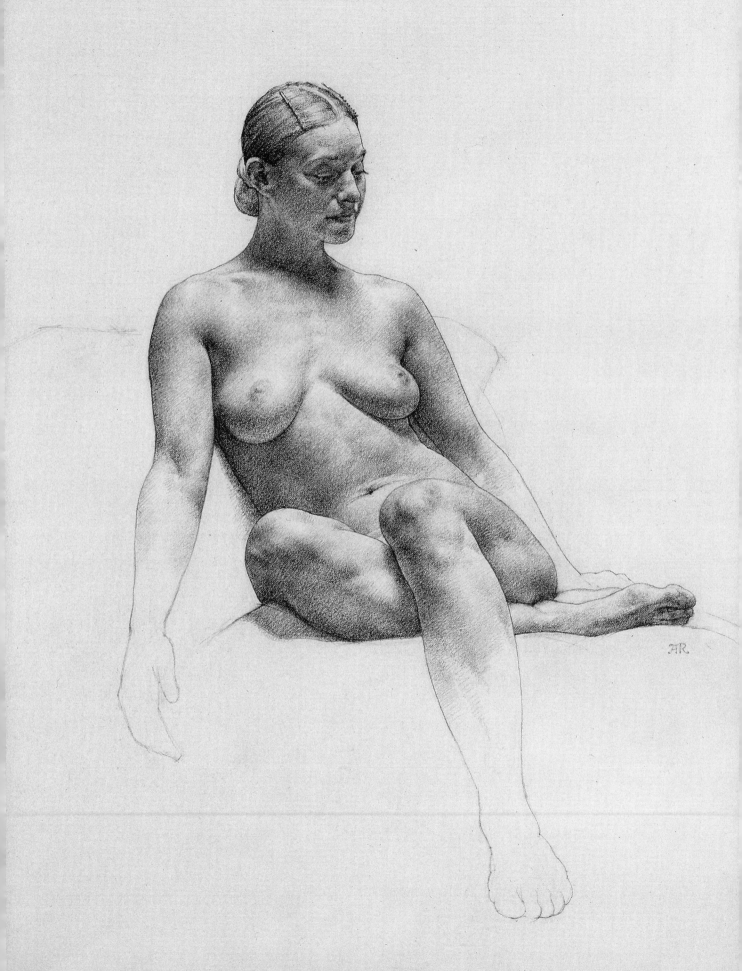

THE CONTOUR

In the first phase of this drawing method, the block-in is used to approximate the two-dimensional shape of the figure. Now in phase two, the *contour,* this shape is refined into the figure's outline.

Like the block-in, the contour uses lines, but in a slightly different way. While the block-in uses straight line segments to approximate the tilted sides of the shapes, the contour uses curved lines to represent the specific *forms* that appear along the silhouette. A *form* is a bulge, or as we say, a *convexity,* on the three-dimensional surface of the body. *Convex* means outwardly rounded (as opposed to *concave,* which means inwardly rounded). The surface of the body consists of many convex forms, all neatly fitted together. Each and every form has its own particular degree of convexity, as if each one was ground and polished like a lens. The contour is the succession of individual convex curves that line up along the silhouette of the figure.

The contour is the edge of the model in space. But since rounded forms don't have "edges," it might be more accurate to say that the contour is the horizon of the rounded form of the body. Like a line of hills on the horizon, the contour is the visual edge where the form turns away, out of sight. It is also the edge along which the form of the model overlaps the background, or along which any form overlaps another. The contour of the body is extremely subtle, difficult to describe accurately, and quite fascinatingly beautiful. Perhaps for this reason research into the contour is almost a separate study unto itself.

Detail of *Woman on a Couch,* 1998
(For full image, see page 13.)

Notice the many individual convexities that make up the contours of the fingers in this detail. The knuckles are full and the form between the knuckles is also full. There are no concavities in the outline.

LEFT: *Music,* 1998
Pencil on paper, 24 x 18" (61 x 46 cm)

The *contour* is the outline that represents the model's silhouette, which contains and defines the figure on the paper.

The contour has played a major role throughout the history of drawing. Line and shape are inherently beautiful, and when the contour is sensitively handled it can stand alone, like a violin solo, or an individual human voice singing a beautiful melody. A fully developed drawing, in which contour and shading are combined, is like a concerto for solo violin and orchestra, or an aria for soprano and accompaniment. There is an amazing amount of form contained very subtly in the contour. When this is integrated with an equally subtle, formal study in light and shade, a synthesis occurs that is very aesthetically pleasing. This is the basis of the classical tradition of figure drawing.

Twilight, 1998, with overlay
(Unobscured image on opposite page.)

There are many subtle variations in the planar orientation of the surface of the body. We call these variations "changes" in the surface, even though nothing is actually changing. The contour should conform to each change in the surface of the model like a coat of paint conforming minutely to the variations in the surface of a wall. These changes are often very slight. In the drawing at right, for example, changes occur millimeter by millimeter. The contour is a continuous succession of full forms indicated by very slight differences in the angulation of the line. No part of the surface of the body is flat. Every part has its own particular curvature, which changes constantly. Compare the contours of the toes of both feet to one another. Compare the long, stretched-out shapes in the contour of the back to that of the hand and fingers.

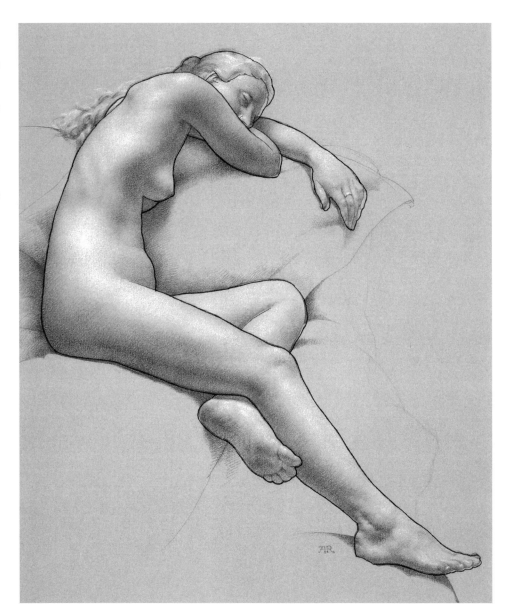

RIGHT: *Twilight,* 1998
Pencil and pastel on gold paper,
25 x 19" (64 x 48 cm)

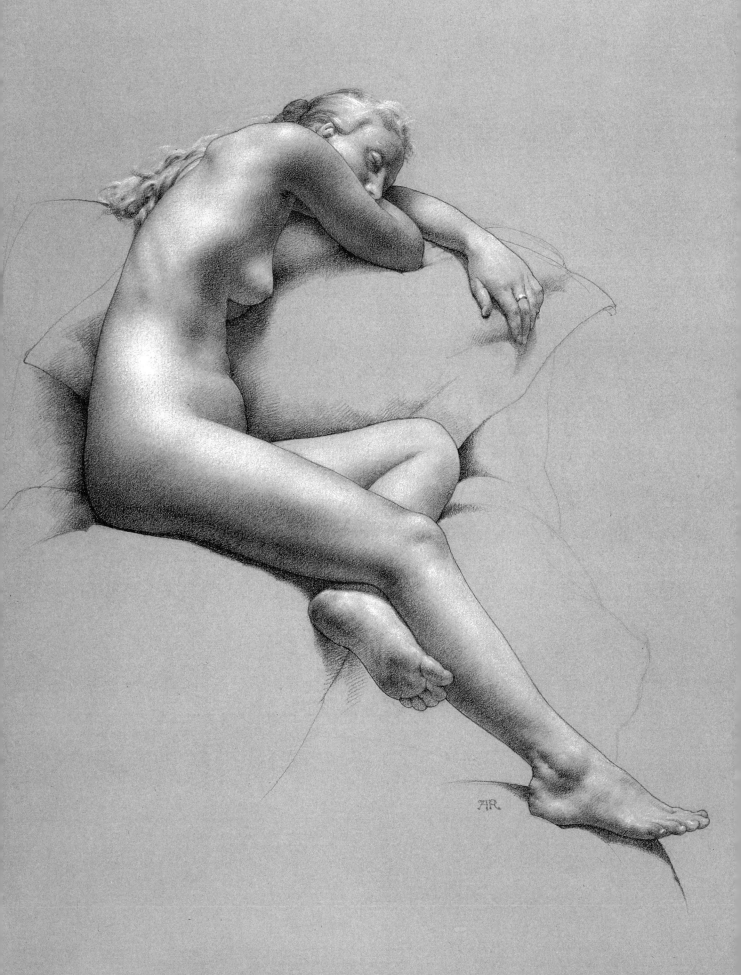

DRAWING
THE CONTOUR

To build the contour, each convexity on the model's silhouette is measured by eye, first for length and tilt, then for curvature, an effort that takes time and concentration. These forms are then riveted onto the underlying structure of the block-in. Each convex curve is drawn as an arc over one of the block-in's straight line segments, following its length and tilt. But each curve also has an additional quality all its own: its amplitude, or fullness. This is the degree to which the curve bows out. Some are "lean" (flattened, attenuated), others are "fat" (full, ample), and many others are somewhere in between.

Each form arcs out and falls back, like the spring of a leaping gazelle. In drawing parlance, each form pushes out from a *point of origin,* reaches its apogee (the highest point in its trajectory), and then drops back to a *point of insertion,* which then serves as the origin for the next emergent curve. In keeping with the idea that the shapes of the body are irregular, the high point should never be perfectly centered between the points of origin and insertion. Instead, it should always be closer to one point, with the bend, or degree of curvature, changing along the length of the curve. The individual, convex curves of the contour leapfrog down the line, following the underlying sweep of the gestural current.

The exact location of each arc depends on the block-in, which you should use as a guide. Work through the block-in section by section, replacing each line segment with a precisely drawn curve that mirrors the line's length and tilt. Focus your attention at the point of the pencil and concentrate on creating, one at a time, each single, fine, fluid curve. Know the exact curvature you wish to produce and avoid going either too shallow or too wide, but don't be discouraged if the curve you make isn't the same as the one you'd envisioned in your mind. In the production of precise curves, the hand easily strays. We are not machines. Making a curve, especially a long curve running in an awkward direction, is a very complex neuromuscular action. Dozens of muscles in the hand, arm, and shoulder are involved. There's always going to be a certain amount of shakiness. To compensate for this manual awkwardness, try supporting your wrist on a bridge, and carefully drawing longer curves in sections. If the first curve you draw isn't correct, erase it and try again. Take your time and concentrate, but try not to be tense.

Contour Study: *Michael,* 1997
Pencil on paper, 24 x 18" (61 x 46 cm)

This sketch was originally produced as a demonstration piece, to illustrate the way individual convexities are supported and aligned on an inner frame. The result was a block-in/contour hybrid that shows characteristics of both phases of the drawing process. The rough, sketchy, sweeping lines are typical of the block-in, while those drawn in the curvilinear fashion of the contour represent specific convexities.

The line drawing has such great visual impact that it can easily overpower the tonal drawing. Therefore, it is important to develop a sensitivity to the lines you use when building your contour. The drawing itself will speak up if a line is too hard or too soft. We all need to learn to listen more attentively to our drawings, to accept feedback from them. They are our best teachers, and will tell us many things.

Creases inside the silhouette are also considered contours, and are called *contours on the inside*. These contour lines aren't necessarily handled with the same line weight as the contour running along the outside of the figure, as they must eventually be integrated into the surrounding tonal fabric. Sensitivity must be used to determine exactly how hard or soft they should appear.

Detail of *Mademoiselle M.,* 1998
(For full image, see page 46.)

Each convex curve has its own tilt, length, and amplitude, from the itty-bitty curves in the fingers to the longer ones in the legs.

Detail of *Philosopher and Poet,* 1988
(For larger detail, see page 157.)

Look carefully at the creases below the jaw and between the neck and shoulder in this detail. Beginning students sometimes draw contours like these much darker and heavier than they should be, creating artificial separations between forms of the figure. Instead, contour lines on the inside should be united with the local tonal conditions so that they act as transitions rather than separations.

It is important to use the block-in as a guide for the contour, but once the contour is complete the block-in has to disappear. The best way to do this is to "ghost" the block-in *before* you draw the contour by gently erasing it with a soap eraser and dabbing with a kneaded eraser. Then draw the contour. When the contour is complete, carefully cut into the interior and exterior surfaces of each curve with the edge of a soap eraser to remove the last traces of the block-in.

The illustrations on pages 71–73 demonstrate the transition from the block-in to the contour. By the time the block-in has been fully elaborated, all the shapes of the drawing should be pretty close to their final form. Then the process of developing the contour really just involves making many incremental changes, moving out of an angular and into a curvilinear mode. One by one, small sections of the drawing are remanufactured, redrawn in a polished and finished form. Though the actual change in the drawing may seem slight, the transition from block-in to contour is accompanied by a fundamental change in perception. A new subject enters the arena of consciousness: the form of the body.

TIP

When drawing the contour, hold the pencil differently than you do for the block-in. In the block-in, pencil movements are free and sweeping, and the pencil should be held as far back as possible. In the work of the contour, the movement is more precise. Hold the pencil up close by the point, as if you were writing. Your grip should be relaxed, but not loose. The pressure on the pencil should be such that it produces a distinct, medium-light line—dark enough to read clearly, but not too much darker.

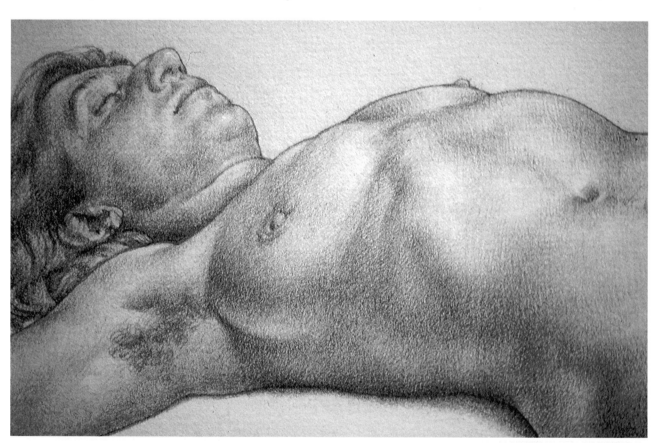

Detail of *Figure in Space,* 1998
(For full image, see pages 144–145.)

In some parts of the drawing the contour may be quite clear and crisp. There are other parts, however, in which the contour should be allowed to dissolve and go fuzzy, to weaken or even entirely disappear. For instance, notice in this detail how the contour rounds the forehead and loses itself in the hair. Notice also how it nearly fritters away in the shadow on the underside of the torso.

DRAWING THE CONTOUR

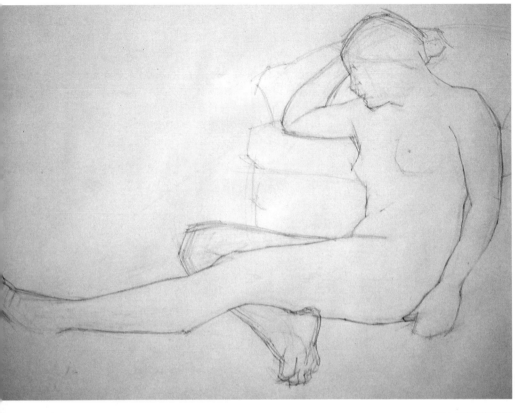

Thought Form (in progress)
(For detail of completed image, see page 150.)

Here you can see the latter stages of the block-in. Notice the uncertainty of the lines. The block-in process is about searching for and discovering the appearance of the model. You need to accept the paradox that, though you can see the model quite clearly, you really haven't the slightest idea what she looks like. Then you can use the block-in as a means to acquire clarity.

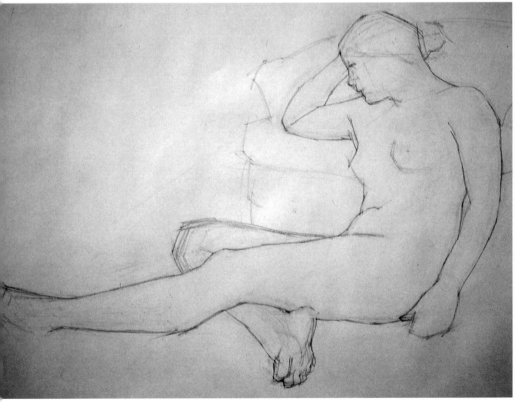

As you work and rework the block-in, you may erase and redo the drawing section by section. Here I've redrawn the model's head and right arm. I look for specific directional changes in the lines defining the opposing sides of the form.

The angular line segments of the face, left arm, and torso are beginning to merge into continuous curves, though at this point they are still only estimates.

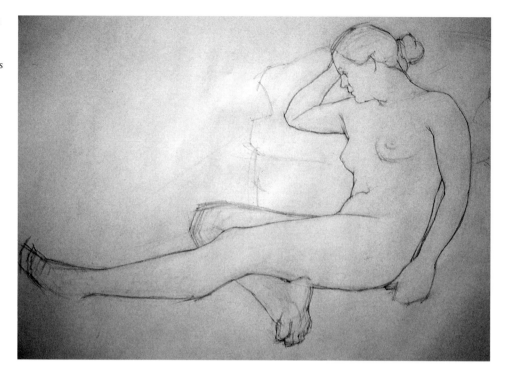

Once the contour has been laid onto the block-in, each form can be revisited and refined, as has been done here for the contours of the face, left arm, and torso. Drawing the contour is like tuning a piano, precisely adjusting the pitch of many individual lines to an exact harmony. As you apply your mind to these refinements you open yourself to an increasingly sensitive state of awareness. With this delicate sensibility you will find yourself able to see much more clearly the very beautiful, delicate structures of the body, such as the features, fingers, and toes, and all the micromodulations of the form.

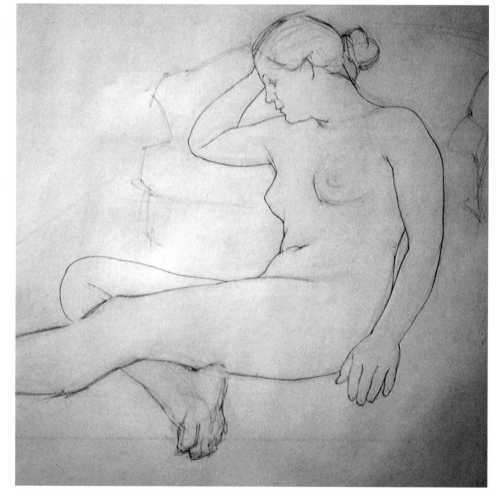

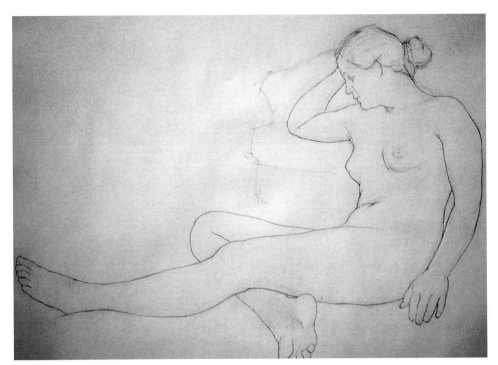

The finished contour. Actually, nothing is ever really finished. You can always go back and readjust anything that you find incorrect. During the tonal phase I routinely correct the contour, very carefully erasing and re-drawing small (and sometimes not so small) sections.

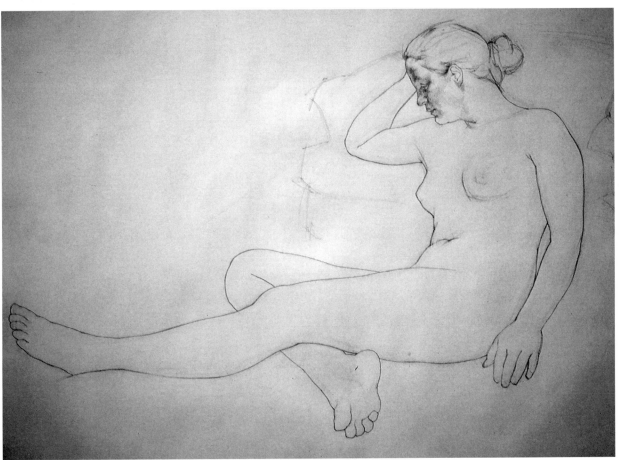

Just so you know what to look forward to, I'm including this illustration to show the beginning of the shading process. An accurate contour drawing greatly facilitates the shading process in two ways. First, it provides the proportion, location, shape, and connection of all the parts of the drawing. And second, it establishes a standard of visual clarity and sensitivity to follow and strive for in your tonal work.

THE FORM
OF THE BODY

The study of the contour brings us to the study of the form of the body itself—no longer through an *approximation* of its shape, but through an exacting account of its very surface, in all its subtle refinement. This work requires more than just careful observation. It also requires an understanding of the principles of the form of the body—the principles of its structure and shape in space. This branch of knowledge is known as *sense of form.*

Form is the three-dimensional shape an object takes up in space. It is the spatial definition of a solid object with a specific surface. The form of the body is one of the fundamental subjects of study in the Western European drawing tradition. It has been a focus of study in art since ancient times, and is considered a training ground for all visual artists. The human figure embodies design principles that apply not only to figure drawing and painting but also to landscape and still-life painting, painting composition in general, and many, if not all, other art forms.

One way to understand form is through the study of anatomy, which teaches us about the body's interior structure, the underlying logic of its surface. Another traditional approach is to study the nature of form itself: the laws of its three-dimensionality, the way it structures space, and its nature as a spatial entity. This second approach is the one discussed below. (Please note that the terms *form, sculptural form,* and *form of the body* will be used interchangeably.)

Form has three fundamental aspects, or qualities: fullness, continuity and discreteness, and organization. Let's look at each one in turn.

FULLNESS

All the forms of the body are convex, meaning that they are outwardly rounded. No part of the surface of the body is flat or concave (inwardly rounded). This is the principle of fullness. No matter how slender the model may be, the surface of his or her body is entirely composed of convex, "full" forms.

Fullness expresses presence in space. Full forms appear to have mass, weight, and substance. They are ample and communicate a feeling of plenitude. The form of the body has volume, burgeoning out from within. Fullness is expressed both in the contour, through convex curves, and on the inside, through the use of tonal progressions that give the appearance of rounded forms. Here we will explore fullness in the contour; fullness on the inside of the form will be discussed in Chapter 6.

The full forms of the body are not simply round. Their outwardly rounded surfaces also have *tautness,* like the surface of a sail. The squishy substance of the body is contained in a spandex-like tendon suit. This suit attenuates the "blobbiness" of the form, pulling it taut. Thus we are not really globular (thank goodness). In fact, if drawings are too full, they are referred to as being "roundy." A drawing without adequate fullness, on the other hand, can look kind of scrawny. As I said, the form of even a very slender model is full. If a contour lacks fullness, it is usually not so much a reflection of the model as it is of the artist's lack of understanding of the fullness of the form.

RIGHT: *Pensive,* 1998
Pencil on paper, 24 x 18" (61 x 46 cm)

The form of the body is full, from the smallest forms of the features to the larger masses of the torso and legs. Even apparently concave aspects in the contour (those of this model's left ankle and the small of her back, for example) are subtly filled out with minute convexities. And fullness exists not only in individual forms, but also in conglomerations of forms. In this drawing, the fullness of the upper torso combines with that of the arm and shoulder. It is echoed in the hair and in the shape of the bow.

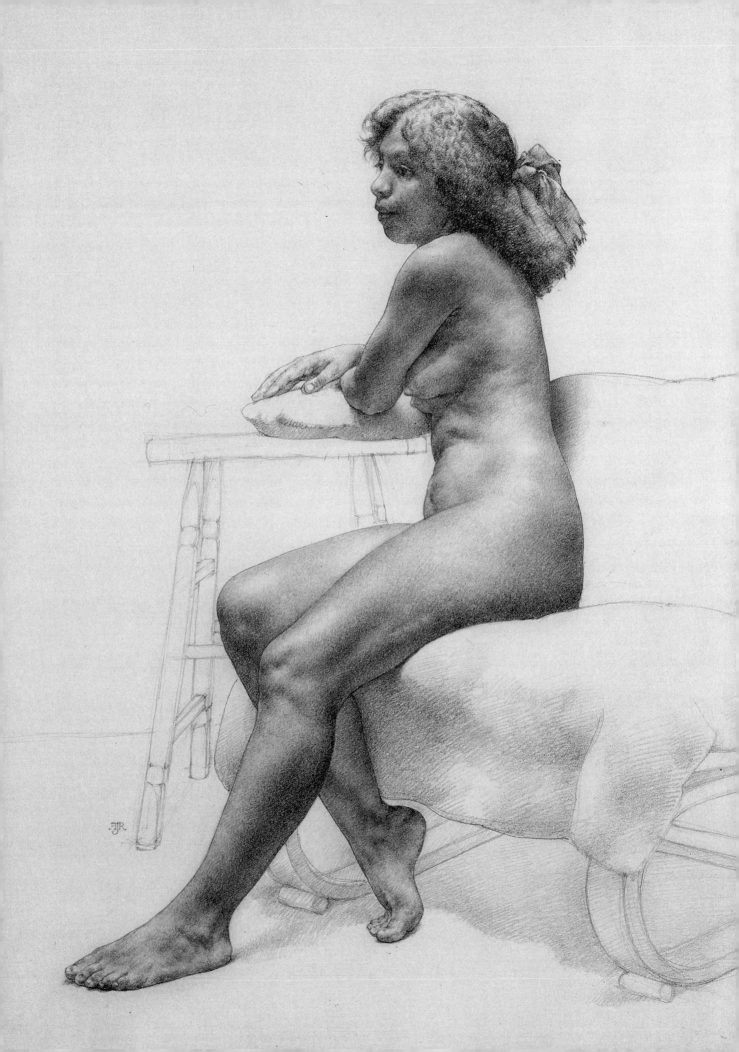

CONTINUITY AND DISCRETENESS

There are two somewhat paradoxical ways of seeing the form of the body: as *continuous* and as *discrete*. In this context, "discrete" means consisting of distinct or unconnected elements; in other words, the opposite of continuous.

The continuous view sees the surface of the body as seamless, unified, and fluid, like the water in a mountain stream. The water in a stream is one continuous substance even though it flows over separate stones. Similarly, the form of the body flows over many separate anatomical parts (bones, muscles, and so on) but never ceases to be one continuous surface. The discrete view, on the other hand, sees the body's surface as composed of many distinct, identifiable convex forms. According to this view the surface of the form is like very finely wrought tile work.

Both of these ways of seeing coexist in the contour, and find expression on a practical level. The continuous mode expresses itself through the progressions of convexities that merge and stream together. The discrete aspect is expressed through the succession of high points and origin/insertion points. In drawing we're constantly dealing with these apparently contradictory aspects of the form: unity and diversity, continuity and discreteness. If the contour is too continuous, it becomes kind of slippery and rubbery. If it's too discrete, it becomes overly choppy.

Consequently, we avoid representing the body as a collection of separate parts, even at the beginning when you may be tempted to start the drawing with a collection of "conceptual building blocks." But you should also avoid representing it as a gooey, amoebic blob. The envelope exemplifies this concern for both wholeness and structure, which the block-in then preserves through its use of open, angular sub-shapes. Likewise, the contour expresses the fluid continuity of the body's surface, while at the same time expressing its individual convexities, which are strung together on the inner curve like beads on an invisible thread. At the point where one convex form ends, the next begins. These transitions are extremely subtle, but they are there. The individual forms should be definitely recognizable, while at the same time the progression of forms should read as one continuous curve.

Detail of *Woman on a Couch,*
1998
(For full image, see page 13.)

Even in cases where the contour is relatively smooth, such as in the shoulders and arms in this drawing, each convex curve begins at a point of origin, pushes out to a high point or two, and then drops back in to a point of insertion. The subtle structure of the curves imparts a definite feeling of dimensionality and spatial reality to the drawing.

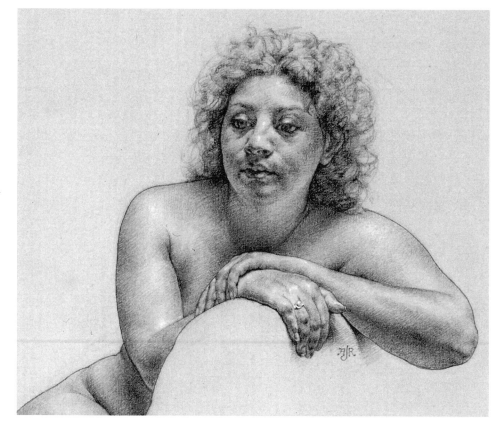

ORGANIZATION

Organization is the orderly arrangement of form in a regular pattern. We see order in all living creatures and in all natural systems. The pattern in the feathers of a bird's wings, the arrangement of clouds in the sky or waves in the sea, the way someone's hair falls, the creases around the corners of someone's mouth when he or she smiles—all of these things have order. The universe is permeated with an order that is incredibly systematic and, strangely enough, chaotic without being disorderly.

The contour forms part of an orderly arrangement that only fully manifests itself in the latter stages of the drawing process. All the forms of the body line up in an intricate network, an organic geometry. This subtle order is best expressed in a finished drawing, when all the forms on the contour key in perfectly with those on the "inside" of the contour—a major organizational feat. This is called "the agreement of line (the contour) and light (the forms

on the inside modeled with tone)." As we all know, the human body is an unbelievably subtle and beautifully structured thing. It is a paragon of design unity and integration. A drawing cannot begin to approach the incredible perfection of the body. However, this is the essential motif that drives the art of figure drawing.

> ### TIP
>
> Just because everyone has the same basic anatomy doesn't mean that a contour will look the same from one person to the next. Don't let your ideas blind you to the character of a particular model and pose. It may be difficult to let go of your old ideas and concepts—you may at first feel anxious and uncomfortable. But a mind once emptied will gladly absorb new, more appropriate thought patterns, and in the end you will be greatly benefited.

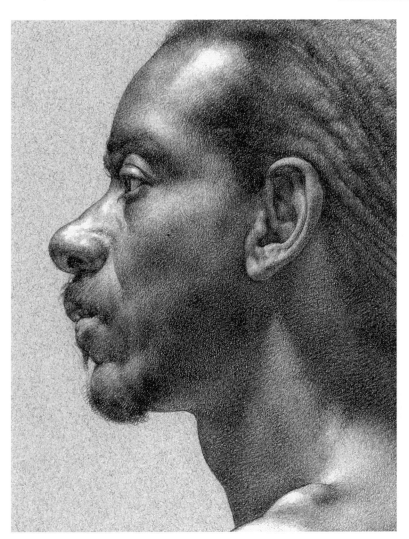

Detail of *Pete Jackson, Capoérista,* 1998
(For full image, see page 140.)

In an actual person, there's no separation between the contour and the form on the inside. So in the drawing, the tonal structure should fit precisely into the linear framework of the contour. Imagine that the contour of this drawing is the coastline of an island. Land on the chin and hike into the interior. Notice that the forms of the chin on the inside correspond to the shape of the chin's contour on the outside. This correspondence is achieved by careful planning in the block-in and contour phases of the drawing.

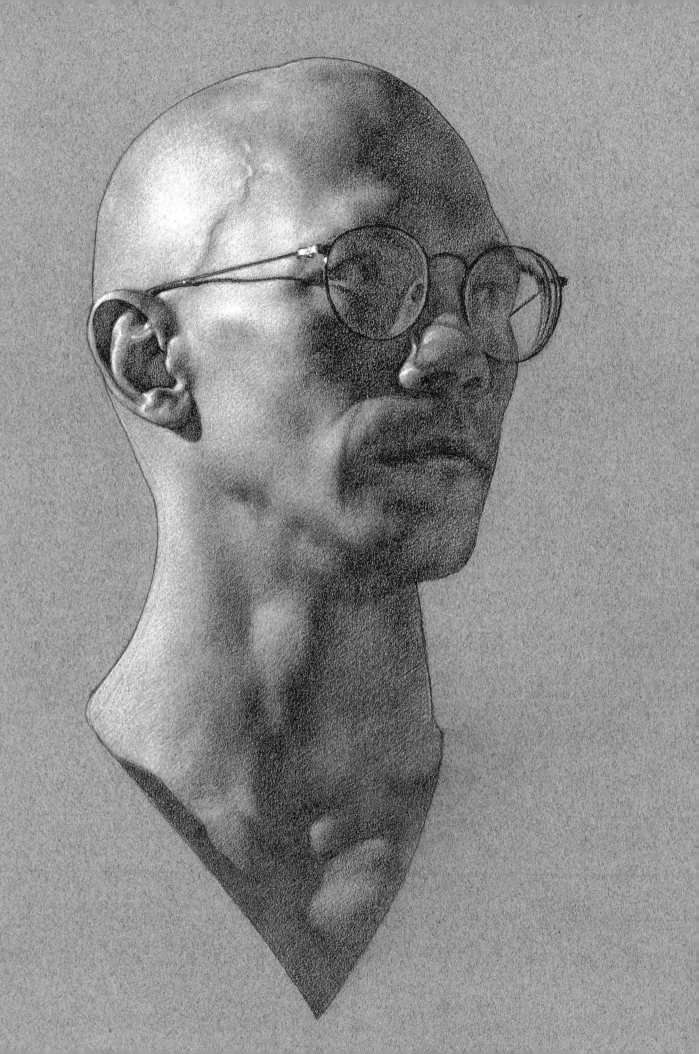

UNDERSTANDING LIGHT AND SHADOW

THE THIRD AND FINAL PHASE of this drawing method is called *drawing on the inside,* or *inside drawing.* Inside drawing is the description of the form of the body within the outline of the contour, done by using gradations of *tone.* A tone is a patch of shading of a certain value, or degree of darkness. A *gradation of tone* is an area of shading in which there is a gradual passing from one degree of darkness to another. This is also called a *tonal progression.* Tonal progressions are the basic building blocks of inside drawing.

But drawing on the inside is more than just the technical act of making tonal progressions. The real core of inside drawing is the ability to recognize the *appearance* of the model, which is gained through knowledge of light and form. It is only with this knowledge that you can apply your shading skills to create drawings that look like the model. In other words, you have to know *what* you're drawing before you can understand *how* to draw it.

You might say, "I know what I'm drawing. I'm drawing a person." Well, yes and no. It's much more accurate to say that you're drawing the *appearance* of a person. You are drawing gradations of light configured by the form of the body, and in order to represent these light gradations in such a way that they communicate the actual physical structure of the model, an understanding of light and

form is crucial. This chapter will lay the groundwork with a discussion of light and shadow. Chapter 6 will look more closely at form on the inside. And Chapter 7 will tackle the actual technique of laying in tonal progressions to "sculpt" the figure with light and shade.

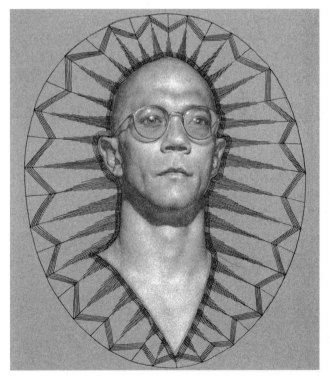

Phases of Dane: Full, 1998, with overlay
(For unobscured image, see page 92.)

Light enlightens and enlivens us. Light creates and transfigures our world. It is an immaterial, radiant energy synonymous with life and consciousness. It illuminates our minds and shines in our hearts. It is the substance of visual experience, the experience of vision itself.

LEFT: *Phases of Dane: Half,* 1998
Pencil and pastel on gray paper, 25 × 19"
(64 × 48 cm)

REPRESENTING LIGHT

So, you might ask, how do we represent light in the drawing?

We represent light with gradations of tone, guided by observation and knowledge of the way light interacts with form.

Why do we need to know about the way light and form interact? Won't our drawings be perfectly accurate if we just copy the values of the light as we see them?

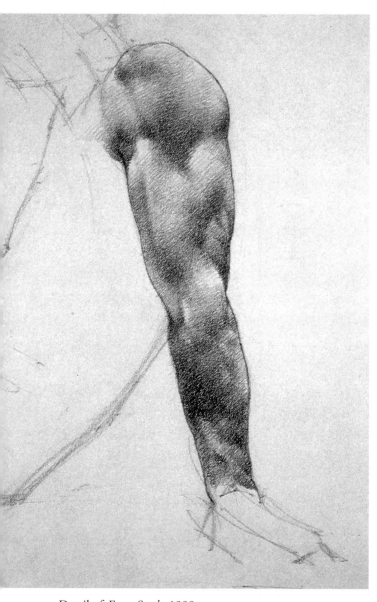

Detail of *Form Study,* 1998
Pencil on paper, 18 x 24" (46 x 61 cm)

In the complicated, interwoven structure of this arm, one thing is consistent: as the forms turn up they get lighter, and as they turn down they get darker.

Not likely. It's very easy to miss the quality of the light if you're just copying values.

What do you mean by the "quality" of the light?

I mean its luminosity, its glow. The light should shine in your drawings.

But how do we do that?

By *shaping the light.* Shaping the light is like molding the amount of light for each form, building up more light in one place and tapering it off in another. It means making value configurations within the linear structure of the drawing by allocating differing intensities of light according to the topography of the form.

How is this done in the drawing?

When drawing on white paper, light is shaped by selectively darkening everything that is not light and leaving the white of the paper to shine in those spots that are lit up on the model. On toned paper, light is shaped by darkening those parts of the drawing that need to be darker than the tone of the paper and lightening the parts that need to be lighter than the paper.

Which are the spots that are lit?

The most light-facing parts of the model—the parts that face the light source most directly—are the parts that are most lit.

Are all the other parts simply dark shadow?

No. The form of the body is rounded. It gradually turns away from the light. Consequently, between the shadow, where no light is, and the lightest light spots, there are tonal gradations, varying amounts of light, which decrease as the form rolls away from the light and increase as the form rolls up toward the light.

Are the shadows really a total absence of light?

No, not really. There's light in the shadows too, reflected light.

Do we leave the white of the paper entirely white for each part of the figure that faces the light source?

No, not necessarily. Many factors contribute to the exact intensity of the light that shines from each point on the model. In general, as the form rolls up it lightens, but there are extenuating circumstances that also affect its intensity.

What are these circumstances?

One is local value, which is the value of the surface of the form itself, as opposed to its value due to the amount of light shining on it. (For instance, very pale skin is of a different local value than very dark, sun-tanned skin.) Others are whether the surface of the form is glossy or matte, its distance from the light source, and probably other factors of which I'm unaware. The exact quality of the reflection of the light from the surface of the body is dependent on an infinite number of variables. We can have only an approximate theoretical model of the nature of the interaction of light and form.

If we can't really know what's going on when light interacts with form, what's the point of having a partial understanding?

Even a partial understanding is very helpful for the purposes of drawing. By combining a basic theoretical understanding of the behavior of light with careful observation, and with an understanding of the physical form of the body, we come up with the information that we need to guide and direct our application of tone in the drawing. With this information it becomes possible to portray each individual form of the body according to the light by which we perceive it, and to build up the complex structure of these forms into a recognizable human figure.

In the following section I would like to offer some information about light. This isn't exactly a scientific treatise, though it is sprinkled with a few scientific terms and concepts. Some of my observations are based on what I've heard or read about the physics of light. Others are based on speculations about the experience of vision, developed through the practical exercise of drawing, through discussions with other artists and people, and especially by way of association with my teacher, Ted.

Detail of *Catch*, 1998
(For full image, see pages 104–105.)

Though the form of the hand is definitely more complex than that of the sphere, the fundamentals of the light effect are the same. If you can learn to see and describe the effect of light on a simple object, you can go on to apply that knowledge to those that are more complicated.

THE INTERACTION OF LIGHT AND FORM

All that we see is light. It is the substance of vision and mediates all visual experience. The light that comes into our eyes has taken on the form of everything that we see around us. Once we realize that one of our fundamental objects of study is light, we can analyze its behavior and build its action into our drawings. Through a study of the light, our drawings become more solid, more real, more true to what we see.

The behavior of light is lawful and mathematically perfect. Light brings us information in a very orderly way. For all intents and purposes, it always travels in perfectly straight lines, from the object of vision to the observer. It never gets mixed up along the way unless it encounters an obstruction that deflects or absorbs its rays.

Form is any material thing or substance that alters the otherwise unimpeded passage of light. Anything that reflects, refracts, or absorbs light is form, and the specific appearance of each individual thing in the world results from the way it patterns the light that falls on it. This patterning is so distinctive and perfectly faithful to the original that the object is instantly recognizable as the absolutely unique creature it is.

When light encounters form, it reacts in one of three ways: it is transmitted, reflected, or absorbed. If the form is transparent, such as air, glass, or water, the light is *transmitted,* passing through the form and in the process being bent, or refracted. If the form is opaque, like paper, the light is *reflected* and bounces off the surface. And if the substance is pigmented, like cloth or skin, the light is *absorbed.*

As soon as light interacts with an opaque, pigmented form, different portions of its wavelengths are differentially absorbed and reflected. It is then no longer homogeneously uniform; it takes on a specific form. Its rays are reflected in a pattern that is unique to the object with which it interacts. This light pattern is radiated in all directions, and small fractions of it enter through the pupils of our eyes and shine upon our retinas, photosensitive neural receptors of the brain that are located on the inside wall of each eye. Each retina contains approximately 124 million rods and cones that register these bits of light energy. The bits of light are literally bits of information, like the bits and bytes of information in computers, and millions of them flow through our optic nerves into our brains each minute. In the brain, the visual information is processed and translated into conscious visual experience: cognition.

For most people, the sequence of vision ends with cognition—the simple awareness of a visual phenomenon. But for artists, there's an additional step: *recognition.* If cognition is seeing, then recognition is *knowing* what you're seeing. That might be called *Seeing,* with a capital "S." Just because you've seen something doesn't mean you've really looked at it. And just because you've looked at it doesn't mean you've really *Seen* it. Drawing requires that you discover certain important facts about what you're observing. Drawing requires that you *See* the model. This means knowing what to look for.

RIGHT: *Ramona,* 1995
Pencil on paper, 24 x 18" (61 x 46 cm)

Everything we see around us, we see through the agency of light. Our vision of the world is constantly refreshed, perpetually and continuously, by never-ending waves of light. When the model sits down in front of us, a vision of loveliness impinges upon our senses. This vision is light, having shape and pattern, varying in intensity and in all the colors of the rainbow. It is this that we draw.

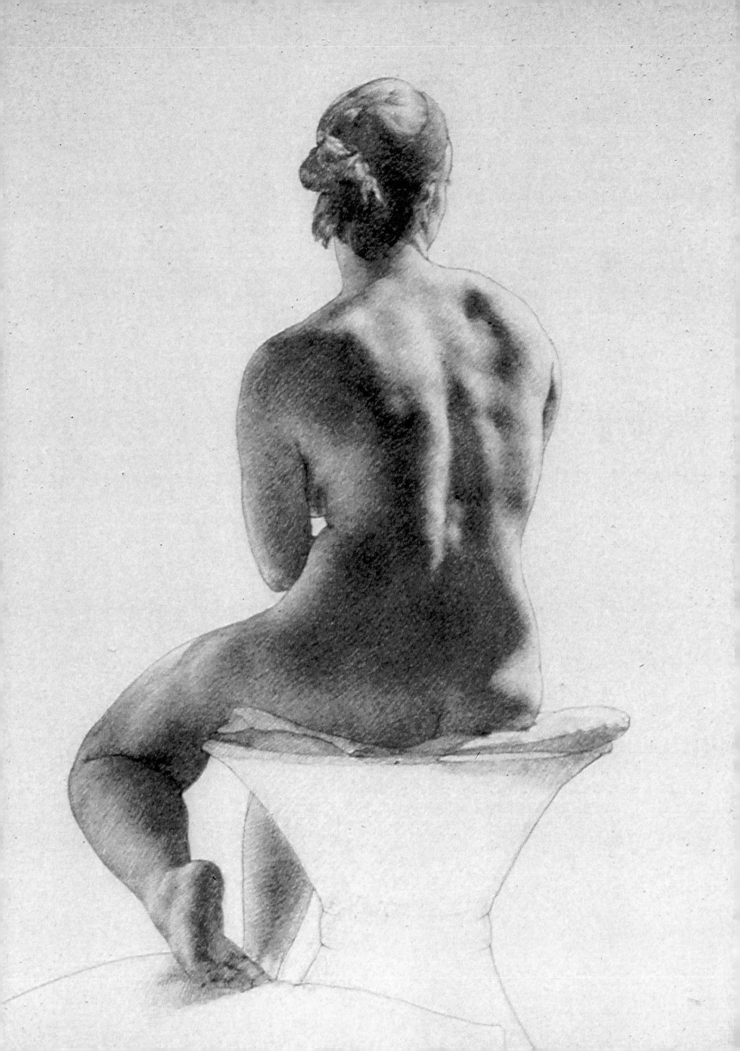

THE ELEMENTS OF THE INTERACTION OF LIGHT AND FORM

Many factors combine to create the visual impression of the model. It is a joint venture in which the light source, the model, and the observer participate. The following is a brief description of these participants and their interaction.

The Light Source

Light always comes from a source. Technically speaking, light is *emitted* by a source, radiating outwardly and uniformly in all directions. There are many kinds of light sources. The sun is a light source. So is a candle, and so is a firefly. Every light source has its own character, a quality called the *key* of the light. And just as a sensitively rendered drawing will reflect the personality of the model, it will also reflect this "personality" of the light.

The key of the light depends on certain factors, including the light source's size, strength, and distance from the model, the degree of concentration or diffusion of the light, whether the light comes through an aperture (like daylight through a window), and the size, shape, configuration, and contents of the space. These characteristics have very real effects on what we see. Even a beginner can notice the difference between a model posing indoors beneath an incandescent light bulb (a relatively small, weak light source) and the same model posing outdoors beneath a cloudy sky (a vast and powerful one).

The light source used for most of the drawings in this book was a north-facing, three- by five-foot (0.9- by 1.5-m) skylight, situated about nine feet above the model stand. I also used a 150-watt, incandescent, indoor floodlight. The floodlight, which I use at night in a darkened studio, produces a high-contrast effect with deep, distinct shadows. The light from the skylight is stronger, but less concentrated, producing a gentler, less contrasted effect with lighter, less distinct shadows.

The Model

For the purposes of this discussion, we need only concern ourselves with four aspects of the *surface* of the model: its distance from the light source, its angle relative to the light source, its local value, and how matte or glossy it is. These factors have to do with the amount of light the surface of the model receives, the amount that is subsequently reflected, and how it's reflected.

- *Distance from the light source.* Light diminishes in intensity as it travels through space. The further it travels, the weaker it becomes. If two separate parts of the model are at different distances from the light source, the one closer to the light will be more brightly lit. This can be observed in standing poses lit from above. Since the upper part of the body is closer to the light source, the light there is stronger than on the lower body, which is further away.

- *Angle relative to the light source.* The angle of the surface as it relates to the light source is another factor determining how much light it receives. In other words, the degree to which a surface faces the light source determines how much light it catches. As a rounded form turns up toward the light, it lightens. As it turns away, it darkens. This is because the amount of light reflected by a surface depends on how much light reaches it in the first place. As a form turns away, the light gets spread out more thinly, leaving less light per square inch. Where there's less light coming in, there will also be less light bouncing off and the form will appear to darken down.

- *Local value.* The local value of a surface is a function of its pigmentation. Pigments absorb light, and light that is absorbed is not reflected. The darker the local value of a surface, the more light it absorbs and the less it reflects, making it appear darker to the observer.

- *How matte or glossy it is.* The surface of the body reflects light in several ways at the same time. Two of the principal modes of reflection are known as *form-light* and *highlight.* Form-light is typical of matte surfaces. It results in a diffuse, random, even reflection of the light. Highlight, on the other hand, is typical of glossy, wet, or polished surfaces. It results in an intense, directional reflection of the light. These two modes of reflection contribute in different ways to our perception of the form of the body. Human skin, which is a semi-matte surface, reflects light in both modes simultaneously, although the majority of the reflection is in the form-light mode.

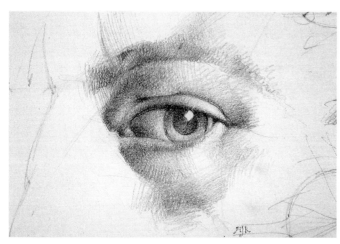

Sketch of an Eye, 1998
Pencil on paper, 11 x 14" (28 x 36 cm)

The cornea of the eye is glossy, so it reflects a highlight that is crisp, bright, and sparkly. The form around the eye is semi-glossy. It reflects light that is more diffused and even, giving a more direct reading of the sculptural surface of the form.

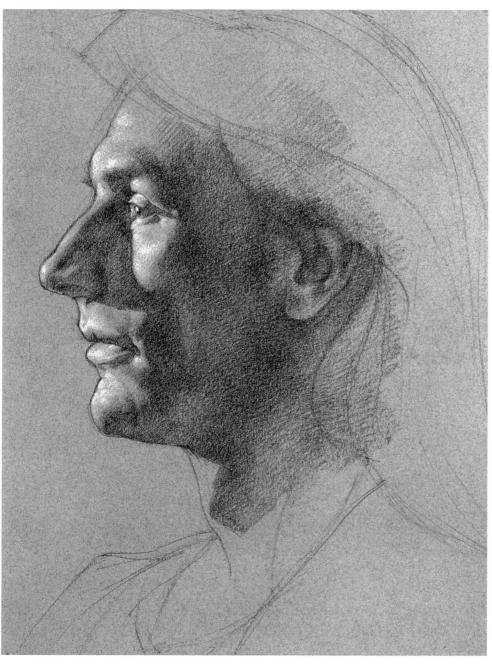

Goyko, 1996
Pencil and pastel on gray paper,
25 x 19" (64 x 48 cm)

An indoor 150-watt floodlight was used to illuminate this model while other light sources were muted. Though there was some reflected light, it was very weak in comparison to that of the floodlight, which was stark and intense. You can see the intensity of the light by way of its contrast with the shadows, which are deep and have strong, definite edges.

Draped Figure, 1998
Pencil on paper, 24 x 18" (61 x 46 cm)

Daylight coming through a translucent skylight illuminated this subject with a soft, diffused light. The shadows are relatively washed out due to an abundance of reflected light coming from the studio's light-colored walls, floor, and furnishings.

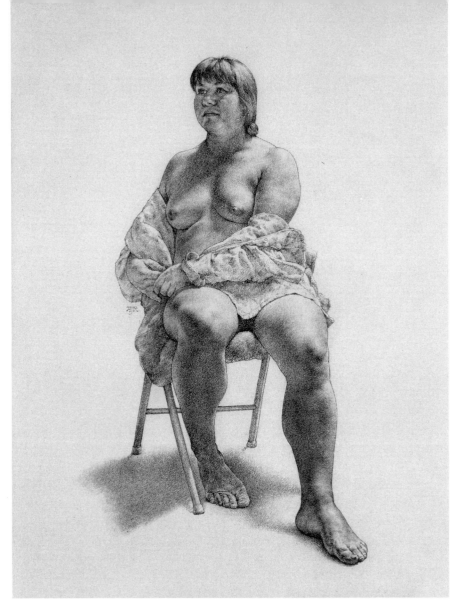

Detail of *A Quiet Afternoon,* 1998
(For full image, see pages 42–43.)

Though the form of the body is complex, its appearance is unified by the action of the light, which acts upon all the individual forms consistently. In this detail, the light from above darkens down on the forms of the shoulders and arms as they turn away from the light. All the forms on the body lighten up, not randomly, but as they turn up toward the one light source. It's as if they were all pointing in the same direction, like a crowd of people all staring and pointing at something in the sky. This unanimity among the many forms of the body contributes to the coherent nature of the illusion of reality in the drawing.

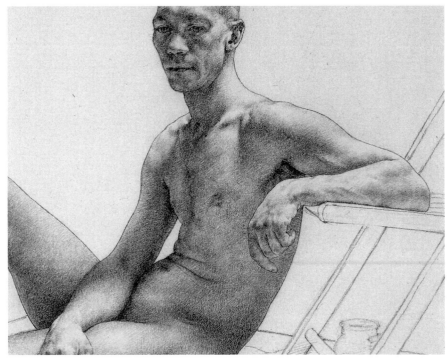

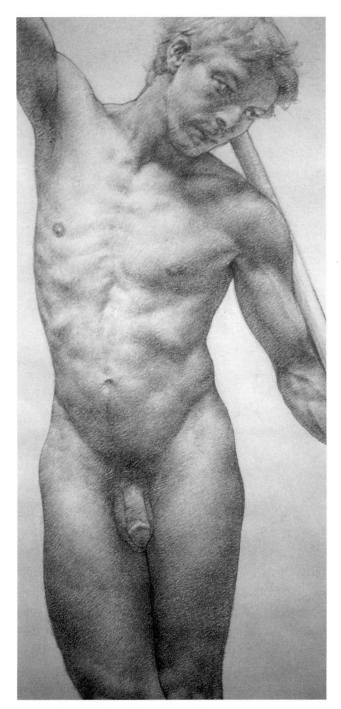

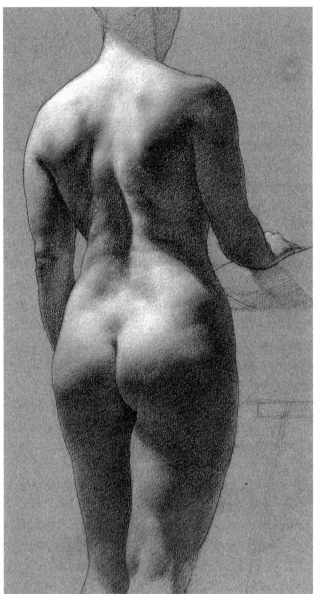

Detail of *Light Study,* 1997
(For full image, see page 126.)

In this drawing, note that the light on the model's upper back is stronger than that on her lower back, which is in turn stronger than that on her leg. Of the three surfaces, the model's leg is the furthest from the light source; it is also the least light-facing. Her lower back is closer to the source of the light and is angled up somewhat more directly, but it is still further from the light source and less directly angled than her upper back, which is the closest and most light-facing of the three.

Detail of *Man with a Pole,* 1998
(For full image, see page 119.)

When the primary source of light is overhead, the effect of the light's diminishing intensity is more evident in a standing pose than in a reclining pose. Notice that the light darkens as it proceeds from the chest down to the legs.

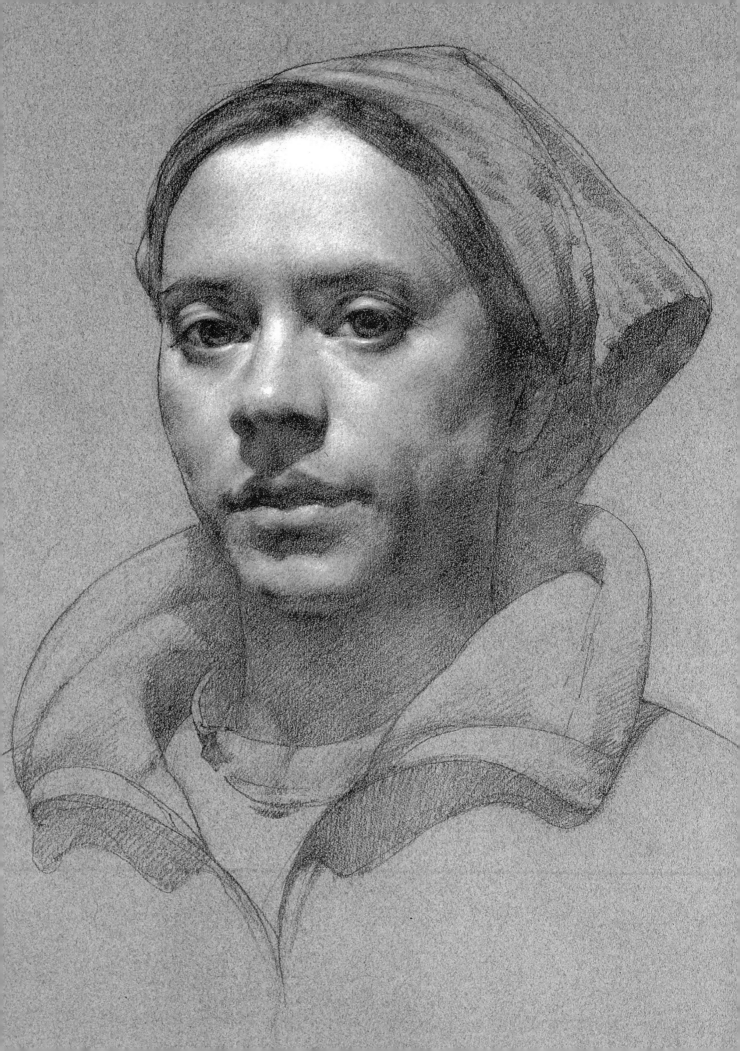

The Observer

The third participant is the observer. He or she experiences the interaction from a single point of view, and from this perspective the relationship of the model and the light source has a specific description. Of particular significance is the observer's viewing angle. The viewing angle affects the apparent allocation of light on the surface of the model—its amount, location, and distribution. There are three aspects of this allocation of light that we will discuss here: the phase of the light, the direction of the light, and the cut of the light.

The phase of the light. The phase of the light on the model is like the phase of the light on the moon. The phases of the moon (full, half, crescent, and so on) are effects of the changing positional relationships of the sun, moon, and earth. Depending on our angle of view, we see more or less of the lit side of the moon. Likewise, depending on our angle of view, we see more or less of the lit side of the model. *Frontal light,* in which the light-facing surface of the model faces the observer directly, corresponds to the full moon. *Three-quarter light,* in which the model is mostly frontally lit, but with some shadow peeking in from the side, corresponds to the gibbous moon (less than full but greater than half). I don't know if there is a name for the light effect analogous to the half moon, but for the sake of consistency I'll call it *half light.* This would be when the light comes in toward the model at a ninety-degree angle, with roughly half the figure in shadow. Finally, *rim light* corresponds to the crescent moon, in which the light source is almost behind the model and only a narrow band of light is visible.

Anna, 1995
Pencil on paper, 17 x 14" (43 x 36 cm)

Rim Light. The primary light shining from the upper left blasts the far side of the face; reflected light, bouncing up from the lower right, gently fills in the near side.

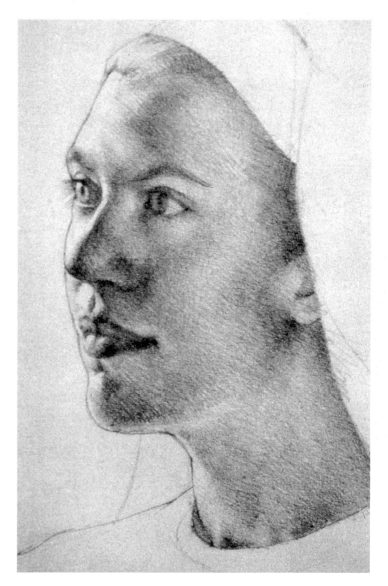

LEFT: *Celeste,* 1997
Pencil and pastel on gray paper, 25 x 19" (64 x 48 cm)

The whole head is a rounded form. In an overhead light, the concentration of the light diminishes from the forehead to the cheekbones, to the mouth, and finally to the chin. The light shines brightly on the more directly light-facing surfaces of the upper part of the face, and diminishes in intensity on the less light-facing surfaces.

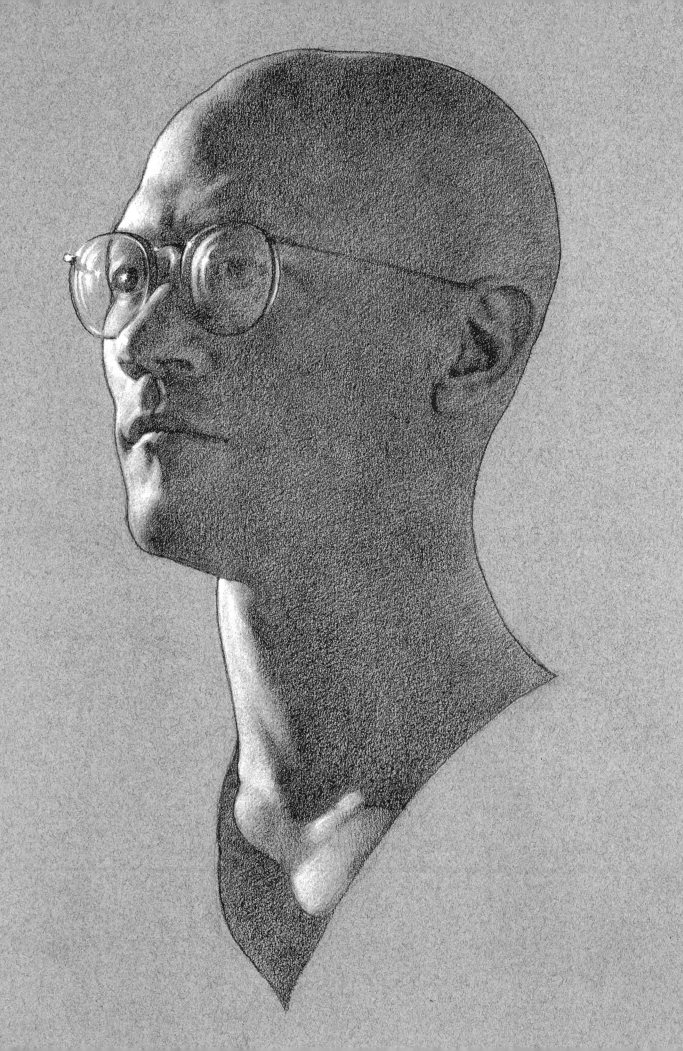

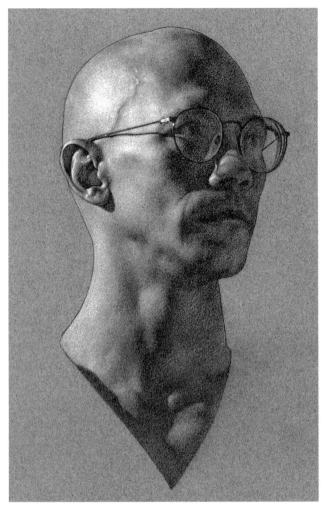

Phases of Dane: Half, 1998
Pencil and pastel on gray paper, 25 x 19" (64 x 48 cm)
(Larger reproduction shown on page 78.)

Half Light. This view is roughly fifty percent light and fifty percent shadow, with the edge of the shadow facing us. It is as if we were flying in a plane over a mountain range that divided the two realms of night and day.

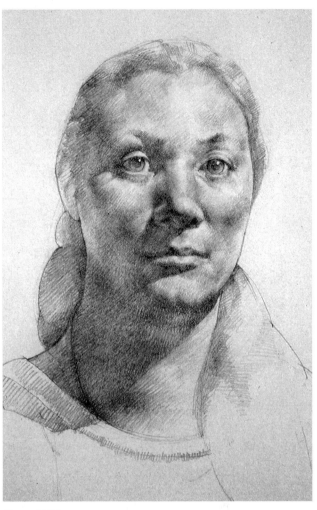

Prem, 1995
Pencil on paper, 24 x 18" (61 x 46 cm)

Three-Quarter Light. Here there's a little more light than in a half-lit view. One sees a lot of portraits with this proportion of light and shadow. The majority of the face is illuminated, but there's enough shadow to convey a feeling of the mass and solidity of the head.

OVERLEAF: *Phases of Dane: Full,* 1998
Pencil and pastel on gray paper, 25 x 19" (64 x 48 cm)

Frontal light. Frontal light is projected onto the model from a source located near the artist, giving the model a lot of light and very little shadow. It is characterized by a foreshortening of the dark-light and shadow shapes, and broad expanses of the lightest light and highlight (to be discussed on page 100). A darkening down toward the edges can be seen if the background is relatively light, as in this drawing, since it contrasts with the dark edges of the model. If, however, the background is relatively dark, the darker edges may merge with the background and seem to disappear altogether. It is sometimes difficult to distinguish between the dark-light and shadow in a frontally lit pose, since they occupy such narrow shapes along the far edges of the form.

LEFT: *Phases of Dane: Crescent,* 1998
Pencil and pastel on gray paper, 25 x 19" (64 x 48 cm)

Rim Light. In the rim-lit condition, the brilliant glare of the light is compressed into a narrow region along the contour. The large, dark mass of the shadow contrasts strongly with the light. The terminator (to be discussed on page 98) separates the bright, primary light from the dim reflected light, which spreads in back of it into the quiet expanse of the shadow.

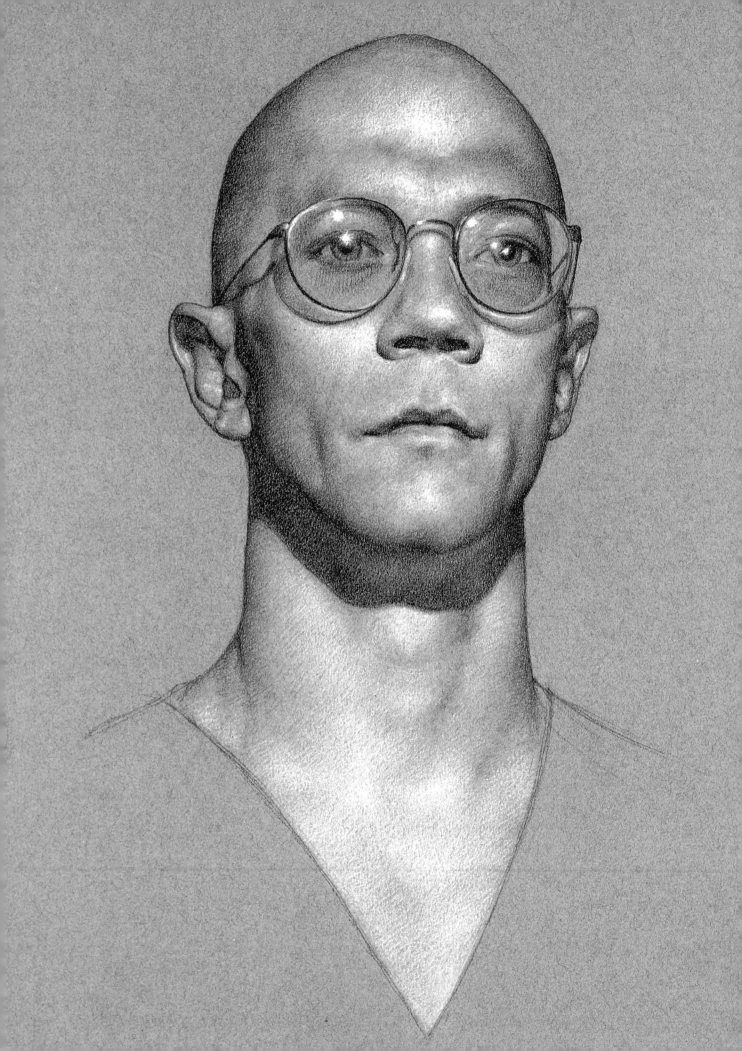

The direction of the light. The light direction is the perceived angle at which the light strikes the surface of the body. It determines, from the point of view of the observer, which surfaces (those facing right or left, up or down, away from or toward the observer) will receive the most light. It also determines the direction of all the tonal progressions. This is an important key to the shading process. As the form of the body rolls away from the light source, it darkens. As it rolls up toward the light source, it lightens. Every progression is oriented with regard to the light source.

The cut of the light. All of the forms of the body are rounded. When light strikes a rounded form, it washes across the most light-facing part, and diminishes as the form turns away. This effect is repeated on all the forms of the body that receive light, large and small, creating a unified pattern of values that is called the *cut* of the light. The cut of the light is the angular orientation of the wash of light across a form. It depends on both the direction of the light and the degree of roundness of the form. On a perfectly round form, the cut of the light is perpendicular to the light direction. For example, if the light comes from the upper right, the upper-right side of each rounded form will receive the most light, while the lower-left sides will darken, and eventually drop into shadow.

TIP

Please note that there is a difference between *round* as in spherical, and *rounded,* which means being spherical to some degree. To the degree that a given form is "round," the cut of the light will be perpendicular to the light direction. The forms of the human body are rounded, but certainly not round. This means that the light will cut across such forms obliquely, but *not* at a perfect right angle to the light direction.

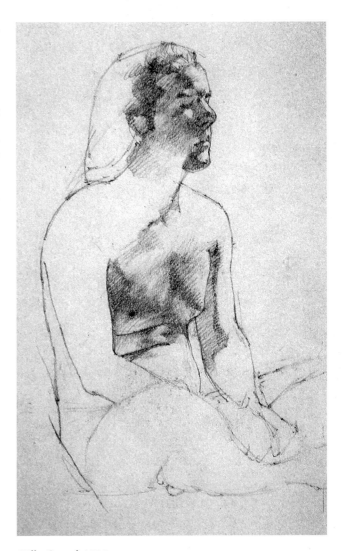

Billy, Seated, 1993
Pencil on paper, 17 x 14" (43 x 36 cm)

The light cuts across rounded forms at an angle perpendicular to the direction of the incoming light beam. In this drawing, the cut of the light can be seen in the angulation of the edges of the shadows across the model's chest muscles, chin, cheek, and forehead.

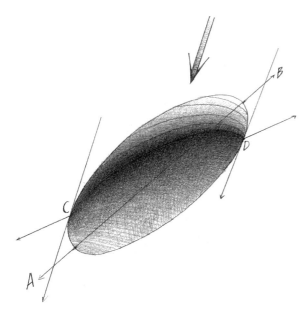

In this diagram the light direction is indicated by the large arrow in the upper right, and by the two arrows parallel to it, tangent to the form at points C and D. This egg shape is more or less symmetrical around axis A–B. Light cuts across the form obliquely, not running at all parallel to the axis of the form.

Drawing Demo, 1995
Pencil on paper, 17 x 14" (43 x 36 cm)

This was a very rough, quick, form and light drawing demonstration. The light cuts from upper right to lower left on a diagonal, with the tops of the forms in the upper left toward the light source. The light cuts across the form of the biceps obliquely, but (as the biceps are not perfectly "round") not at a perfect right angle to the light direction.

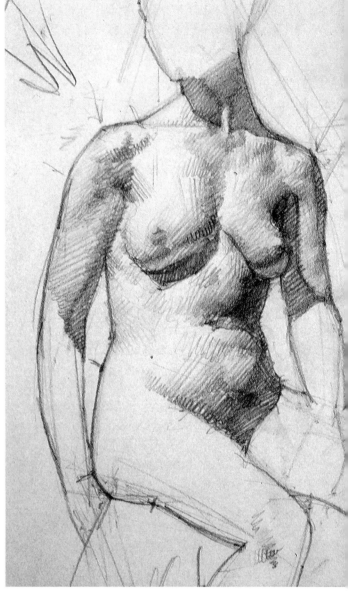

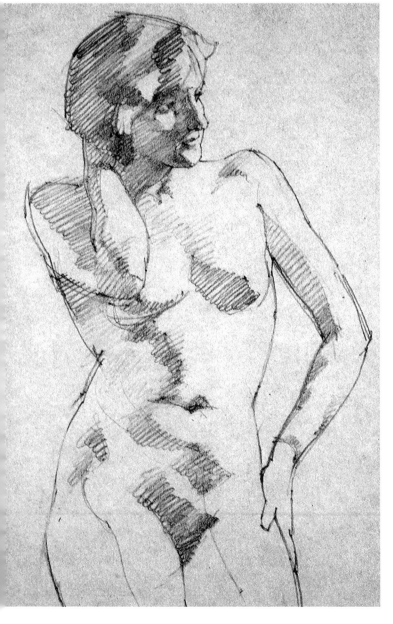

Gesture Study, 1995
Pencil on paper, 17 x 14" (43 x 36 cm)

Once you get a sense of what the light is doing and the pattern of the cut of the light across the form, you can work with it in an abbreviated manner in your quick sketches. In this study, the light was coming from the upper right and the cut of the light across the form was from upper left to lower right.

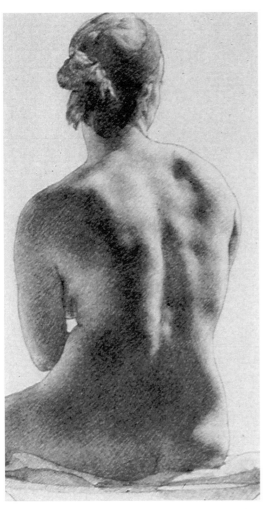

Detail of *Ramona,* 1995
(For full image, see page 83.)

Here, the cut of the light on the model's back runs from her left shoulder to her right hip. The light, coming from the upper right, washes across her right shoulder and back in patterns that echo the cut of the light.

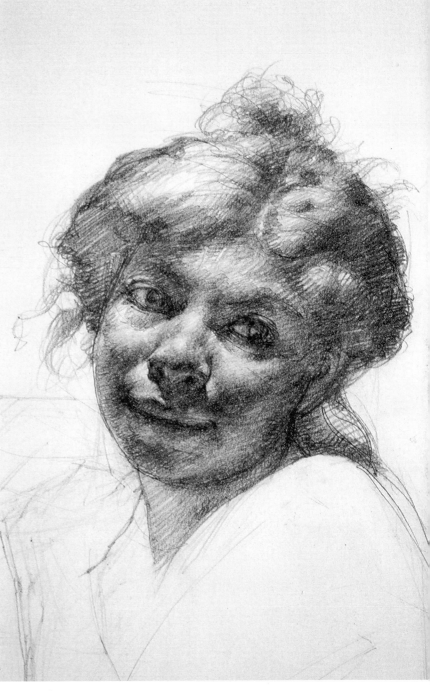

Portrait of Patricia, 1997
Pencil on paper, 24 x 18" (61 x 46 cm)

The light direction in this illustration is downward and slightly toward the right. The cut of the light is perpendicular to the light direction, a nearly horizontal line, pitched down slightly on the left side. All the patterns of light and shadow in the face and hair wash across the form according to the cut of the light.

Figure Reclining on a Wicker Couch, 1996
Pencil on paper, 18 x 24" (46 x 61 cm)

In this drawing, the light shines
from above and the cut of the
light on the figure is more or less
horizontal. Light washes across
the tops of each form in the
direction of the cut of the light,
unifying the form as a whole.

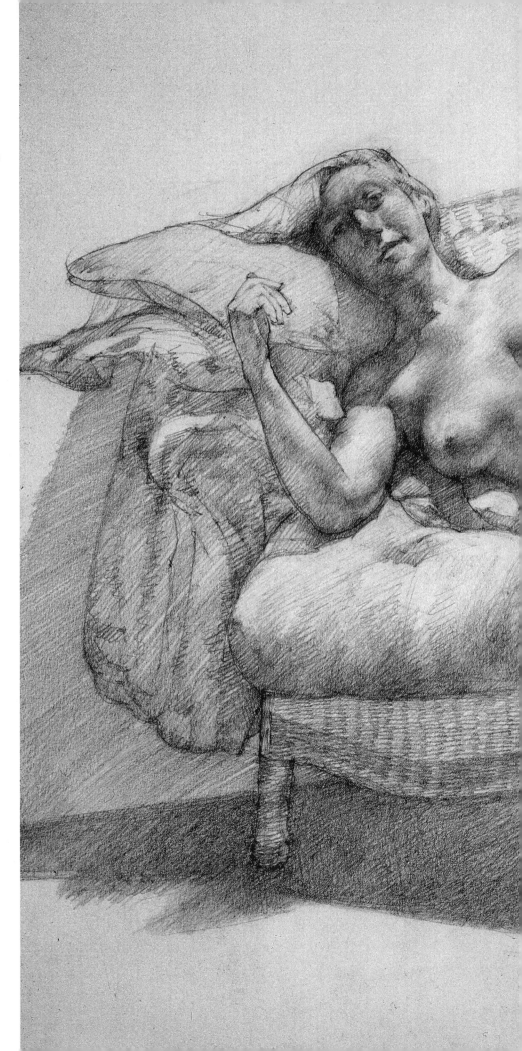

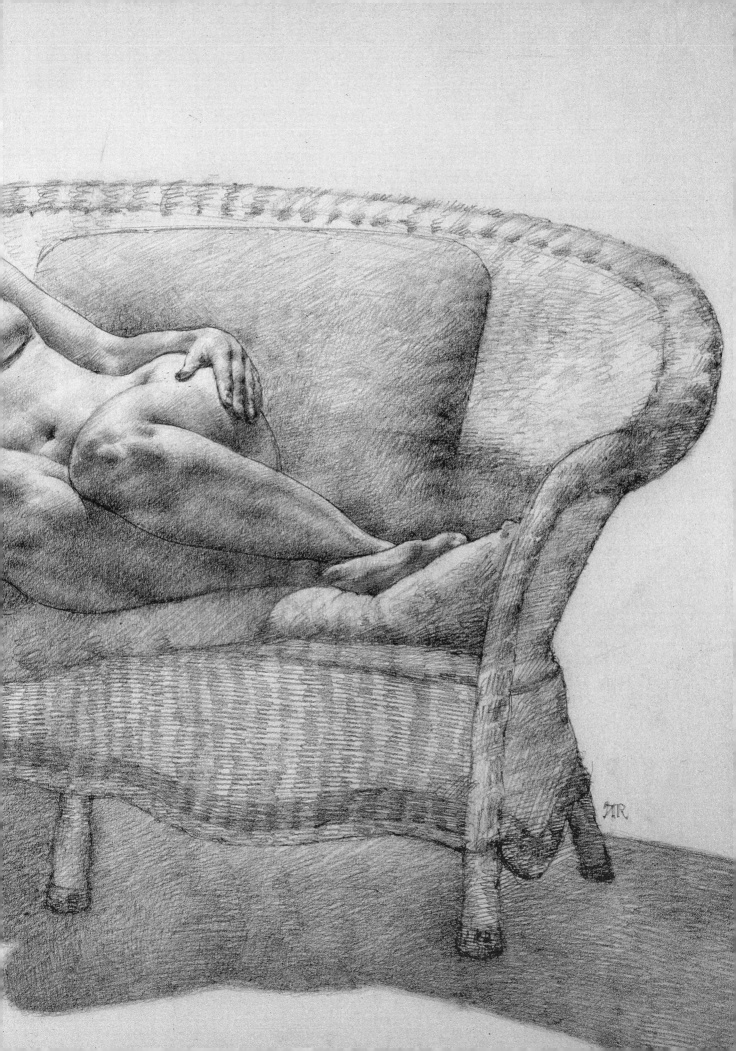

LIGHT AND SHADOW ON THE MODEL

In the classical tradition of figure drawing, a single light source is almost always used to illuminate the model. This use of a single light source results in distinctly separate realms of light and shadow. Each of the two realms is an independent value structure, each with its own light source. This may sound like I'm contradicting what I just said about a single light source, but I'm not. The light side is ruled by the aforementioned single light source, called the *primary* light. The shadow side is ruled by a much weaker light source, called the *secondary,* or *reflected,* light, which is a reflection of the primary light into the shadow side. The two realms of light and shadow are distinctly separate. They meet at a complex set of borders, the *edges of the shadows.*

THE EDGES OF THE SHADOWS

In order to talk about the edges of the shadows, it is first necessary to give some explanation of the nature of shadows in general. Shadow is a relative absence of light. A surface is in shadow when it is deprived of direct light from the primary light source. There are two different ways that this can happen. Consequently, there are two different sorts of shadow, known as *form shadow* and *cast shadow.* Each type of shadow produces a different type of shadow edge.

Form shadow edge (a.k.a. the terminator)

As a form turns away from the light, it gradually darkens. Sometimes a form turns away so much that it turns out of the light altogether and drops into shadow. Shadows that arise in such a way are called *form shadows.* Form shadows always occur on the side of the form that faces *away* from the primary light source.

The point where the light ends and the form shadow begins is called the *form shadow edge.* Along the form shadow edge, the rays of light shooting out from the light source are tangent to the rounded surface of the form. Instead of striking the surface, as they do wherever the form is lit directly by the primary light source, the light rays shoot past, just missing it. This edge is also called the *terminator,* since it marks the line where the light ends and the shadow begins.

Cast shadow edge

When a form interrupts some portion of the light radiating from a source, it blocks out the light and projects a "light void" in the space behind it, in which the light source is eclipsed. This light void extends away from the light source, from the terminator of the form that's blocking out the light. When it is projected onto another form we see a *cast shadow.* Cast shadows always fall upon parts of the form that face up *toward* the light source.

When a cast shadow falls onto a form with a curved surface, it wraps around the form like a rug thrown on top of a car. The border of the shadow, called the *cast shadow edge,* acts like the lines in a topographical map, helping us discern the shape of the form underneath.

Cast shadow edges range from very hard and crisp to soft and diffuse, depending on the light source and forms involved. If the light source is small and intense, like a light bulb or candle flame, the cast shadow edge will be hard and definite. But if the light source is broad and diffuse, such as a large skylight or bank of windows, the edge will be soft. Also, the further the casting object is from the surface receiving the shadow, the more diffuse the edge will be.

When a cast shadow edge is soft, it is called a *penumbra.* The penumbra is still partially in the light, while the *umbra,* the core of the cast shadow, is cut off from any direct light from the primary light source. For the sake of clarity, we consider the actual cast shadow edge to be those points along the edge of the umbra that separate it from the penumbra.

If you look at the detail of *All-Star,* opposite, you will see that the most distinct cast shadow edges are those associated with the model's hands and fingers. These shadows have a very short distance to travel, so they have clean, definite edges. The edge of the shadow cast by the model's brow onto her cheek and nose has further to go, and is a little less hard. The cast shadow of her breast is still more diffuse, and that of her arm is the most fluffy and insubstantial, especially the further it gets from her armpit.

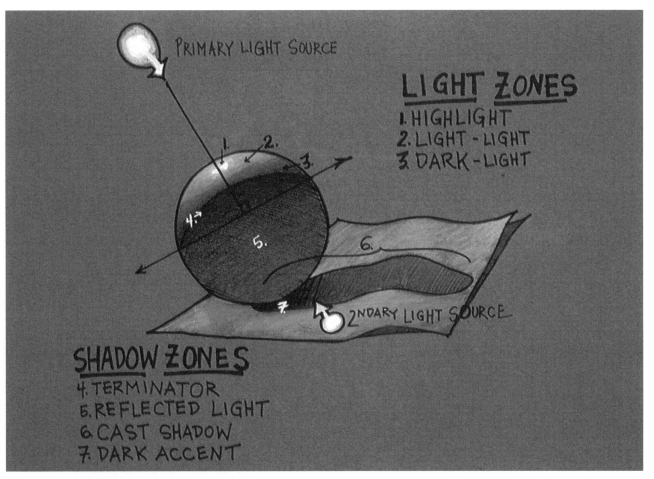

PRIMARY LIGHT SOURCE

LIGHT ZONES
1. HIGHLIGHT
2. LIGHT - LIGHT
3. DARK - LIGHT

2NDARY LIGHT SOURCE

SHADOW ZONES
4. TERMINATOR
5. REFLECTED LIGHT
6. CAST SHADOW
7. DARK ACCENT

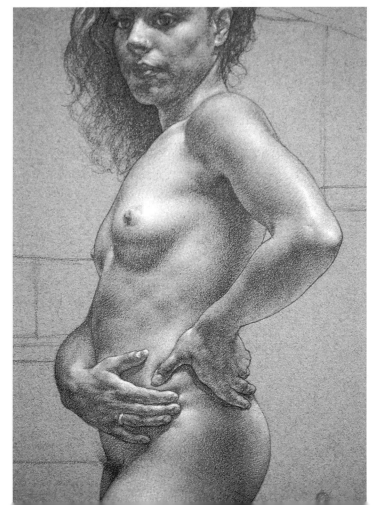

This diagram can serve as a toolbox for your work with light and shadow. It represents in a clear way things that are often not so clear.

Detail of *All-Star,* 1998
(For full image, see page 102.)

Each form of the body has its own topography, its own particular shape in space. We read each shape by the way light interacts with it. In this detail, cast shadows help define many rounded forms. For instance, a shadow cast by the model's brow falls on her nose, and on her cheek below the eye. This cast shadow's edge rides up over her cheekbone, down into the valley below her eye, then up the side and over the bridge of her nose. The edges of the shadows cast by the model's arm and breast describe the rounded mass of the rib cage. The shadows of her fingers and thumbs are appliqued onto the form of her hip, almost like pieces of tape.

PROGRESSIONS OF VALUE

In this approach to drawing there's no such thing as "halftone," an indeterminate mixture of light and shadow. Every point on the surface of the body is either in the light or in the shadow. That's all. There isn't any mushy twilight zone. The dividing line is the shadow edge—either a form shadow edge or a cast shadow edge—which divides the inside drawing into the two complementary realms, each with its own set of tonal progressions. On the light side, these progressions begin at the terminator and culminate in the highlights. On the shadow side, the progressions also begin at the terminator but then run in the other direction, culminating in the reflected light. In both cases the terminator is the dark beginning of the progression. The form turns up in both directions from the terminator: on the light side, it turns toward the primary light; in the shadow, it turns toward the reflected light.

About the light side

The light side of a form starts at the terminator, or form shadow edge, and grows progressively lighter as it rolls up toward the primary light. There are two main kinds, or modes, of light that combine to make up the light side: form-light and highlight.

Form-light is typical of matte surfaces. It results in a diffuse, random, even reflection of the light. When drawing the human body, which is a semi-matte surface, most of the light you see is form-light. The motto of form-light is: "As form turns toward the light, it gets lighter; as it turns away from the light, it darkens." In the form-light mode, the light reflected from a surface is scattered in all directions uniformly. This means that in the studio, for a given point on the surface of the model, the intensity of the form-light is constant no matter what the observer's viewing angle. In this regard it differs from the effect of the highlight, to be discussed below.

Glossy surfaces, like the wet surface of the eye, reflect incoming light as *highlights*. Highlights are stronger, more focused, and brighter than form-light. Some highlights are small and intense, easily distinguished from the form-light surrounding them. They sit on top of the form-light like chrome trim on a rounded automobile fender. Other highlights are spread out in sheets of glare that merge with the local form-light to such a degree that they become difficult to distinguish. On semi-matte surfaces like skin, highlights are always embedded in the form-light.

In highlight mode, light is reflected directionally. It bounces off the surface of the form in a single direction,

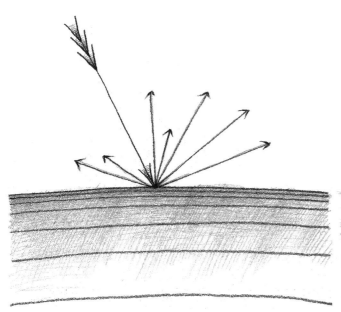

On matte surfaces, incoming light is scattered randomly, like a handful of tiny rubber balls thrown against a pebbly wall. This type of light is called *form-light.*

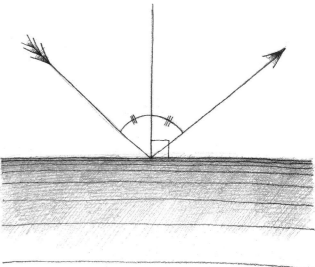

On glossy surfaces, the angles of the incoming light and reflected light are equal and opposite. This type of light is called *highlight.*

rather than in all directions like form-light. Its angle of reflection (the angle at which it bounces off a surface) is equal to and opposite its angle of incidence (the angle at which it strikes the surface). It's like the action of a ball that's being bounced off the floor toward a target across the room. The ball rebounds off the floor at an angle equal to that at which it struck the floor, but in an opposite direction (up instead of down). In order for an observer to perceive a highlight, he or she has to be in the spot toward which the light is bouncing. This means that in the studio, for a given point on the model, the intensity and placement of the highlight effect varies depending on the viewing angle. One observer may see a highlight in a certain location on the surface of the model, while another observer with a different vantage point sees one in an entirely different spot.

Sometimes it's said that highlights follow you around, meaning that as you move around the studio, the highlights shift across the surface of the form. You can look for this effect the next time you go to the ocean. As you walk along the water's edge, notice that the reflection of the sun on the water always points directly at you, no matter where you go on the beach. This differs from the form-light, which is constant for any point on the form, regardless of the position of the observer.

Highlight and form-light combine to create the general effect of the light. The transition between form-light and highlight is a question of gradually increasing and decreasing the concentration of highlight effect on top of the underlying form-light. The highlight is an additional nebulosity of light applied over the form-light progression, sometimes appearing as a galaxy of stars loosely gathered together around a concentrated, gravitational center.

Progressions on the light side span the tonal distance between the top of the form, which faces the primary light source, and which is where the *light-lights* and highlights gather, and the *dark-light* adjacent to the terminator, where the form drops into shadow. Dark-light and light-light are relative terms used to describe differences in the intensity of the form-light. They're used to describe what happens as the form rolls toward the light source (into the light-light) and down, away from the light source (into the dark-light). The orientation of the surface to the light at any given point determines the concentration of light at that point. The more concentrated the light, the lighter the form. The less concentrated the light, the darker the form.

About the shadow side

Just as form-light is composed of the light-light and the dark-light, form shadow is composed of the terminator and the reflected light.

The *reflected light* is actually light from the primary source that is received by a multitude of surfaces and reflected onto the underside of the form. While the primary light illuminates the top of the form, the reflected light illuminates the underside.

The *terminator* is sandwiched between the primary and reflected lights. The term *terminator* is used to refer to both the border between the light and shadow (the form shadow edge), and the broader band of shadow immediately adjacent to this border, which turns toward the reflected light in a seamless progression of tone. This part of the form receives little reflected light, and is therefore one of the darker parts of the shadow, depending on just how much reflected light it receives. Occasionally, the terminator is entirely washed out by reflected light, in which case the transition between the light and shadow sides is subtler than usual.

The terminator varies in width, depending on how quickly the form turns. If the form turns slowly into the reflected light (meaning that its surface is relatively flat), the band will be broader; if the form turns quickly

TIP

As a form turns away from the lightest lights, it darkens gradually. Since this value change is continuous, it can be easy to overlook. In order to see the extent of the value change in the light, it may help to scan quickly between the highlights and the dark-light immediately adjacent to the shadow. This kind of scanning will enable you to better perceive the amount of difference in the light. The same principle holds true for values in the shadow.

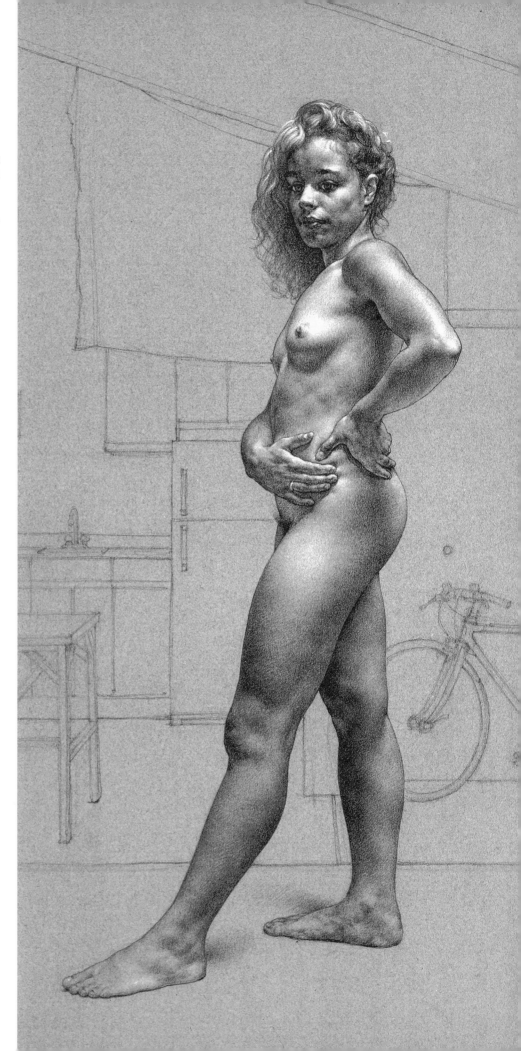

All-Star, 1998
Pencil and pastel on gray paper,
25 x 19" (64 x 48 cm)

The effect of the highlight is an
integral part of the effect of the
light as a whole. The highlights on
this model's face, upper chest, and
upper arm are the culmination of
the long, slow trek of light
progression that begins in her feet.

(meaning that its surface is well rounded), the band will be narrower. The terminator on a shoulder, for instance, may be much broader than one on a knuckle.

Obviously, the shadow side is darker than the light side, as the reflected light is much weaker than the primary light. Consequently, the progressions on the shadow side span a much shorter tonal range. But apart from this narrower range, and the fact that the tones are in a darker key, progressions in the shadow side act just like those in the light. They begin at the terminator and then gradually lighten up as the form turns, culminating in the reflected light.

Sometimes there are creases or other deep indentations in the shadow side that form small shapes of concentrated shadow. These shapes are darker than the other parts of the shadow, and are called *dark accents*. Dark accents are openings into small, particularly light-deprived spaces, like an open closet door in an already dark room. They are located at the bottom of the value scale and anchor the tonal structure of the drawing.

T I P

Shadow is a relative absence of light, and therefore a relative absence of definition. Form in the shadow is soft and quiet, like a whisper. Be careful to avoid grinding in details in the shadows. The use of hard edges and highly contrasted effects can disturb the quiet, nocturnal nature of the shadow.

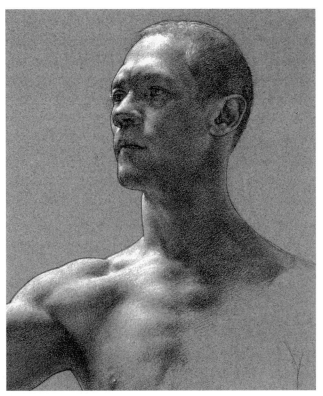

Detail of *Catch*, 1998
(For full image, see pages 104–105.)

As a rounded form turns up, more and more light accumulates like snow on its upturned surfaces. As it turns away, it accumulates less light, until it turns out of the light altogether and drops into the shadow.

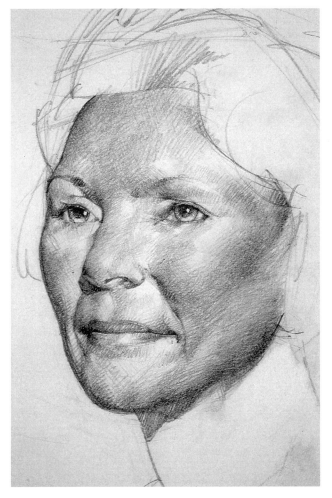

Lorraine, 1997
Pencil on paper, 17 x 14" (43 x 36 cm)

As you can see in this drawing, even in the very light plateaus there are modulations in the form and value changes in the light. All the light-facing surfaces of the forehead, nose, cheeks, and mouth area are modeled. No part of the form is flat, so it follows that everywhere you look you should find variation in the light.

Catch, 1998
Pencil and pastel on gray paper, 19 x 25"
(48 x 64 cm)

Dark-light is only dark as it
relates to the light-light; it is
light in relation to the shadow.
In this image, dark-light can be
seen on the ball, sandwiched
between the light-light and the
terminator, and in all those
places on the figure between the
light-light and the terminator.

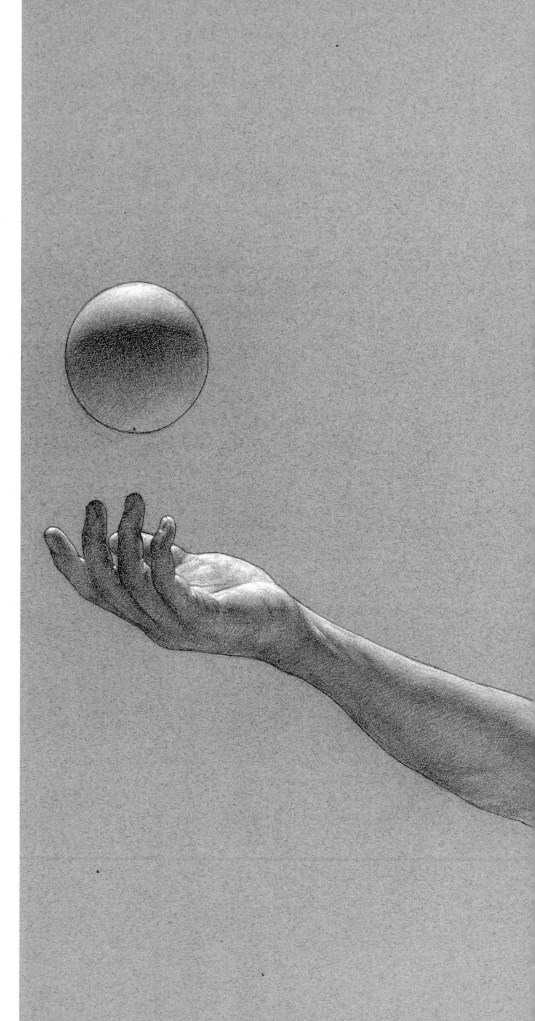

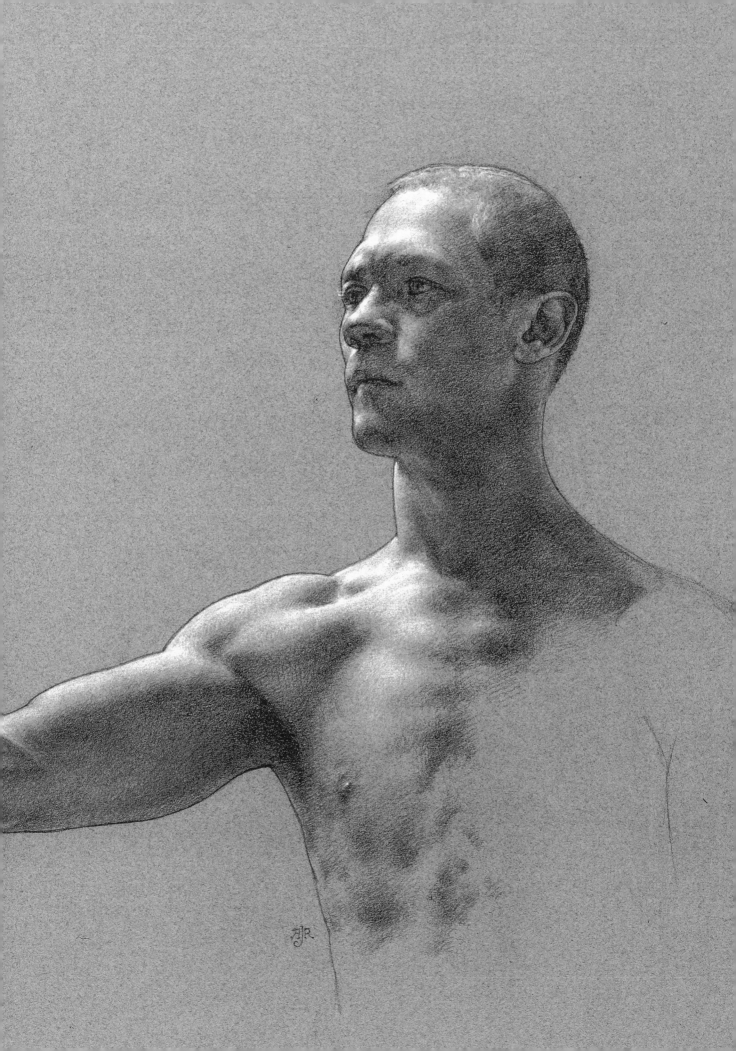

The entire world of light and form is created out of the elements just described: highlight, form-light (light-light and dark-light), form shadow (terminator and reflected light), cast shadow, and dark accent. These are the principle permutations or states of the light. An understanding of these states helps us to produce order and an illusion of a coherent reality in our drawings.

As artists we develop an objective relationship to light. We examine it and record it in our drawings. You should now understand that what you see—your *optical field*—is not composed of the actual *things* you see, but of the light by which you see them. It is a patterned light field, like the picture on a television screen: a light picture. If I go up to my television and look at the picture on the screen I see lots of little bits of light. The news-caster is made of little bits of light, as are his desk and his glass of water. Everything I see on television is light. In fact, everything I see, period, is little bits of light.

Because of this, our perception of the objects in our optical field is really not as razor-sharp as we might think. Everything is slightly out of focus. Though objects might seem to have definite borders, all visual edges are in fact somewhat gradual and transitional. In other words, they are tonal progressions. You can see an example of this by looking at a newspaper photograph, in which apparently solid objects are composed of many tiny pixels—little bits of black and white. Seen from a distance, the pixels combine to make hard edges, but upon closer examination you can see a haze along each edge's perimeter, as if the object had an atmosphere. The boundaries of the object fray into the adjacent field (other objects and the background), while the adjacent field in turn permeates the object along its edge. This interpenetration of object and field creates a unified, seamless effect in the optical field. It's this seamless progression that we aim to re-create when drawing on the inside.

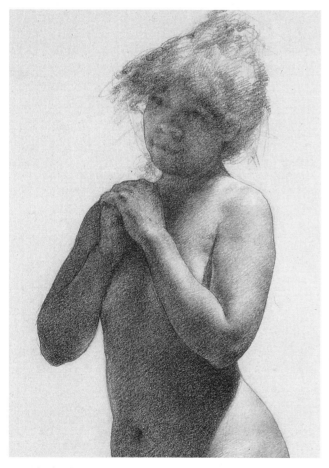

Detail of *Obverse,* 1997
(For full image, see page 26.)

Since forms in the shadow are rounded, reflected light also gradates, although within a very narrow value range. In this detail, the reflected light shows us some detail in the model's face. Her right cheek turns toward the reflected light and lightens up, whereas the left side of her face turns away and darkens down.

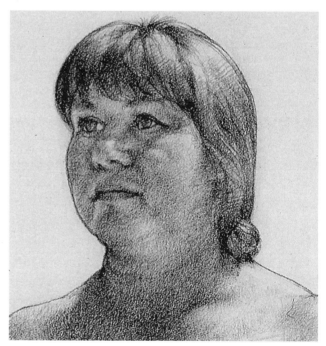

Detail of *Draped Figure,* 1998
(For full image, see page 86.)

Dark accents were used here—in the line of the lips, the nostrils, the eyelashes, irises, and pupils—to structure the low contrast tonal field. The shadows in this portrait are relatively light due to an abundance of reflected light. Without dark accents the portrait would hardly read at all.

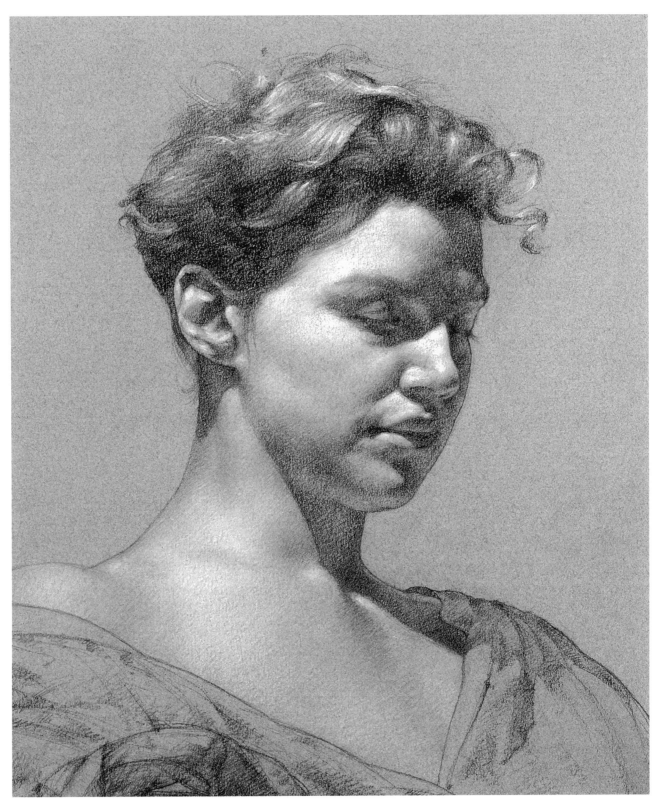

Portrait of Emily, 1996
Pencil and pastel on gray paper, 25 x 19" (64 x 48 cm)

Reflected light bounces off lit surfaces and lights up forms in the shadow. In this drawing, the undersides of the chin, jaw, lips, nose, and eyes are the surfaces most turned away from the primary light source and toward the sources of reflected light. Terminators and cast-shadow edges prevent the effects of the primary and secondary light sources from mixing.

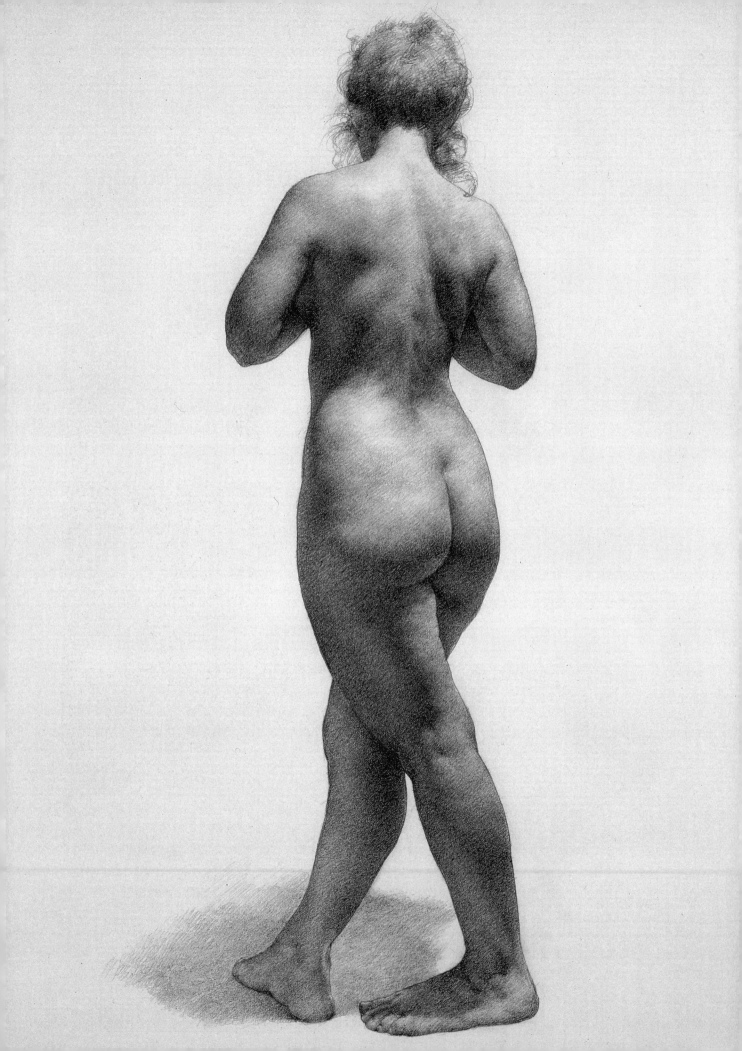

UNDERSTANDING FORM ON THE INSIDE

NO PART OF THE BODY IS FLAT, nor does its curvature remain constant from one point to the next. (That would be another, more insidious kind of flatness.) Instead, it is characterized by converging, irregularly turning, twisting forms that have changing degrees of curvature. In other words, it is very complex. That's one of the things that makes drawing the figure so interesting. And it's why we lay out the groundwork (the block-in, gesture, and contour) so patiently and methodically. Without a well-organized linear foundation, it's very difficult to construct the form on the inside.

The representation of form on the inside is guided by the same principles that guide the representation of form in the contour: fullness, continuity and discreteness, and organization. But while these principles are expressed through line in the contour, here they must be expressed with tone. On the inside, as in the contour, forms are rounded; they "turn." Every form turns. One end of the form "turns up" toward the light and the other "turns down," away from the light. Thus, every form acquires a degree of value change and a definite tonal progression. This is true of all forms on the body, both great (the model's back) and small (the seventh cervical vertebra). Inside drawing is the process of giving each of these forms the specific progression proper to its place in the figure as a whole.

LEFT: *Reverse,* 1997
Pencil on paper, 24 x 18" (61 x 46 cm)

Class Demo: *Right Ear,* 1997
Pencil on paper, 24 x 18" (61 x 46 cm)

Curving, wrapping, wedging, and tapering: such is the action of form on the inside. It doesn't have to be moving to be energetic. Nothing in the body is static, even if the model is holding perfectly still. Notice how the forms of this ear twist and funnel into one another. Everything tapers and turns. Notice the interlocking convergence of forms as the earlobe modulates into the rim. This is not just some kind of mushy transition; it is a very specific structural connection.

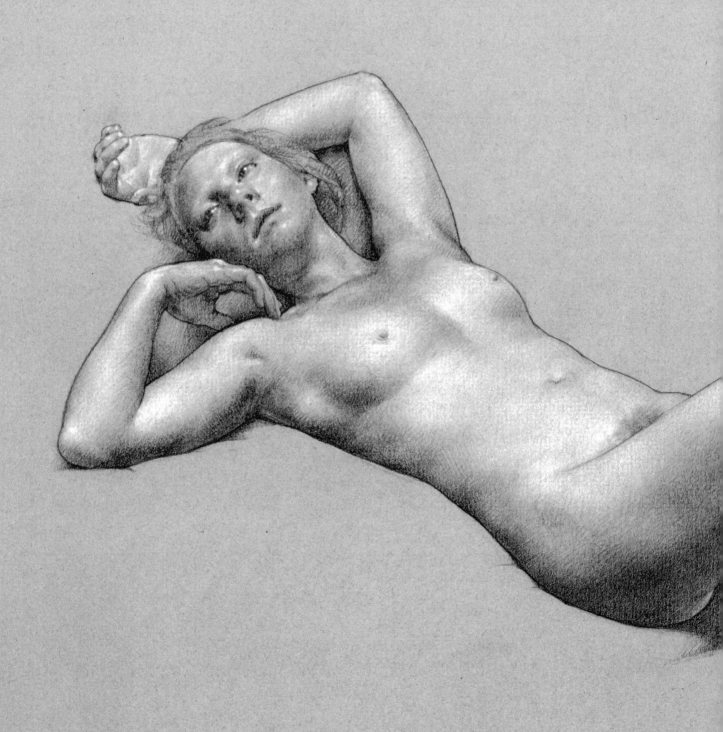

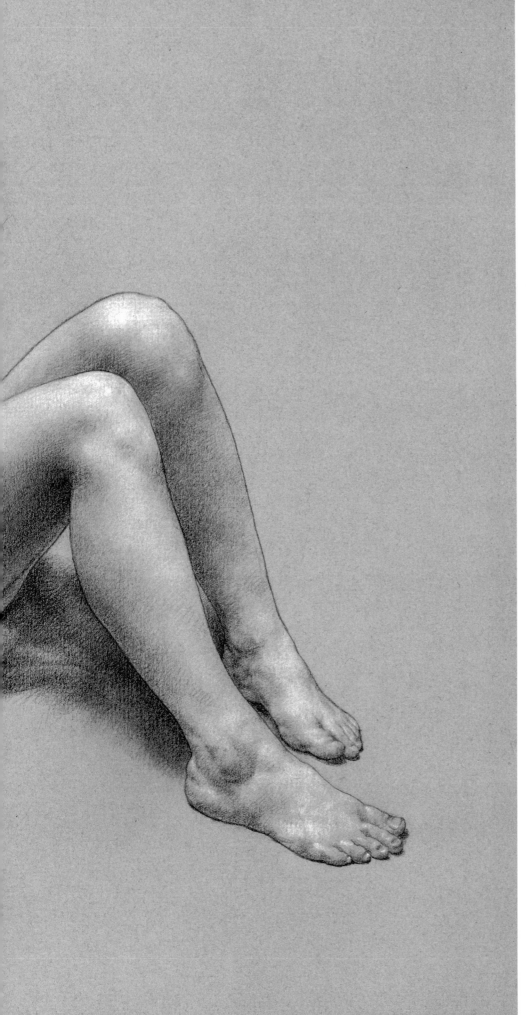

Aurora, 1998
Pencil and pastel on gray paper,
19 x 25" (48 × 64 cm)

Form and light are really
inseparable parts of the
same study.

FULLNESS

The fullness of the body is expressed through a multitude of convex forms. *Convex,* as you may remember, means outwardly rounded. In the contour, convexity is expressed with arcs of varying amplitudes. On the inside, it is expressed with tonal progressions.

Each form on the inside has a subtle border and its own flat, block-in shape: its shape as projected onto the picture plane. Within that shape you can express fullness by creating a tonal progression that darkens as it moves away from the light source. This makes the form appear to turn. If the light source is to the upper right, for example, the form would darken on a diagonal toward the lower left. You can increase or decrease the degree of a form's convexity by manipulating the *tonal range* of its progression. The tonal range is the amount of value change from beginning to end. More value change makes a form appear rounder and fuller; less makes it appear tauter. This handling of tonal progression on the inside of each form is one of the subtlest aspects of inside drawing.

MAJOR FORMS

Fullness of the form is expressed not only in each of the many convexities of the surface of the body, but also in

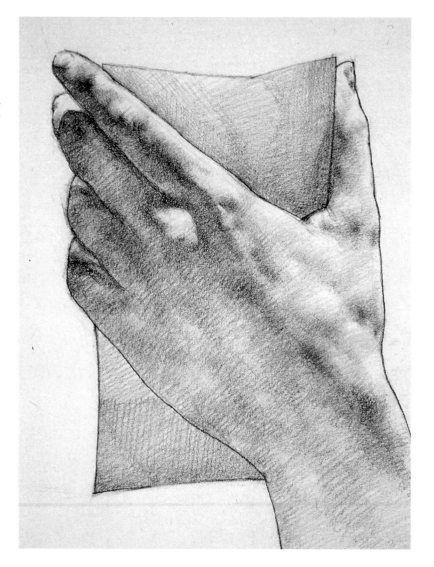

Hand with Seed Packet, 1997
Pencil on paper, 24 x 18" (61 x 46 cm)

The quality of tautness can be felt and seen in this drawing, especially in the form and contour of the thumb. The forms are full but, hopefully, not too full. The curves are stretched tightly along the contour. The roundness of the forms on the inside is regulated by carefully controlling the progression of values.

the massive, underlying structures that support them. The individual forms of the ribs, for example, curve around the mass of the rib cage. The forms of the knuckles are built onto the mass of the hand. The tiny puckered forms of the lips sit upon the lobes of the lips, which in turn conform to the "tooth cylinder" (the con-

vexity of the form of the teeth when taken as a whole). This then combines with other composite forms to express, finally, the mass of the jaw and the head. Such underlying masses are called *major forms*. The hierarchical stacking of lesser forms upon major forms is called *packed form*.

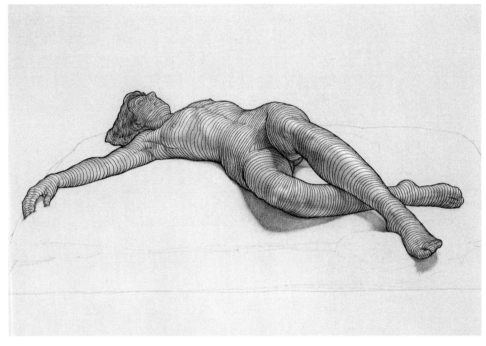

Figure in Space, 1998, with overlay
(For unobscured image, see pages 144–145.)

An opaque object is seen by way of the light patterns it reflects, which are in turn a function of its form and the light that shines on it. The form of an object is its mass, shape, surface, and structure. Through study of the figure we begin to develop sense of form—the awareness and understanding of the form of the body. Here an overlay of cross-contour lines has been added to illustrate how the figure occupies space through its full, massive shape.

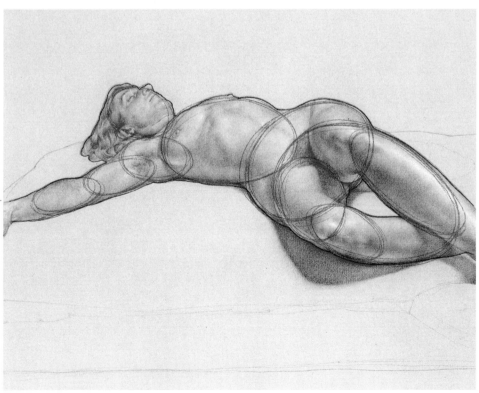

Detail of *Figure in Space,* 1998, with overlay
(For full, unobscured image, see pages 144–145.)

In this detail, you can perceive the influence of inner, full, massive elements, not only in the shapes of the skull, rib cage, and pelvis, but also in the shapes of the arms and legs.

Detail of *Sleeping Giant,*
1995
(Full image shown below.)

Note the successive convexities
that culminate in the kneecap of
the far leg. This illustrates the
concept of *packed form.* Packed
form is what happens when
multiple individual convexities
appear to be stacked, like a
wedding cake, atop a major,
underlying full form. Here, the
individual convexities of the
shin, knee, and thigh are packed
on an underlying fullness that
comes from the pressure of the
leg on the stool.

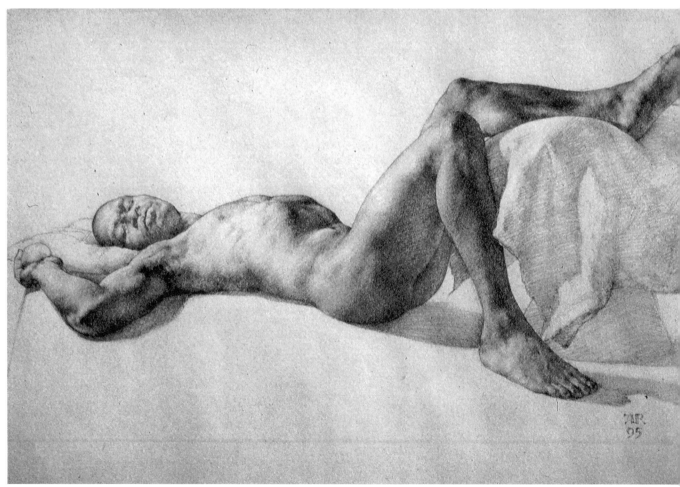

Sleeping Giant, 1995
Pencil on paper, 18 x 24" (46 x 61 cm)

CONTINUITY AND DISCRETENESS

Tonal progressions begin and end at the borders of forms. Within each form, the progression is continuous. But between forms the tone change is discontinuous, meaning that there is a sudden, abrupt value change. On the active side, where forms collide and bunch up, it's easy to see these edges between forms. On the passive side, where they stretch out, the effect is nearly invisible, but it is there.

The form of the body is one uninterrupted surface, but it is also a multiplicity of separate structures. If the tonal system within a drawing isn't discontinuous enough between forms, the drawing can look too smooth and undifferentiated. This results in an unnatural "auto body finish" style of drawing. On the other hand, a tonal system that lacks unity can make a drawing look choppy. This is called *overmodeling*. What we want is a tonal system with differentiation and structure, and at the same time a feeling of oneness and wholeness. As you develop your skills you'll acquire an ability to see and represent ever more subtle tonal progressions and edges.

Detail of *Twilight,* 1998
(For full image, see page 67.)

Though we tend to think of anatomical parts as separate from one another, in appearance and function the structure of the body is one, simple and indivisible. Here the foot, ankle, lower leg, knee, and thigh can be seen as one continuous form. An unbroken succession of full forms proceeds out of the leg and into the foot and toes in a cascade of integrated structures. Notice that while the progression is continuous, the surface isn't uniformly smooth. To produce these kinds of effects it's necessary to identify each specific form, the progression of light cutting across each form, and the very delicate transitions between forms.

Detail of *Moon Maiden*, 1998
(For full image, see pages 54–55.)

The surface of form on the inside is defined with light rather than line. We need to learn how to shape and modulate the light very subtly to create form that is smooth (but not too smooth), well ordered, structured, continuous, and unified. We do this by very carefully monitoring the subtle tonal progressions within the forms, and the equally subtle edges between forms. Notice for example the way the forms along either side of this model's spinal column are individually shaped, how each has its own specific tonal progression. Notice also how each form fits in with the other forms around it.

TIP

Words are of all things perhaps our greatest obstruction in learning to draw. Take the nose, for instance. It goes without saying that when we mention the nose we refer to a specific piece of real estate, occupying a definite part of the face and bounded on all sides by property lines that divide it from the rest of its surroundings. So in drawing the nose we very nicely delineate those boundaries and isolate it from the rest of the face, as if it were the Duchy of Liechtenstein or the Principality of Monaco. The only problem is, it isn't. The nose is not a separate country. There is no Great Wall of China protecting the genteel population of the nose from the barbarians of the forehead and cheeks. No airlift need deliver food and medicine to an embattled nose surrounded by hostile forms of a different political persuasion. The nose doesn't take its neighbors to court. It doesn't have any neighbors. It is so knit, so rooted into the head as to be inseparable from it: one, undivided.

In fact, the nose is of the very substance of the head, of the whole body. There are no boundaries of the nose. It reaches all the way to the tips of our fingers and the soles of our feet. Each of us is a nose with hands, a nose with a job, a nose with clothes. The rest of our body parts are just there to lend support. The point I'm trying to make here is that there are no boundaries, or at least there are very few, between the various regions of the surface of the body.

Detail of *Aurora*, 1998
(For full image, see pages 110–111.)

In this detail, the model's eyes, nose, and mouth are suspended in the surrounding tonal field of the face. They turn as the face turns. They're not separate from the structure of the head. They *are* the structure of the head.

CONNECTING FORMS

When major forms in the body collide, they send out ripples. Major forms wedge into one another like tectonic plates, pushing up mini mountain ranges. The impact is expressed in a pattern of smaller, intermediary transitional forms. These are called *bridging* or *connecting forms*. Connecting forms are small forms that connect major forms to one another. In a sense, all forms are connecting forms, since they're all acting as transitional elements, uniting forms around them. All forms are part of a flow of form, an orderly succession of both great and small elements. But the term "connecting form" refers in particular to a class of small forms that connect larger forms by providing little transitional ramps, thus expressing continuity of the form.

As you work up convex forms on the inside, you have to look carefully to see how they connect along their edges. The forms of the body don't generally butt up to one another like two bricks lying side by side. Instead they *interdigitate*. To interdigitate is to form a connection like the kind you get when you interlock the fingers of your two hands. Forms mesh with one another, with the help of connecting forms, across zigzag, sawtooth edges. These kinds of connections have a lot of tensile strength; they're not apt to pull apart. The entire surface of the body is woven together in this way.

> ### NOTE
>
> The surface of the body has a very beautiful texture. Communicating this texture is a matter of careful observation. It pertains both to the subtle micro-modulations of the surface and to the equally subtle modulation of light. By *modulation,* I mean having the quality of rising and falling in value: the light getting lighter and darker as it falls across the dipping and rising surface of the body, the way a boat goes up and down over the waves. When you're actually making form on the page, it's almost as if you can feel that smooth, soft texture of the skin through the pencil.

Detail of *Phases of Dane: Full,* 1998
(For full image, see page 92.)

In this detail, the sternocleidomastoid muscles wrap around the neck, with the larynx in between and small portions of the trapezius visible to left and right. All these forms are full and massive. The borders between the large forms are bridged by small, connecting forms, which fill in parts of the surface that would otherwise be concave. In fact, the entire surface is coated with a thin sheet of connecting forms. It is this outermost layer of form that interacts with the light, that we see, and that we draw.

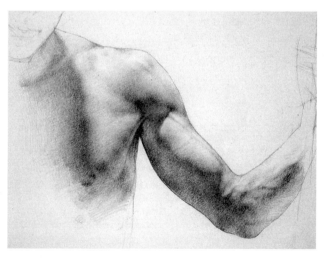

Arm Study, 1997
Pencil on paper, 18 x 24" (46 x 61 cm)

Connecting forms are the small, full forms that bridge the gaps between the various larger, fuller forms of the body. They are little transitions, like the little concrete section between a driveway and the street: nearly invisible, but nevertheless very important. Without them, the form would be choppy and unnatural.

Detail of *Self-portrait,* 1997
(For full image, see page 10.)

The form of the body is never entirely
smooth. Micro-modulations, subtle form
changes, spreading in all directions, cover
its gently undulating surface. These delicate
modulations can be seen here in the
forehead. They appear as a result of a
combination of factors, including the
irregular surface of the skull, the form of
the frontalis muscle, and the thickness and
texture of the skin. In order to see and
draw the actual surface of the body, it's
necessary to tune your perceptual faculties
to a refined and delicate sensitivity.

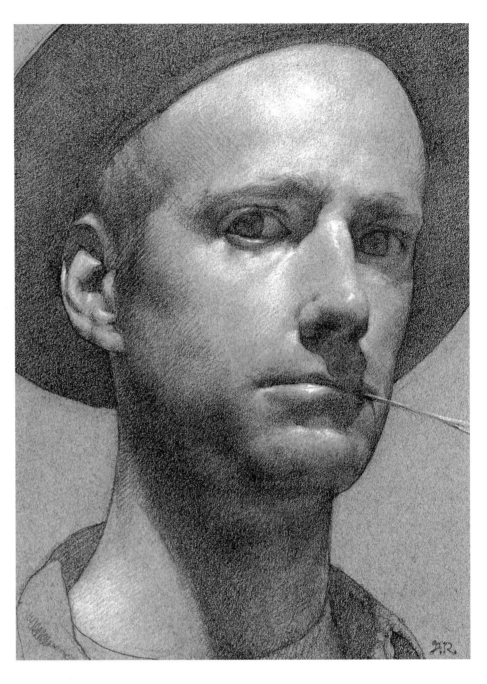

RIGHT: *Man with a Pole,* 1998
Pencil on paper, 24 x 18" (61 x 46 cm)

At a certain stage in the development of the embryo, the outer surface
of the body is formed. In one of the last phases in this particular
developmental stage, the two sides of the surface of the body approach
one another and "zip together." They interlock like the sutures of the
skull, or like the fingers of two hands inserted into one another. This
occurs along the centerline of the front of the body, the line along
which the right and left halves of the body meet. This centerline is not
really a line, like a simple pencil line. It is a place of union. It is
bridged by many small connecting forms, woven together and
interlocking. In this illustration, a portion of the centerline can be seen
running from the pit of the neck down along the front surface of the
sternum, past the belly button and into the pubic region. Small
connecting forms join all the way down the centerline's path

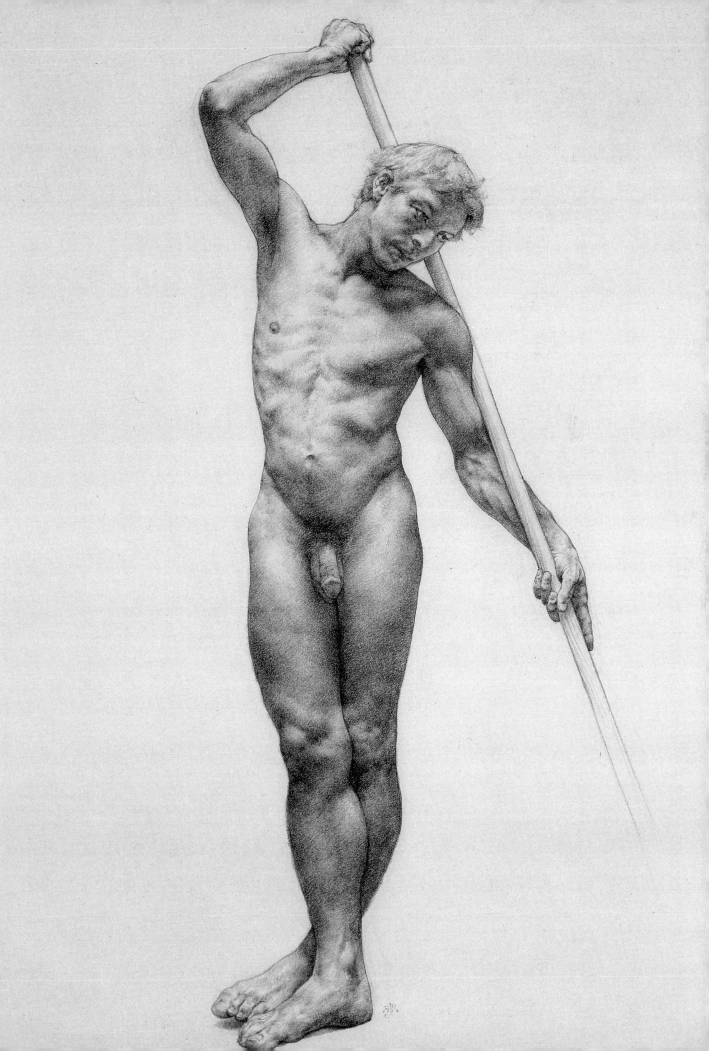

THE EFFECT OF THE GESTURE

The gestural action reconfigures all form, not only in the contour, but also on the inside. The substance of the body has plasticity. Its form changes radically. There are no normal forms, but there are "normal actions," and we should be able to read this action in the form on the inside as easily as we can in the contour.

The normal actions that are the basic elements of gesture are flexing, extending, turning, suspending, and compressing. Where muscles are flexed, or active, forms bunch up. Where they are extended, or passive, forms stretch and attenuate. Turning twists the forms of the body like the strands of a piece of rope. Suspension results in draping and hanging forms; compression results in forms that are squeezed and squished. Every pose has an overall gestural action that consists of most, if not all, of these actions, combined in various ways throughout the figure. Thus, for instance, the head may be turned to one side, one hip compressed, one arm extended and the other flexed, and a leg suspended.

Detail of *Constellation*, 1998
(For full image, see page 29.)

In this detail, notice how the (invisible) chair is compressing the muscles through the bulging shapes of the upper arms and the crunched gesture of the torso. The front of the body is bunched up, an effect typical of the contracted, active side of the form.

This detail also shows the effects of suspension. As gravity pulls on the forms of the body, it sometimes results in draping (suspension) effects. When a form hangs between two points of attachment, this draping effect is expressed by a downward curve. You can see this in the upper right arm of the lower figure and the thighs of the top figure.

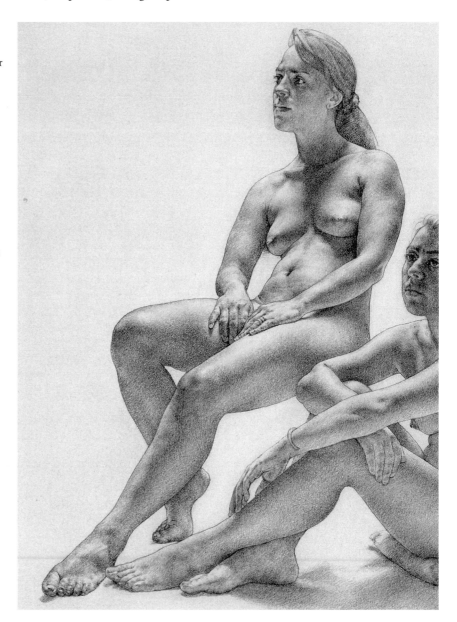

ORGANIZATION

The surface of the body is orderly, but not mechanically so. It is patterned after the manner of other natural forms, like wood, for instance, with its grain, water with its waves, and mountains with their geological strata. These patterns have a rhythmic quality. The rhythmic arrangements of the forms of the body wrap around the figure like a suit made of an intricately marbleized fabric. But unlike the arbitrary patterns of a piece of fabric, the patterns of the form of the body are always functionally related to the underlying anatomical structures, as well as to the action of the pose and the light direction. Each point on the surface of the body is an intersection of two or more wave patterns. That's why we refer to the surface of the form as a fabric, although it's a fabric in which the threads don't run at right angles to one another.

PATHWAYS OF FORM

The strands of which the figure's fabric is woven are called *pathways of form*. Pathways of form are strings of formal elements that appear to line up on the surface of the body. The formal elements are bits and pieces of forms and their associated light effects—an edge here, a highlight there, a little downturn, a dark accent, a shape of reflected light, then an upturn, and so on—that often have no apparent functional "reason" for lining up as they do. Perhaps they exist for no other reason than for artists to draw them. Whatever their purpose, or whether or not they even exist apart from our perception of them, it is at least certain that they have played an important role in figure drawing at least since the time of Michelangelo, in whose drawings they are demonstrably present.

Pathways of form cover and organize the surface of the body, providing a network by which all individual forms may be located. By scanning along the pathways one develops a sense of the proportional and positional relationships of the various forms. You may remember the point-to-point scanning method used in the block-in, and the idea of the inner gestural flow (see pages 32 and 52, respectively). These two modes of seeing are combined in the way we locate forms by following pathways. The eye cascades along the pathways, skipping from one form to the next. In the process we register positions and connections of disparate elements, and get a feeling for how they all link up and relate to one another.

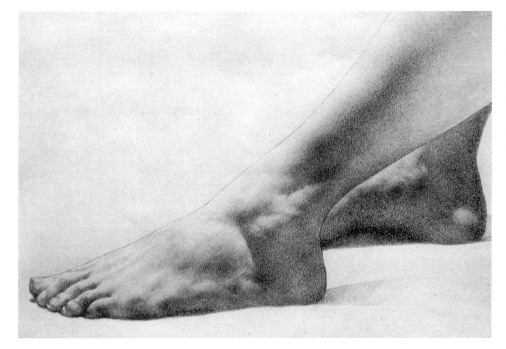

Foot Exam, 1996
Pencil on paper, 18 x 24" (46 x 61 cm)

The form of this foot is like a thin sheet of water, rippling over the surface of a piece of weathered rock and creating a multilayered pattern in three dimensions: ripples on top of ripples.

The human figure is living sculpture of the most sublime kind. It occupies space in a fascinatingly beautiful way. As you examine and evaluate form in your drawing, always think about how it turns, how its structures foreshorten, how its aspects change depending on its rotation in space, and how it projects within the virtual three-dimensional reality of the drawing. Give the form mass by developing its quality of fullness. Make these masses appear to turn (to have a particular degree of rotation in space) by situating their features correctly. Differentiate the masses by elaborating a network of pathways that wraps around them. And then refine this differentiation by chiseling into their surface to create many individual forms.

Finally, pay attention to your scale of observation. Forms of many different sizes coexist peacefully in the figure. Depending on your scale of observation, you may see only the tiny little forms, such as the separate forms that compose the eyelid, or perhaps only the great big ones, like a single mass of the hips and thighs. Large underlying forms convey the monumental nobility, while lesser forms suggest the anatomical mechanics, and the smallest forms express the elaborate and intricate structure of the surface of the body. If, in the course of drawing the figure, you integrate these different scales of observation, your drawing will develop a dynamic structural integrity, and the form of the body will take on a beautiful, naturalistic quality.

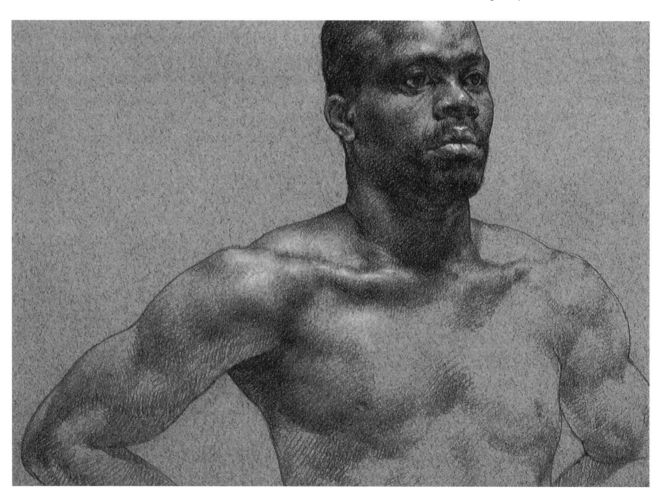

Detail of *Philosopher and Poet* (in progress)
(For image with tonal work further developed, see page 157.)

This model is a veritable museum of pathways of form. Notice the movement coming from his left shoulder diagonally down across the chest. There's also a nice pathway running from the back of his right elbow, diagonally up the arm, skirting the underside of the shoulder, right through the middle of the collarbone, and into the neck.

Ripples, 1997
Pencil on paper, 24 x 18"
(61 x 46 cm)

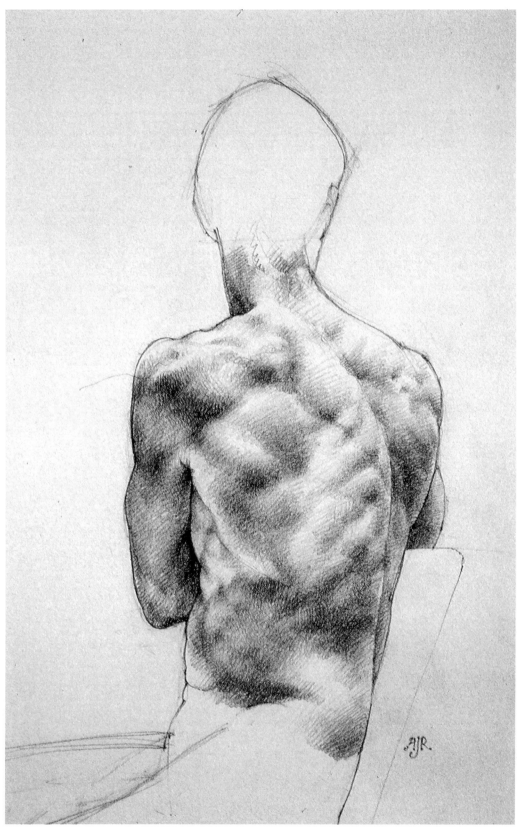

Pathways of form curve around large, underlying, full forms. They wrap like ribbons
around the rib cage. They don't go straight. They don't run parallel to one another.
They converge and radiate. Notice in this illustration the slightly nonparallel
orientation of the ribs. Their axes converge toward the model's right shoulder.

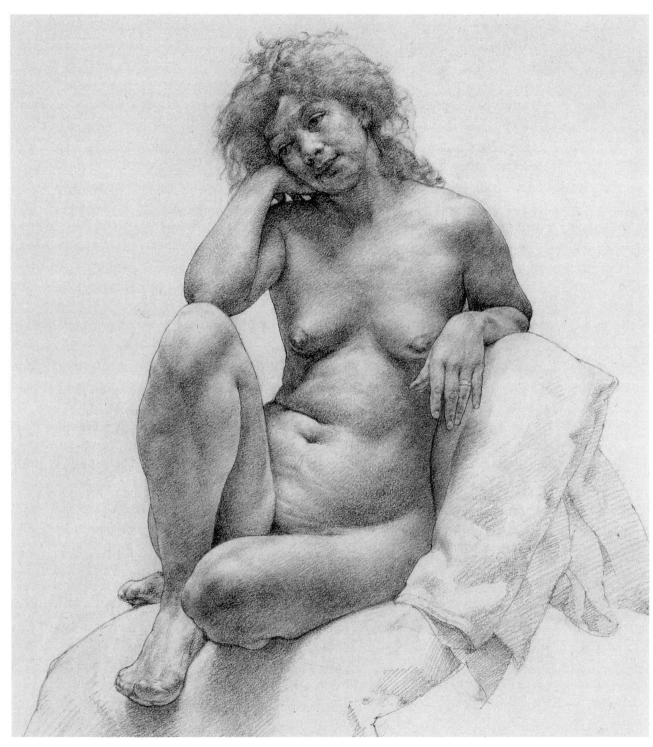

Lost in Thought, 1998
Pencil on paper, 24 x 18" (61 x 46 cm)

In this drawing, forms of different magnitude can be seen in the tummy, which has one simple, underlying rounded nature (a major form), composed of a half dozen or so midsized convexities, each of which in turn consists of a handful of small forms and connecting forms. This same kind of analysis could be made of any part of the surface of the body.

RIGHT: *Scott,* 1997
Pencil on paper, 24 x 18" (61 x 46 cm)

The myriad small, individual, convex forms on the surface of the body manifest the inner, noble masses underneath. We refer to the underlying masses of the body as *noble* because of the way drawings look when such masses are missing: pinched, meager, and mean-spirited. The trick is to organize and draw all the tiny little forms as if they were many little wavelets on a great big wave.

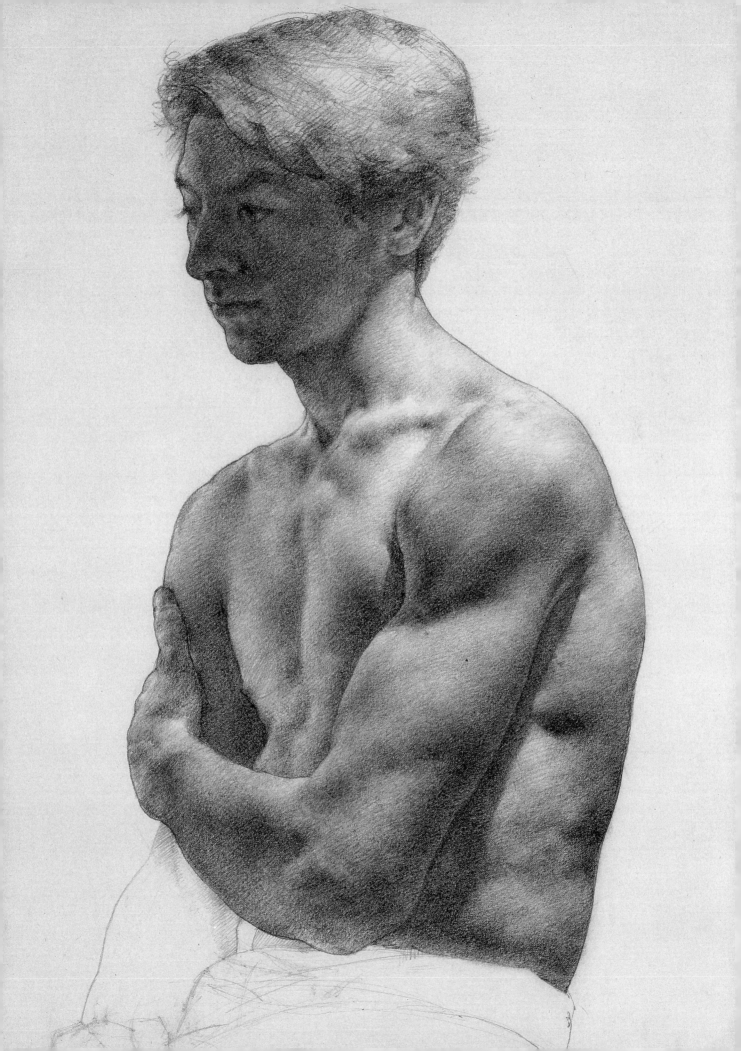

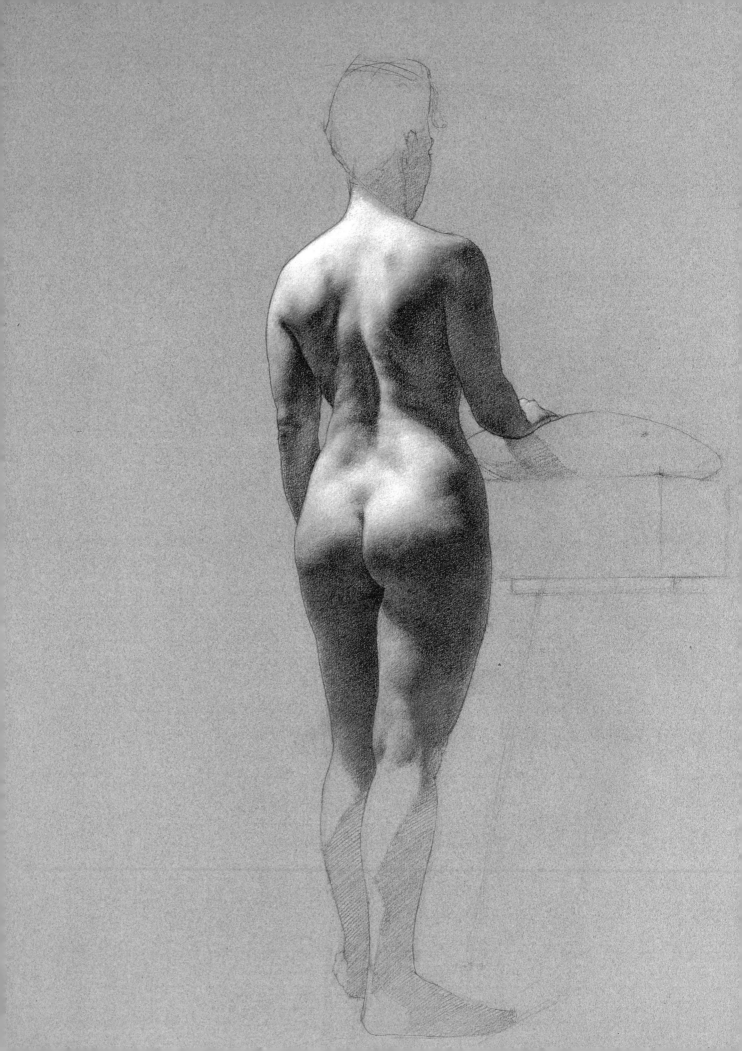

DRAWING ON THE INSIDE

IN THE PREVIOUS TWO CHAPTERS I described the theoretical factors involved in the third and final phase of this drawing method, called drawing on the inside. In this last chapter I'll talk about the actual techniques used to represent light and form.

Once you develop an understanding of the theory, and by this I mean learning to *see* light and form, then the technical aspect is really very easy. It boils down to two basic skills: carefully spreading graphite onto the surface of the paper in a controlled way (the *manual* technique of drawing on the inside), and developing your washes of shading in a logical sequence (the *procedural* technique). The first part of this chapter, called "Shaping the Light," offers a review of the simple, manual techniques of shading as covered in Chapter 1. The second part, called "The Shading Process," discusses the procedural technique of developing your drawing. At the end of the chapter, a few sequences of step-by-step illustrations walk you through the entire shading process.

SHAPING THE LIGHT

We represent light with gradations of tone, guided by observation and knowledge of the way it interacts with form. It's very easy to miss the quality of the light if you're just copying values. Instead, you need to *shape* the light. This means molding the amount of light for each form, building up more light in one place and tapering it off in another. It means making value configurations within the linear structure of the drawing by allocating differing intensities of light according to the topography of the form.

When drawing on white paper, light is shaped by selectively darkening down everything that is not light and leaving the white of the paper to shine out in spots that are lit up on the model. On toned paper, light is shaped by darkening down those parts of the drawing that need to be darker than the tone of the paper, and by lightening up those that need to be lighter.

Many factors contribute to the exact intensity of the light that shines from any given point on the model. You learned about some of these in Chapter 5, such as the direction of the light, the distance between the model and the light source, and the observer's angle of view. In general, the most light-facing parts of the model are the parts that are most lit, and the least light-facing parts are the least lit. Between the shadow and the lightest light spots, there are tonal gradations that decrease as the rounded form of the body rolls away from the light, and increase as the form rolls up toward the light.

LEFT: *Light Study,* 1997
Pencil and pastel on gray paper, 25 x 19" (64 x 48 cm)

CREATING TONE

Tone is the basis of inside drawing, and the ability to create it with pencil is critical to this drawing method. In Chapter 1, you were introduced to the techniques of hatching and cross-hatching (see page 23). These are the means used in this drawing method for producing tone.

To refresh your memory, hatching and cross-hatching are shading methods that employ batches of close, evenly spaced lines. To produce a tone, all you have to do is make an even, tonally homogenous patch of shading by moving your hand (and therefore your pencil) rhythmically from side to side, while slowly progressing across the page at a right angle to the side-to-side motion. Try creating a few identical patches of tone on a piece of scrap paper. After that, see if you can make patches that differ in value. Find out how much range you can get with a single pencil. Then work with pencils of other degrees of hardness and do the same thing. With practice, you will be able to produce tone in a wide range of values. You'll learn how and when to use pencils of differing degrees of hardness, and you'll develop a feeling for how much pressure to apply to the drawing surface. Make sure you repeat the above exercises for both hatching and cross-hatching.

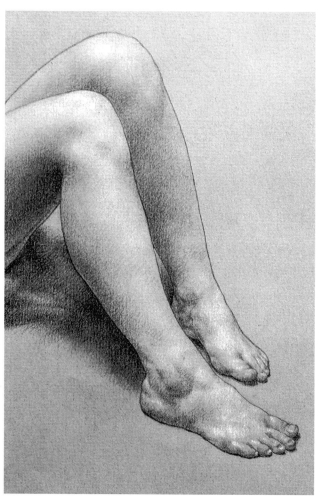

Detail of *Aurora,* 1998
(For full image, see pages 110–111.)

Inside drawing expresses everything in terms of tonal gradations, or progressions. In this detail the muscular and skeletal structures of the legs and feet are expressed in modulated washes of chalk and graphite. These washes of tone represent individually shaped, convex forms that wedge into one another, spiraling diagonally around the inner, gestural curve.

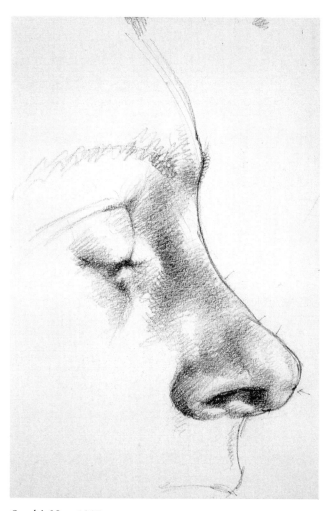

Sandy's Nose, 1997
Pencil on paper, 17 x 14" (43 x 36 cm)

Here, miniature tornadoes (curving, tapering tonal progressions) mingle, merge, and lace together, forming the fabric of the nose.

CREATING TONAL PROGRESSIONS

Once you get the knack of producing flat (of one value) patches of tone, the next step is to work on patches with gradual value change, also called tonal progressions, or gradations. There are three ways to create basic tonal progressions: by changing the pencil pressure, by changing the line spacing, and by cross-hatching. In practice you'll find that you often combine these methods intuitively.

- *Pencil pressure:* Gradually increasing or decreasing the pressure of the pencil point on the paper as you progress from the beginning to the end of the patch will result in a gradual change in line value, and consequently a progressive darkening or lightening of the tone.

- *Line spacing:* Decreasing the space between lines will darken the tone's value; increasing the space will lighten it.

- *Cross-hatching:* Loading more and more layers of hatching progressively toward one end of the shading patch will darken the tone. With each additional layer, or "wash," of hatching, the tone darkens.

Another important skill to work on is that of *shaping* your tonal progressions. In a truly naturalistic drawing style, each patch of tone has a specific shape. Tapering, curving, slanted, and asymmetrical shapes are the rule. Sound familiar? Here's where your block-in and gestural curve training will come in handy again, since through such training you will have learned how to recognize and draw organic shapes. Some shapes are broad; others are needle-thin. The shape depends on the specifications of form and light.

Tonal progressions create an illusion of rounded, curving surfaces. There are no flat surfaces on the human body. Every part of the surface turns in all directions, all the time. The form of the body has a complex, constantly changing curvature, resulting in equally complex progressions of tone. It is therefore important to develop the ability to produce tonal progressions of all degrees of value change, in every shape, in every direction, and over every distance. With practice you will develop a wide vocabulary of shaped tonal progressions. This is a major step toward learning to speak the "language of drawing" fluently.

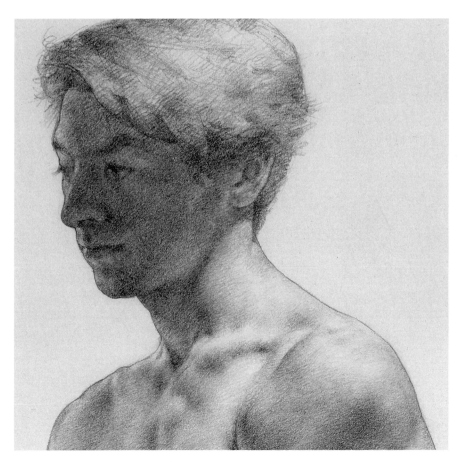

Detail of *Scott,* 1997
(For full image, see page 125.)

Individual, specific, convex forms are portrayed according to the direction and key of the light with washes of hatching and cross-hatching.

CREATING A SEAMLESS TONAL FABRIC

Much as the block-in is one shape composed of many sub-shapes, inside drawing is really one continuous tonal progression consisting of many individual "sub-progressions." These sub-progressions should be applied so that their borders disappear; they should merge to become one, indivisible fabric. This is done by very carefully controlling the edges of each patch of shading. Still, you'll find that some of your edges will be ragged and abrupt, and will break up the continuity of the surface. In a finished figure drawing there may be thousands of such edges. "Edge control" is the remedy. It is the microsurgical, cosmetic process of cleaning up the edges.

Two tools are used to clean up such edges: kneaded erasers and pencils. Use a kneaded eraser to pick out small dark marks on the inside. Shape one end of the eraser into a point by twirling it between your thumb and forefinger. Then use this point not to erase entirely, but to ease up on the endpoints of each hatching line. These points tend to be a bit heavier and crisper than the lines in between, and can give shading patches a kind of a crust around the outside, like a slice of French bread. By gently pecking away at these little borders, you can make the patches seem to melt into one another.

The second tool is a pencil, sharpened to a precise point, which is used to bond the shading fabric seamlessly into itself. Super tiny patches can be micro-hatched along the edges of larger patches, suturing them together and providing smooth value transitions. You can also combine careful micro-hatching with pinpoint erasing to correct blemishes and glitches.

As mentioned earlier, the human form doesn't have an auto body finish, and absolute smoothness isn't really what we're after. The surface of the form of the body is structural, meaning that it is built of many interlocking, interpenetrating convexities—small forms layered atop larger forms, which are in turn layered atop yet larger forms. The purpose of edge control is not to smooth over the structural quality of the surface, but to remove errors.

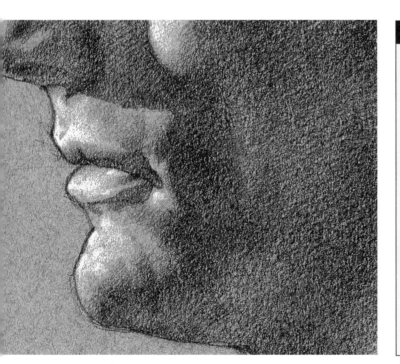

Detail of *Goyko,* 1996
(For full image, see page 85.)

This man's chiseled features crisply configure the light to create a definite pattern of light and shadow. When we correctly shape the light we convey the particular likeness of each form. Try to avoid shading formulas and instead tune your mind's eye to the exact specifications of the model. Such articulate refinement enriches the artistic process, and sharpens and trains the artist's faculties.

> **NOTE**
>
> As mentioned at the end of Chapter 5, our optical field is made up of little bits, or pixels, of light. Because of this, all visual edges are gradual and transitional, combining to form a seamless visual experience. If handled in the right way, paper and pencil will naturally produce a grainy texture that creates the illusion of pixels, mimicking those of the optical field. Depending on the tooth of the paper, the hardness, sharpness, and angle of attack of the pencil, and the pressure of the pencil on the paper, the marks you make will appear more or less grainy, thus creating a more or less seamless illusion. Seurat, for example, did this to the extreme in his charcoal drawings.

THE SHADING PROCESS

So how do you actually *start* drawing on the inside? First, you begin by finding things, by placing the forms that you intend to develop tonally. Suppose you've been working on a drawing for a few days. You've been through the envelope and the block-in, and now you've got the contour to a reasonable level of refinement. However, the inside of the contour is still new, unexplored territory. At this point it may be tempting to just start shading, but my advice is to hold off until you've worked out the placement of the forms on the inside. This task is called *locating landmarks on the inside.*

LANDMARKS ON THE INSIDE

The "landmarks" I'm talking about are tonal in nature. Terminators, cast shadow edges, dark accents, "downturns" in the light, and contours on the inside can all be used as landmarks. They're in the toolbox labeled "stuff for setting up the inside drawing." Such landmarks are associated with underlying anatomical structures, but they aren't identical with the structures themselves. For instance, the collarbone is not a landmark, but some portion of the light effect associated with the collarbone, such as a bit of shadow or shape of dark-light, might very well be. Terminators, cast shadow edges, and dark accents are all dark parts of the shadows. Downturns in the light are the undersides of forms that haven't turned away from the light enough to drop into shadow, but have turned down somewhat and have thus darkened as a result. A dimple in the cheek, for instance, might be a downturn in the light. Contours on the inside are places where the form has overlapped itself, so that one part of the form is silhouetted against another part; one example would be the line where the lips meet.

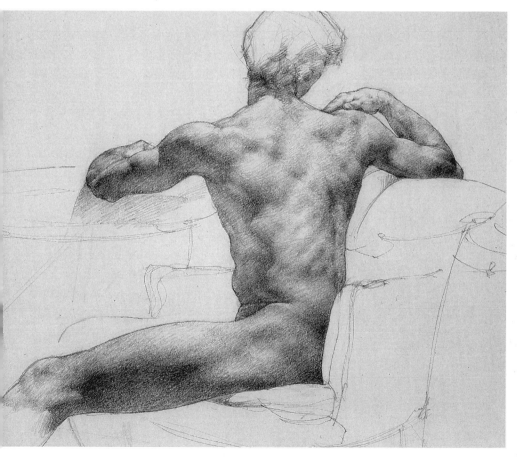

Scott's Back, 1997
Pencil on paper, 18 x 24" (46 x 61 cm)

Landmarks structure the drawing, creating proportion in the space within the contour. In this drawing, terminators, cast shadow edges, and downturns in the light were used to organize the form of the model's back.

To locate and place landmarks on the inside, you simply triangulate from the origin/insertion points in the contour. To refresh your memory, the origin/insertion points are the points in the contour at which the convex curves begin and end. The contour is loaded with them. You can scout out the interior with forays based on these points, gradually structuring the inner space of the drawing. This may be done for the drawing as a whole (as a distinct phase of the drawing process), or it may be done hand-in-hand with the development of the overall tonal structure, one section at a time.

Landmarks act as points of reference to help you map out the inside. They line up along pathways, gradually defining a network of tonal elements that tie into the contour. As you recognize these landmarks in the model and try to position them in your drawing, constantly refer back to origin/insertion points in the contour so that the contour and the inside drawing become structurally integrated.

Sketch in your landmarks lightly at first. With the exception of contours on the inside, which may be lightly rendered with line segments, all landmarks are of a tonal, rather than linear, nature. These landmarks shouldn't be outlined. Instead, indicate them with small shapes of hatching and cross-hatching. (For examples of this, see the illustrations on pages 133–135.) Try to form the shapes accurately and control their edges so that they begin to suggest specific forms. These initial

TIP

Whenever I draw on the inside I try to remember and obey the following rule: Each form to be shaded must first be recognized as such and its shape in space understood. The light progression that cuts across the form must also be seen and carefully studied. Then a corresponding tonal progression is made in the drawing to represent that specific form as it's conveyed by that particular light progression.

tonal indications are meant to eventually disappear, to merge seamlessly into the overall tonal structure.

The landmarks you place will serve as a second set of reference points, correlated with the origin/insertion points of the contour. As you work them out, they will line up along the pathways of form, gradually defining a network of tonal elements that ties into the contour. Thus the contour and the inside drawing become structurally integrated.

Working up the edges of the shadows

When there is a strong, clear shadow shape (as when using incandescent light), the edges of the shadows are particularly useful, effective landmarks. They can be blocked in *very lightly* with lines. (Make sure that these lines are *not* parallel to the lines of the contour.) When the figure is illuminated with a diffuse light from a broad light source, however, the shadows may not present particularly strong, highly contrasted edges. In such situations the use of hard-edged block-in lines to indicate shadow edges is inappropriate, since such lines tend to scar up the surface of the form. Instead, use patches of cross-hatching to work up a chain of linked patches that zigzag across the form, making a somewhat permeable tonal hedge, rather than a hard linear fence, between the regions of light and shadow.

Of all the landmarks, the terminator is the most centrally important. Its little zigs and zags serve as starting points for tonal progressions that grow out of it—into the light on one side, and into the shadow on the other—further defining the various features of the form. I guide the growth of these tonal progressions according to my perception of the pathways of form, which cut across the terminator at various oblique angles.

Once the edges of the shadows are blocked-in, whether with line or tone, they can be used as landmarks for placing other landmarks on the inside. Remember to keep referring back to the origin/insertion points in the contour as you do this, so that the form on the inside develops in harmony with the contour.

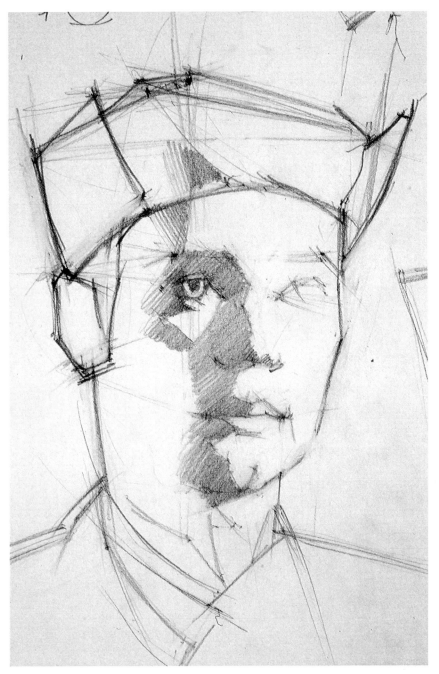

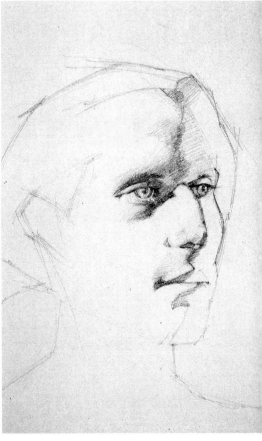

Jonathan, 1995
Pencil on paper, 17 x 14" (43 x 36 cm)

This sketch was done for a very brief pose. Notice how the introduction of the shadow edge already brings a sense of light and form to the drawing, even though very little else was done in the way of shading.

Block-in Demo, 1997
Pencil on paper, 24 x 18" (61 x 46 cm)

In this drawing, I blocked in terminators and cast shadow edges with a progression of line segments, running from the edge of the hat down the forehead, across the eyebrow, down to the bridge of the nose, along the nose to the tip of the nose, and so on to the collar. I also blocked in shadow edges around the eye on the shadow side. Most of these landmarks were terminators, but a few were cast shadow edges: on the underside of the nose, on the upper and lower lips, and on the chin. There is also a cast shadow edge around the side of the model's right eye, formed by the shadow cast by the bridge of the nose. Once these landmarks were blocked in, I used hatching to begin massing the shapes of the shadows in a rough and general way. As soon as that happened, the light came on in the drawing and the form began to take on a feeling of substance and solidity.

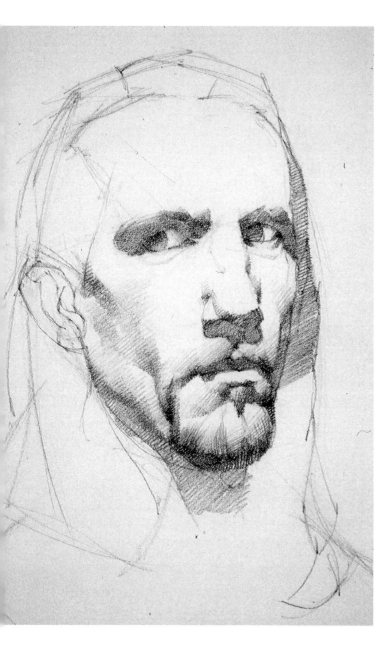

Portrait of an Actor, 1994
Pencil on paper, 17 x 14" (43 x 36 cm)

Notice the shaped hatching swaths
around the nose, mouth, and cheeks.
Each patch of shading has a sweeping,
curving action to it. The forms are
carved as if with a chisel out of a block
of wood. Through the pencil we are in
touch with the virtual realm of the
drawing. We reach into our drawings
with our pencils and sculpt solid forms.

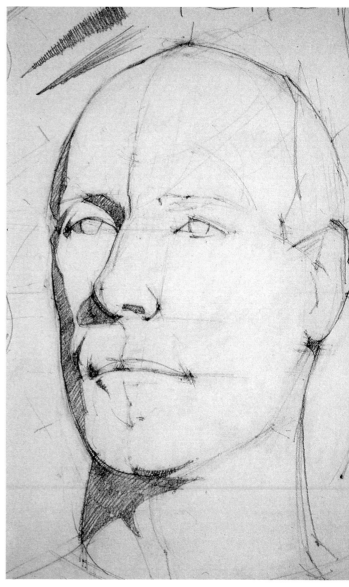

Portrait of Robert Hoggard, 1997
Pencil on paper, 17 x 14" (43 x 36 cm)

This sketch was done in a lighting
situation that produced clear, easily
defined shadows. I blocked in clean,
crisp, definite shapes, with lines
around the shadows that are dark
enough to read but still light enough
so that they won't show through in
the final drawing.

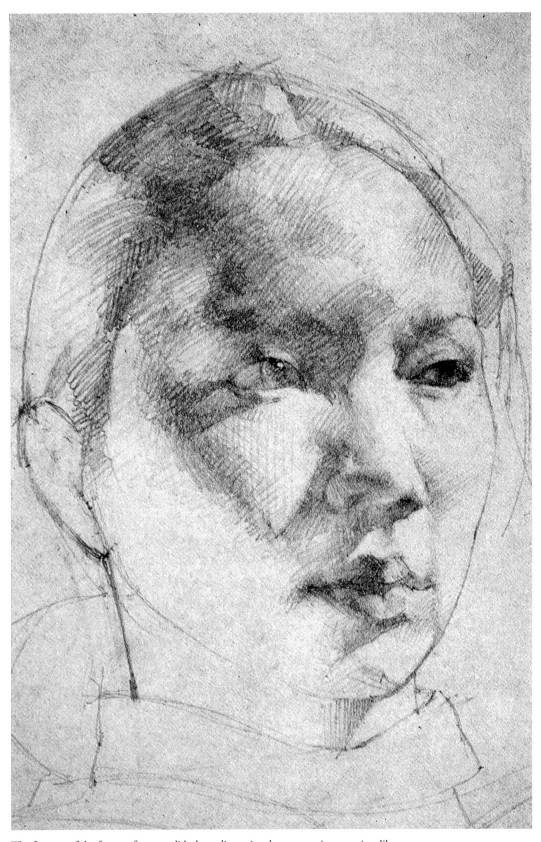

Free, 1995
Pencil on paper,
17 x 14" (43 x 36 cm)

The features of the face are form—solid, three-dimensional structures in space, just like every
other part of the body. This means that they interact with light in the same way as all other
forms do. If you look carefully at this drawing, you will see how the edge of the shadow wends
its way over the forms of each feature.

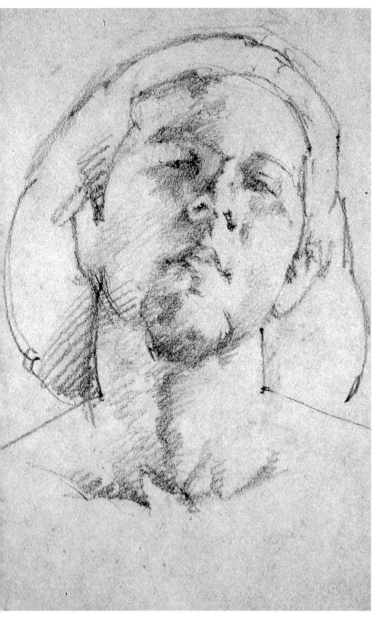

Head Study, 1994
Pencil on paper, 17 x 14" (43 x 36 cm)

In this twenty-minute sketch, the shadow edges were blocked in with light patches of cross-hatching that form a long, squiggly core running down through the middle of the shape. Everything extends from the terminator, either into the light or into the shadow, so this served as my main landmark. The features were simply strung around it like rock candy on a string. Voilà, insta-portrait!

DEVELOPING THE OVERALL TONAL STRUCTURE

The appearance of the model is a pattern of light gradations, an integrated value structure. Every part relates to the whole. The lights and shadows exist together as a balanced tonality. Translated into the drawing, this is the *overall tonal structure,* the ultimate goal of this drawing process. To this end, your faint tonal map of networked landmarks will serve as an organizational "blueprint" for placing and shaping all of the tonal progressions in the drawing.

Keying the Drawing

Once you have located and placed the landmarks in the inside, your next step is to "key" one part of the drawing. This means fully developing one section to establish a tonal standard—a range from the darkest dark to the lightest light. Then you can shade the rest of the drawing using this same tonal standard.

Pick a section to work up, such as the head, torso, or upper arm. Using your faint tonal map as a blueprint, begin pushing your darks darker. As the dark-lights and shadows drop in value, the lighter lights will begin to shine and the drawing will take on depth and dimensionality. There's no rule as to how dark you can go. The only thing you should keep in mind is that all your values must darken down proportionately, with only your very lightest lights and highlights remaining unchanged. The further you darken your darkest darks, the more the values in the middle will also need to be darkened.

Proceed slowly, remembering that the light direction will influence the way the light cuts across the form—both the form as a whole and each form individually. Observe each form and the amount of light and shadow

TIP

Be careful not to "dirty up" your lights. In other words, try not to draw darkly all over the tops of the forms—the parts that face the light most. These are the lightest parts of the model, so they should also be the lightest parts of the drawing. Remember that as there are two light sources (the primary light source and the reflected light source), there are two sets of "tops," one in the light and one in the shadow.

associated with the way it turns. Then reach into the drawing and turn the form under by shading it down. Gradually flood the shadows and dark-lights with washes of tone. Work back and forth across the shadow edges, dropping the darker values down and leaving the lighter lights alone. Once you portray the shadows, the lights will begin appearing all by themselves, which is why we work from dark to light. The light-lights should be the last to be developed. They won't read as light unless the darker values around them have been established.

As you shade, shape and graduate each wash of hatching to reflect each specific form. Although I sometimes lightly wash in flat areas of hatching, I don't wash in big, dark, flat areas of value, since I find that they flatten everything out. They also tend to inhibit *Seeing.* Each form in the body has its proper shape, and fits in with the adjacent forms in a very particular way. Your visual attention must be coordinated with this methodical activity of selecting, shaping, and shading each form. Then *Seeing* and drawing become a single, unified, integrated activity.

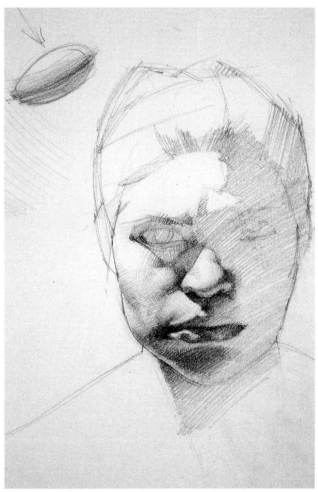

Keri, 1995
Pencil on paper, 18 x 14" (46 x 36 cm)

In this class demo, the shadow was first blocked in and lightly shaded. The result was two flat fields, one of light, the other of shadow. The remains of this block-in stage can still be seen in the forehead. I then began working back and forth across the shadow edge, dropping the darker values down. The reflected light on the underside of the lips and nose is just the original shadow tone, with the darker shadows worked up around them. The lightest parts of the nose and upper lip in the light are the white of the paper.

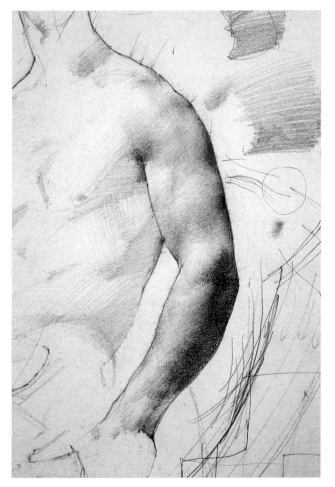

Form Demo, 1996
Pencil on paper, 24 x 18" (61 x 46 cm)

Here I've worked up tones in the upper arm and forearm. At the shoulder I let the edge of the cross-hatching fray so it would be easier to merge it with the shading still to be done on the upper torso. Notice how the torso has been lightly mapped out.

KEYING THE DRAWING

**Detail of *Pete Jackson, Capoérista,*
(in progress)**
(For full view of finished drawing, see page 140.)

I have begun developing tone on this head
with a cottony mass of shadow and dark-
light. Just because this shading is soft and
cloudy doesn't mean that it's mushy and
inaccurate. Once that cloud of values gets
started, I just let it migrate around the
drawing like a herd of caribou. It gradually
moves into all the shadows and dark-lights
so as to surround and isolate the lights. Also
note that some dark accents have begun to
appear in the block-in of the eye. They're
like the seeds of the eye's future tonal
structure.

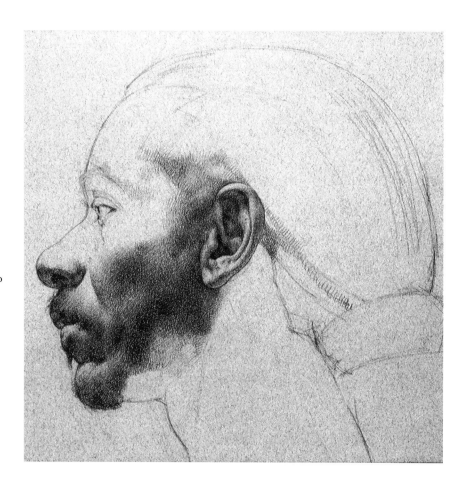

Additional dark accents and an associated
structure of light and shadow have been
worked up around the eye. Remember,
shadows occur where the form rolls away
from the light, such as on the underside of
the brow ridge and below the lower lip.

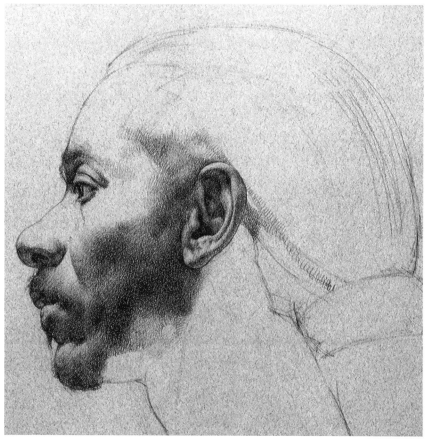

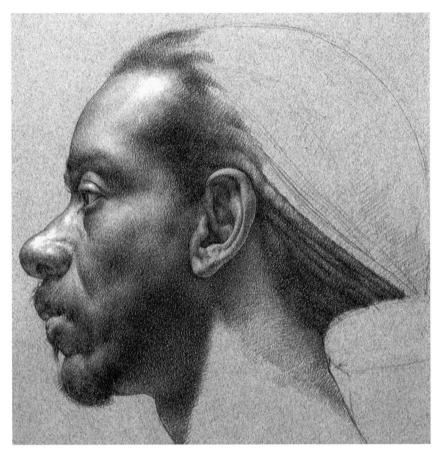

Everywhere the procedure is exactly the same as previously described. You first observe a given form and the light progression associated with it. Then you reach into the drawing, like Alice through the looking glass, and carve the form by shading it down.

Here, the shading has moved out from the face and into the hair and neck. Running between the chin and ear is a terminator, which is not very distinct. Beneath the terminator, on the underside of the jaw, is some reflected light. The change of state in the shadow, from terminator to reflected light, is gradual and smoky. There are, however, small but important variations in this transition that reflect the micrognarly surface of the form. Next to the reflected light is a cast shadow. The curved shape of the "edge" between the reflected light and the cast shadow conveys the roundness of the underside of the jaw.

You can also see here how I am using the pencil to simulate the texture of hair. Pete's mustache and beard were wafted into the drawing without hard edges, and were made to conform to the turn of the forms beneath them. I tried to work the dreadlocks up so they would have a certain fuzzy distinctness.

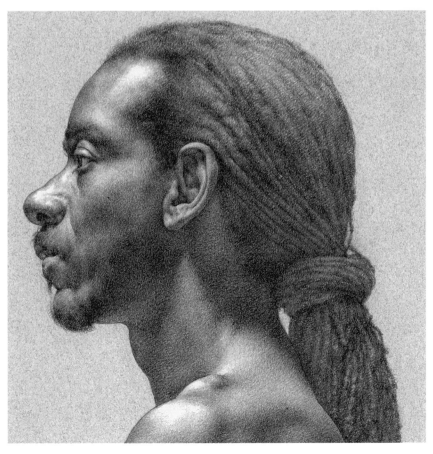

The shading has now progressed down the neck and onto the shoulders. Out in the light are various full forms that reflect the musculature of the neck, each having a subtle convexity. The inside of each form shows a gradual value change, with the value darkening as the form turns away from the light. Between one form and the next there is a sudden value change. This scenario is repeated throughout the light region except near the highlights, where it is somewhat overwhelmed by the blast of the light.

Highlights can look like pieces of forest that have been cleared by powerful explosions. Whereas the rest of the progressions in the light have a certain consistency, highlights step out of that range altogether. It's as if you stepped out of a house into the bright sun. In this detail, a clump of highlights is located on the upturned surface of the shoulder. The transition out of the form-light is relatively sudden, but not absolutely sharp. If it is too gradual, the highlight will leak into the form-light and fail to stand out. If it's too sharp, the highlight will look pasted on, like a white dot.

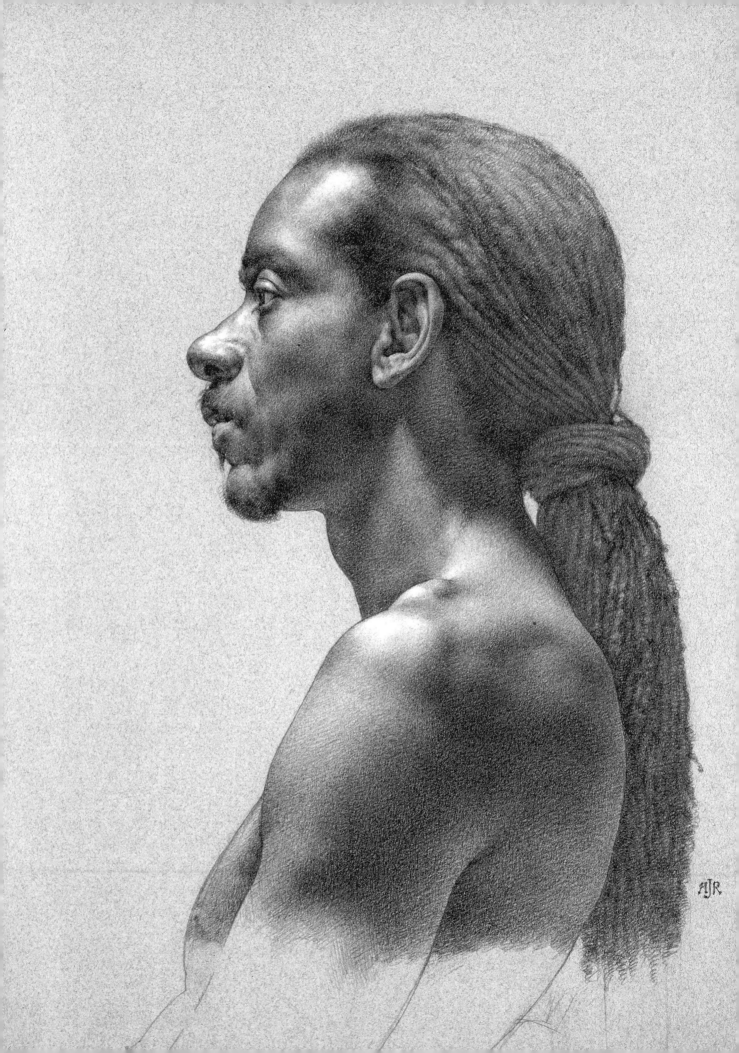

Advancing through the drawing

Once you've keyed the drawing, you're ready for the third and final stage of the shading process: the elaboration of the overall tonal structure throughout the remainder of the drawing. In each section, work up your blueprint first, at least with a few light indications, then follow the process just described to develop the overall tonal structure. Later, you may decide to go back and slightly recalibrate the first section, adjusting the standard tonal range that you established in the beginning to improvements you've made elsewhere. In this way the whole drawing settles into a tonal consensus.

As you work, keep in mind the key of the light. The light effect on the mass as a whole should always govern the light effect on individual forms. Each small modulation in the surface needs to be shaded within the value range appropriate to its location in the overall progression of light. If this is done correctly, nothing will look out of place. But doing it can be a little like driving in the fog at night. Since you haven't gotten there yet, it's hard to know if you're going in the right direction. The only recourse is constant comparison of the drawing to the model, and the adjustment of values in relation to one another in the drawing.

There are no breaks in the shading process, but there are sections. Sections are flooded with shading one at a time, and in the process the walls between the sections dissolve.

Portrait of Nicole, 1997
Pencil on paper, 17 x 14" (43 x 36 cm)

The forms and features of the head are arranged atop an underlying full, rounded mass. As this mass turns up toward the light it lightens up; as it turns away, it darkens down. The fullness of the greater light effect embraces all the lesser forms.

Detail of *All-Star,* 1998
(For full image, see page 102.)

Change of value in the light can be very gradual. In this detail you can see how the legs slowly lighten up, progressing from the feet to the hips. Each small modulation in the surface needs to be shaded within the value range appropriate to its location in that overall progression.

LEFT: *Pete Jackson, Capoérista,* 1998
Pencil and pastel on gray paper, 25 x 19"
(64 x 48 cm)

STEP-BY-STEP
ADVANCING THROUGH THE DRAWING

Detail of *Figure in Space* (in progress)
(For full view of completed image, see pages 144–145.)

In this detail and the two that follow, notice the arch of the rib cage, which develops as a rounded succession of forms rather than a hard ridge.

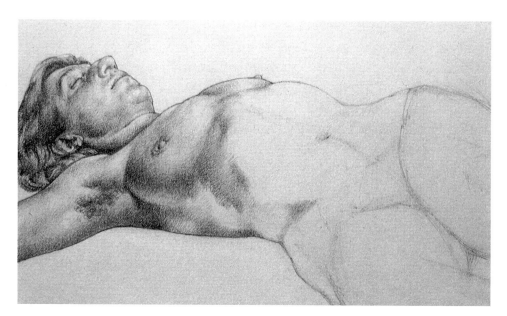

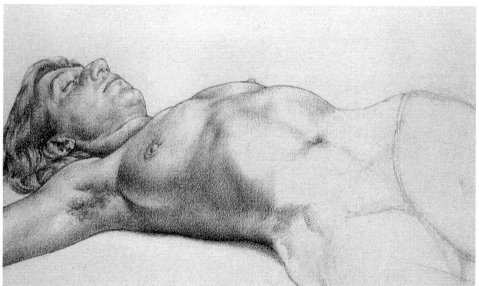

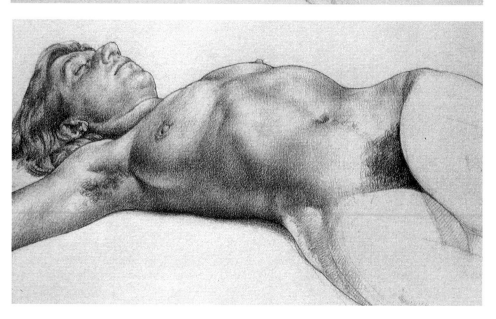

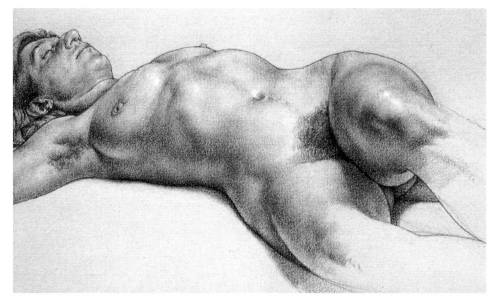

In the process of shading, the contour may be reworked one last time. Shading and the contour go together like hand and glove. Notice the way the contour and shading are bonded together along the edge. It is important to observe exactly how the value progression approaches the edge of the form. Forms wrap obliquely and drop over the horizon, creating a feeling of continuity between front and back.

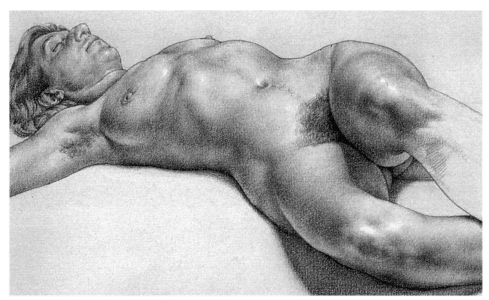

This detail and the one that follows show the shading progression in the legs, and especially the development of the highlight/form-light progression on the model's left shin.

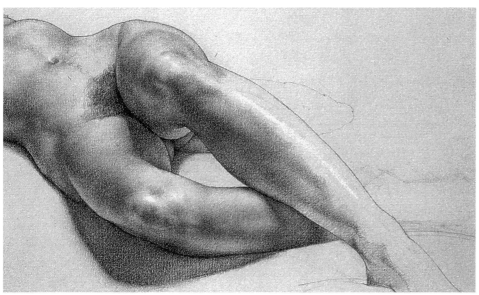

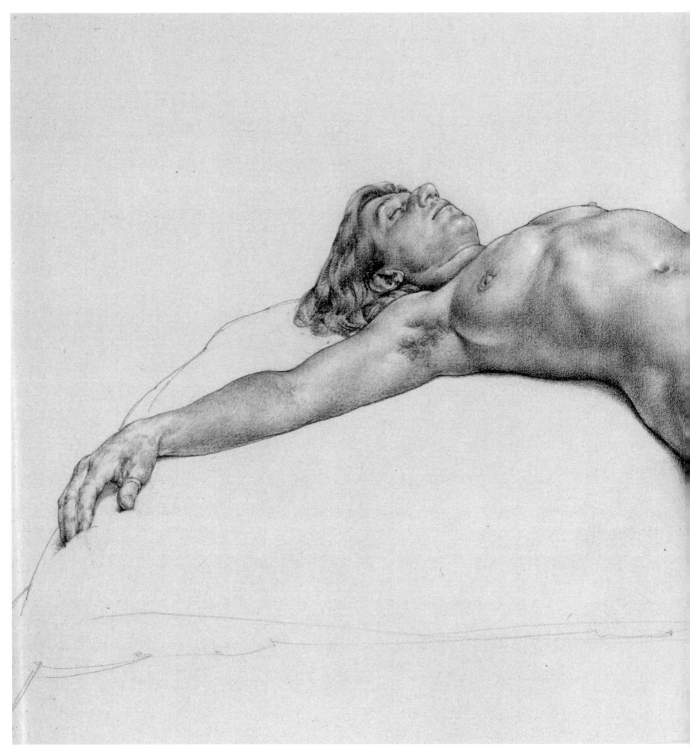

Figure in Space, 1998
Pencil and pastel on gold paper,
19 x 25" (48 x 64 cm)

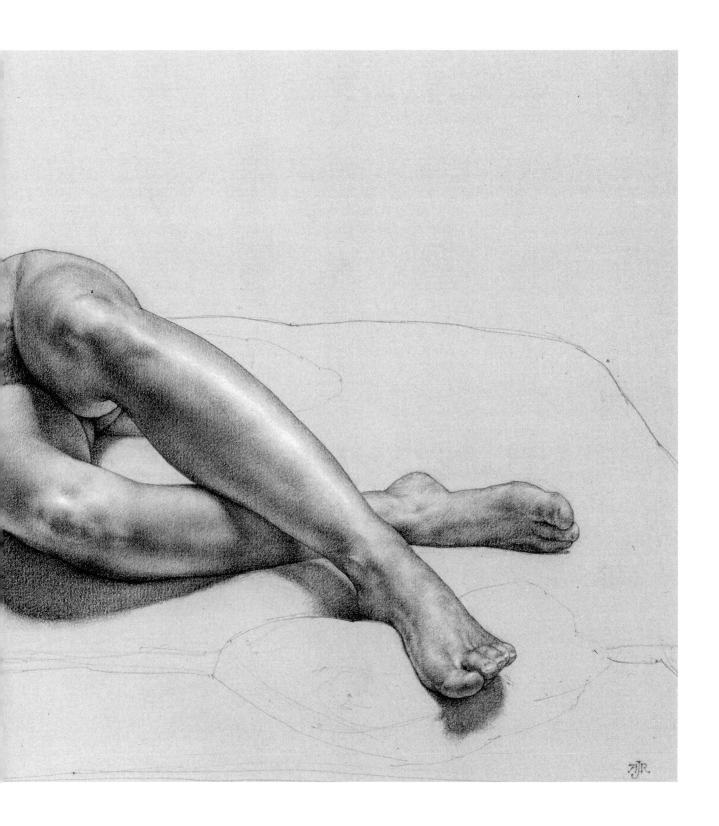

THE SHADING PROCESS

The following series of illustrations gives you a step-by-step look
at the entire shading process, as done for *Thought Form* (1999).

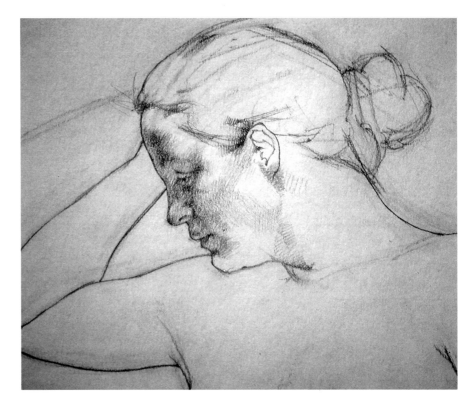

After about twenty minutes of shading,
I've applied a number of washes of tone,
creating progressively darker values to
develop the effects of light and shadow.
Notice the terminator on the forehead,
the reflected light in the eye socket, the
cast shadow on the bridge of the nose,
the dark-light in the cheek, and the
lighter light on the cheekbone. These
light washes of hatching were "brushed
on" with a very sharp pencil, with
delicacy and a regard for the subtle
modulations in the form of the model.

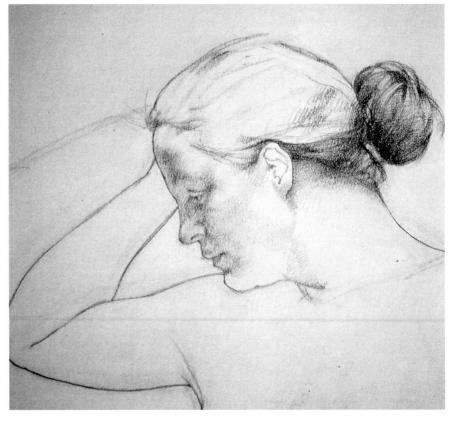

Hair always has its own curvilinear
directionality. Here I've varied the
orientation of my pencil strokes in an
effort to suggest the curved shapes of
each individual lock of hair. Notice the
fluffy little bunch at the nape of the
neck, the way the mass of the bun
resembles a ball of rubber bands, and the
stretched taffy-like shapes of the hair
behind the ear.

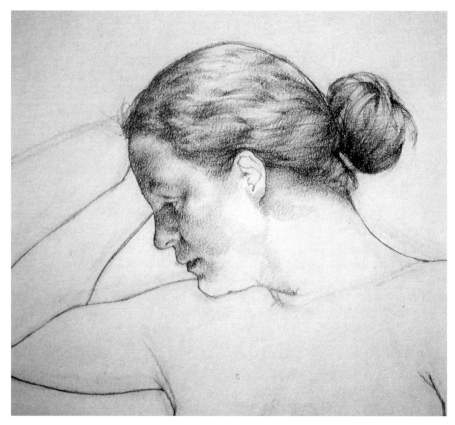

The mass of the hair varies in value according to the underlying form of the head. In this illustration the mass is lightest in the upper center of the shape, so this area has fewer washes of cross-hatching than the darker regions. Notice that most of the cross-hatching is *not* applied with the hair direction. It cuts across the directionality of the hair and creates a tonal fog into which I've carved, with a few directional lines, the shapes of individual locks.

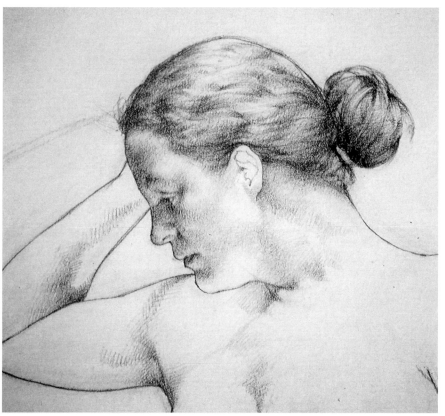

I've begun to research the tonal pattern of the arm, shoulder, chest, and neck. The edges of the shadow cast by the head and neck onto the shoulder are lightly indicated. Also indicated are terminators on the arm, elbow, and breast (shown only partially here), the downturn of the sternum, and the woven forms of the muscles of the neck. Many inexperienced students would mark out these phenomena with lines like those used in the contour, puncturing the delicate illusion of light and form and indelibly scarring the image. I prefer to breathe the image onto the page by developing a web of narrow, curving, nonparallel shapes of hatching and cross-hatching. Hard, dark, scratchy lines not only scar the drawing, but also blind the thought process to the essentially continuous nature of the surface of the form.

Here I have begun to develop the form by gradually building up the tonal gradation with many washes of hatching, always keeping in mind the effect of the light. Throughout the shading process, I use a bridge to support my wrist so that only the articulate muscles of the fingers are used. Using control and a sharp pencil, keep your mind in the drawing, relax, and realize that time is of no significance, only beauty.

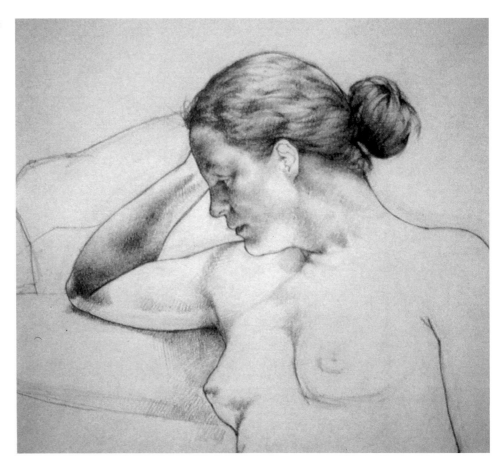

I've now begun working up the cast shadow on the shoulder. I first washed in a base tone along the lower half with patches of unidirectional hatching, then gradually deepened the value up to the contour of the chin. This cast shadow is the largest single dark mass in the whole drawing and the tendency might be to apply it as a large mass of flat tone. But this type of treatment would inevitably have an unsightly texture and be out of harmony with the rest of the drawing. It would also ignore subtle variation within the shadow, as well as the specific softness of the shadow edges. Consequently, like everything else on the inside, I build it up slowly and carefully.

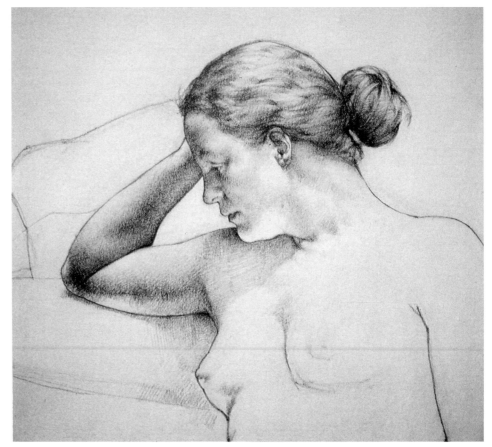

Besides finishing the modeling of the upper arm, I've gone back into the face and neck. This serves both to finish those areas and to prepare for shading the model's left arm and chest. Notice the two slight indications of the collarbone. In this pose, the model's collarbone appears as a series of delicate modulations in the very lightest light. It would have been easy to stomp around this area with a dark pencil, but sometimes less is so much more.

I've now begun using tone to develop the form of the chest and upper abdomen, with each wash of cross-hatching carefully shaped and graduated. There's no rule as to which direction the hatching lines should run. The only rule is that every application of shading must relate to the form as it's perceived with the effect of the light. This gives it a kind of inner formative directive.

Detail of *Thought Form,*
1999
Pencil on paper, 18 x 24" (46 x 61 cm)

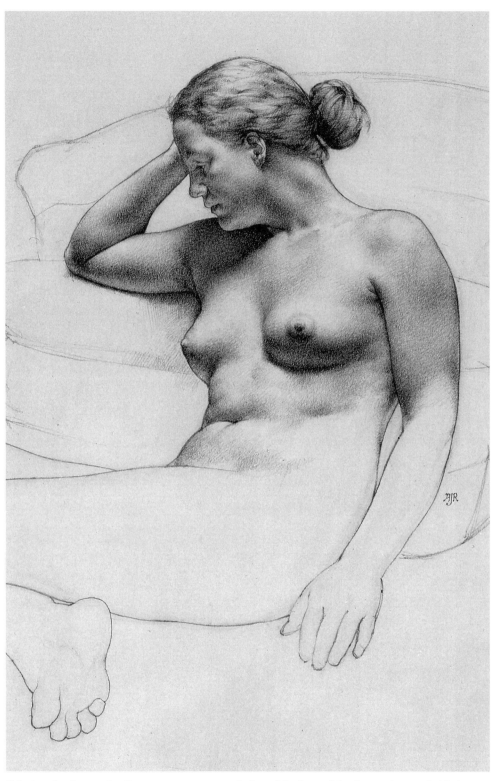

Skipping ahead a couple of hours, you can see a resolution of the form of the chest and stomach. Notice that all the edges of the forms on the inside are slightly out of focus, creating an atmospheric effect and, paradoxically, increasing the impression of reality in the drawing. If you carefully examine the actual quality of the visual impression you have when looking at someone, you may notice that it's slightly less hard-edged than you'd first thought. If you draw this *actual impression,* the drawing will look more real. This may be hard to accept, but it will help you to draw better as you will be dealing not with what you *want* to see, or what you *think* you see, but with what you *really* see. By empowering your mind with this understanding, as well as with practical experience, you will acquire the ability to draw with great beauty.

Working on colored paper

If you work on colored paper, you can use white pastel to paint the light effect in a way that isn't really possible on white paper. I used a white pastel pencil to bring up the lights in almost all the drawings done on colored and gray paper in this book.

Instead of working from dark to light, as I would on white paper, I generally work in two directions on toned paper: from dark to light with graphite pencils, and backward with white pastel, working from the lightest lights down. After you've used graphite to establish the basic blueprint for the shadows, key the lights by applying small blobs of white pastel in the spots where the lightest lights and highlights are to be found. Then graduate the lights back toward the terminator. Go easy on the first pass, then go back a second and third time, readjusting the value relationships and thickening the pastel in the lightest parts of the form. As always, a sense of form and an understanding of the light are essential guides in this work.

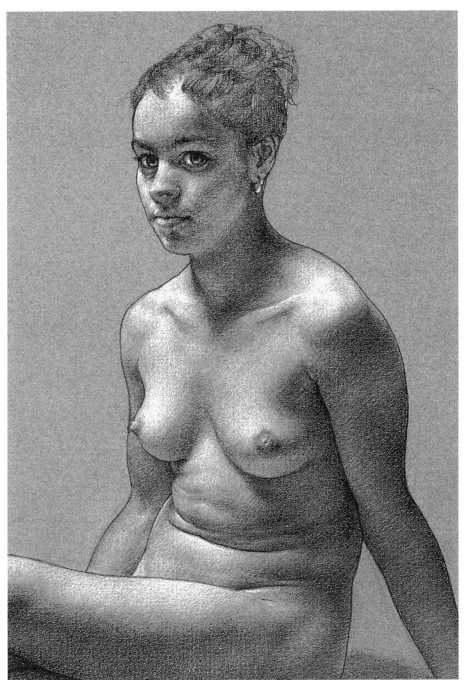

Detail of *Piano Student,* 1998
(For full image, see page 49.)

The fluttering down of grains of white pastel occurred in this drawing one section at a time (the head first, then the torso, and so on), slowly accumulating on upturned surfaces and settling in the drawing like fallen snow. The "snowfall" piled up little by little, beginning with the most light-facing parts of the form. Over time its thickness increased, almost imperceptibly, on the tops of the forms, most deeply in the highlights and less deeply elsewhere. Spreading outward, it tapered and diminished as the form turned away from the light.

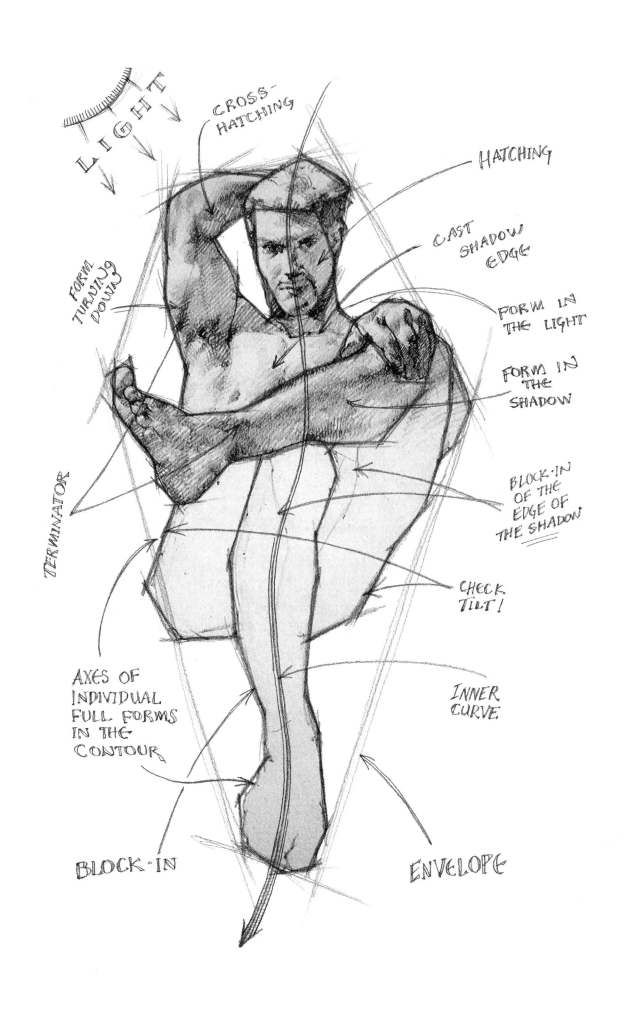

LIGHT

CROSS-HATCHING

HATCHING

CAST SHADOW EDGE

FORM IN THE LIGHT

FORM IN THE SHADOW

FORM TURNING DOWN?

BLOCK·IN OF THE EDGE OF THE SHADOW

TERMINATOR

CHECK TILT!

AXES OF INDIVIDUAL FULL FORMS IN THE CONTOUR

INNER CURVE

BLOCK·IN

ENVELOPE

PULLING IT ALL TOGETHER

BENEATH THE FINE POWDERING of graphite on the paper is a massive amount of thought. There are gigabytes of information in the model, and all of it has to come through the pencil, one byte at a time. As visual information from the model flows through the pencil, it must be synthesized with a second body of information, one that has to do with the principles of drawing. Each pencil stroke reflects the model on the one hand, and the drawing thought process on the other.

That can be a lot to handle. When you're drawing, you have a lot to think about. That's why pacing and working at a reasonable tempo are so important. Crashing and burning are *not*—I repeat, *not*—part of this drawing method. It's very important to cut yourself a little slack now and then. Try not to judge yourself too harshly. You wouldn't be angry with a little sapling, just because it hadn't become a big tree overnight, would you? It's incredible how much you can accomplish if you're patient. Before you know it, you'll be drawing like an angel.

The illustrations on pages 154–157 show the three basic stages of this drawing method: block-in, contour, and drawing on the inside. They show the working process that I normally follow, except that I don't usually work out the figure's entire network of pathways of form before building the full tonal range in one section, as shown on page 156. Usually, I do some pathways, then develop some shading in that section, do more pathways, then more shading, and so on. That way I kind of migrate across the form.

Brewmeister, 1995, with overlay
Pencil on paper, 17 x 14" (43 x 36 cm)

Technique translates our understanding of the principles of drawing into a process, with a beginning, a middle, and an end. In this drawing method, that process is represented by the block-in, the contour, and tonal work on the inside. As long as each section of a drawing is put through this entire process, different sections can be in different stages of development at the same time. Shading can begin to make its appearance in one part of the drawing, for example, while work on the block-in or contour is still going on in another part. There are no hard-and-fast rules. The more important issue is pacing. Be careful not to rush. Each thing you do in a drawing, each line or patch of shading, must be done with attention.

The block-in. Use long, breezy pencil strokes to keep your block-in light. Remember to measure the tilts and distances of each line segment. Move things around, finding the nonparallelism of the shapes and getting a feeling for the gestural curve. Try to find the midpoint of the figure and then use it to gauge the lengths of the legs, torso, and head.

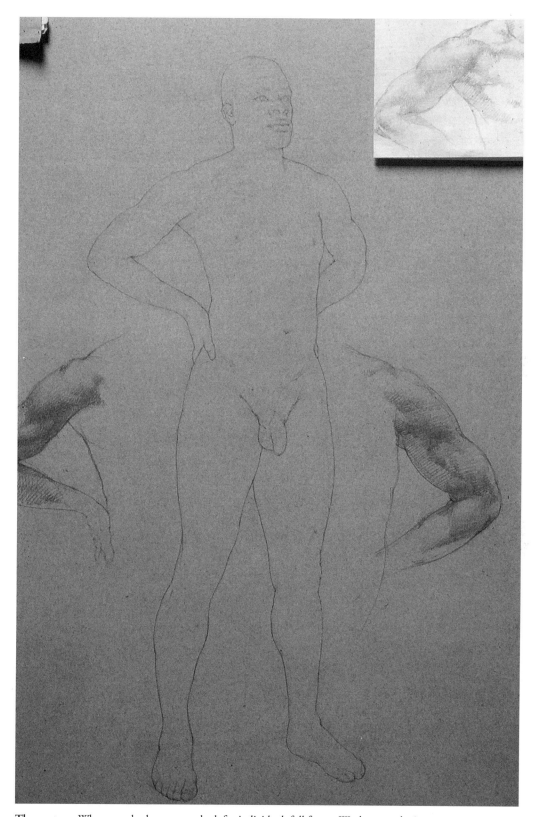

The contour. When you do the contour, look for individual, full forms. Work on producing an articulate, clean line—nothing fancy, just try to refine your observation. Remember to take good care of your paper with the eraser, cleaning up as you go. Notice the many small forms in this contour, such as those shown here in the legs.

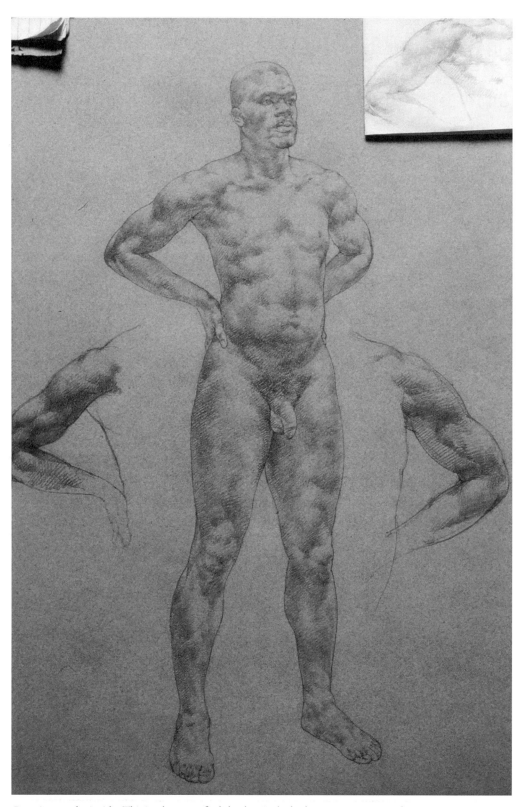

Drawing on the inside. This is where you find the drawing's rhythms, movements, and connections on the inside. Skim your eyes over the tops of the forms like a sea bird flying close over the tops of the waves. Try to find structure that wraps, turns, twists, and wedges. For instance, see how the shapes of the knees in this illustration wedge up into the thighs and down into the calves.

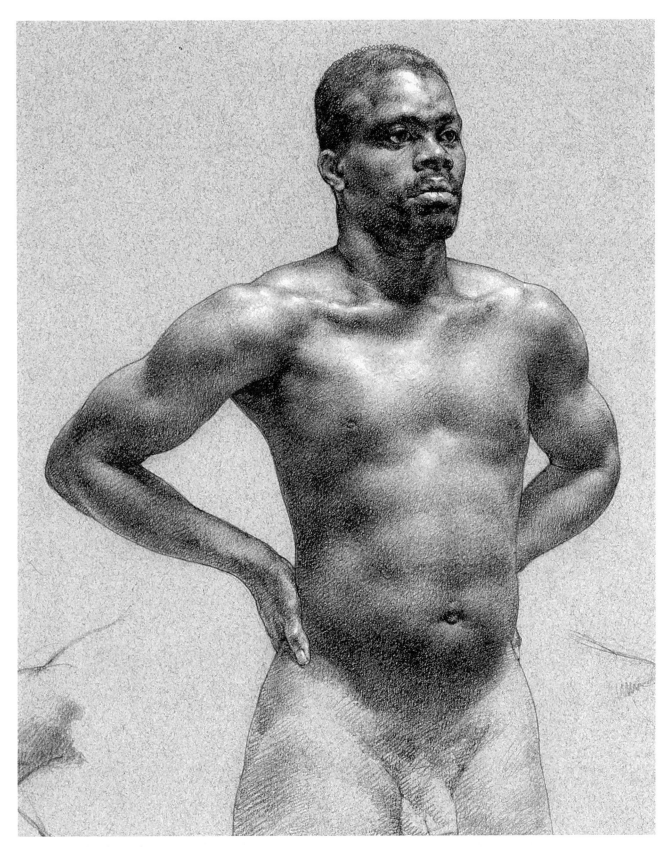

Detail of *Philosopher and Poet,* 1998
Pencil and pastel on gray paper, 25 x 19" (64 x 48 cm)

Here is the drawing halfway through the final stage
of tonal work.

Drawing isn't confined to what we do outwardly—the use of paper, pencils, and erasers. It also involves our inner awareness of the drawing process. You should constantly remind yourself, for example, to look for the gestural curve, even while in the middle of hatching with a pencil, to look for the fullness of the form, and to find the shape of the light. This is called *presence of mind.* It is how we increase the magnitude of our attention in the drawing. This, above all else, makes for great drawing.

When you watch an experienced draftsperson at work, you probably don't notice much in the way of technique. He or she just seems to be drawing. Outwardly, what the artist is doing doesn't seem any more complicated than scratching a mosquito bite, or eating a soft-boiled egg with a spoon. Inwardly, though, he may feel like he's balancing his egg on top of a beach ball, on top of a cane, on top of his nose, and singing the national anthem in front of a large audience while scratching his mosquito bite. It's this inner balance that

Sketch of a Torso, 1991
Pencil on paper, 14 x 11" (36 x 28 cm)

The fundamental elements of a drawing, such as the gestural curve, are not expressed in any one line. It is easy to forget these inner generalities as you focus your mind on "technical issues," like how to use the pencil to create tonal progressions. In this sketch, notice how the gestural curve manifests itself through the head, neck, and torso, and the connected circuit of the shape of the arms.

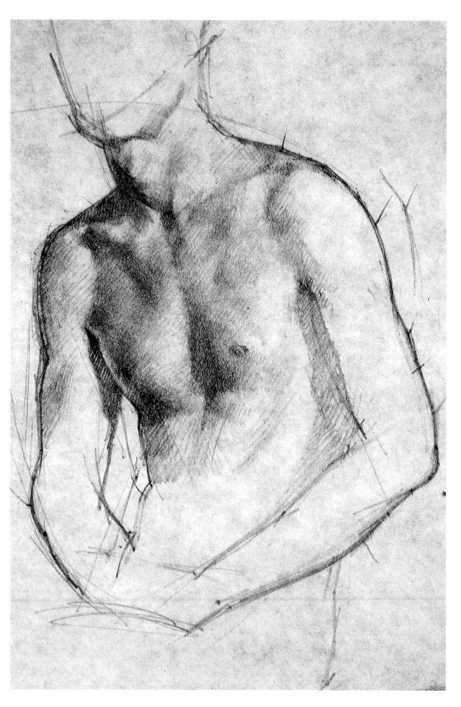

is difficult to maintain. That's why I encourage you to focus on one thing at a time, to bring your mind into the drawing, and to work as slowly and carefully as necessary to craft each line and patch of shading with your undivided attention. For my part, this is how I keep from being overwhelmed by the magnitude of the task. I try to build a little fortress of concentration. Eventually, it can become a vast domain. It is built one pencil stroke at a time.

But while you may be unaware of all that is going on in the head of an experienced artist at work, you *are* likely to notice his confident reliance on tried-and-true, methodical, practical experience. In my imagination, I picture an experienced artist's place while drawing to be in the control room of a great drawing factory, with windows overlooking the factory floor. There he sits, quietly surveying a vast industrial domain in which drawings, like airliners, slowly blossom forth, soon to fly away and serve the needs of mankind.

Perhaps this sounds like delusions of grandeur? Well, I say that each of us can be the chairperson of our own drawing domain. Why not? Development of our faculties should be our primary goal, since together they constitute our *enabling factor*—the sum total of all the skills and abilities that empower us. The enabling factor is our industrial capacity, developed through years of serious practice within the framework of a coherent drawing method.

The seed of the art of drawing is planted in each person who has in his or her heart a desire to draw. It is an urge to explore and express life with beauty, meaning, craftsmanship, and grace. If you want to learn how to draw, cultivate in yourself the study of drawing. Look at master drawings in books or go to museums and study them there. Go to open drawing sessions and take classes in drawing at your local art supply store or community college. Find a way to draw. Avail yourself of these opportunities and the art of drawing will develop in you. The history of drawing expresses itself uniquely in each artist. It is wonderful and exciting when *you* begin to discover how it expresses itself through your own hand and pencil.

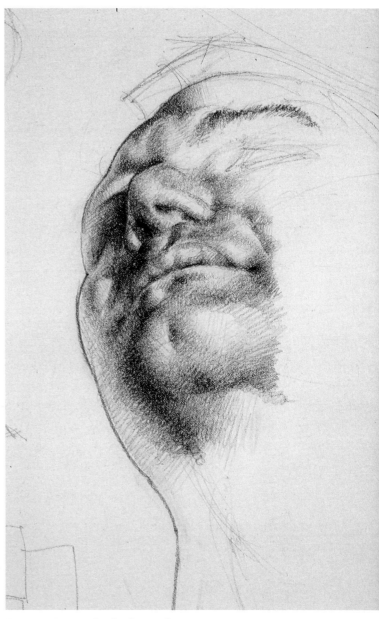

Drawing Demo: *Study of a Head,* 1998
Pencil on paper, 17 x 14" (43 x 36 cm)

In this difficult pose, the model's head is thrown back, compressing the view of the features and diminishing the distance from the eyebrows to the hairline. Gnarly hills of form, densely patterned with pathways, pile up like the mountains of West Virginia. It is richly, intensively configured territory. This is where experience comes into play. In order not to lose my way in such drawings, I rely on the underlying structure of the drawing process as I've learned it and practiced it all these years. In other words, I scan throughout the block-in shape, tap into the gestural current, study the particular shape of each form within the unified, organizational structure, and then apply the light as it pertains to its direction and key.

INDEX